The Joy of Art

A Creative Guide for Beginning Painters

Serge Clément

Marina Kamena

Translated from the French by Anthony Roberts

HARRY N. ABRAMS, INC., PUBLISHERS

Editor, English-language Edition: Ellen Nidy
Design Coordinator, English-language edition: Dana Sloan

Library of Congress Cataloging-in-Publication Data
Kamena, Marina
 [Monde reste á peindre. English]
 The joy of art / a creative guide for beginning painters / Marina Kamena and
Serge Clément ; hand lettered by Beata Szpura ; translated from the French by
Anthony Roberts.
 p cm.
 Includes bibliographical references and index.
 ISBN 0–8109–4225–9
 1. Painting—Technique. I. Clement, Serge, 1950– II. Title.

ND1500 .K27413 2000
751—dc21 00–038972

Harry N. Abrams, Inc.
100 Fifth Avenue
New York, N.Y. 10011
www.abramsbooks.com

Printed and bound in France

Contents

Preface

This book is an invitation to painting. Painting is our passion. Any kind of painting—on walls, objects, canvases, or sheets of paper, in watercolors, tempera, oils, and acrylics.

We believe that knowledge is not the enemy of emotion, any more than curiosity is the murderer of innocence, or dexterity the destroyer of instinct. As painters, we rely on certain basic principles, which are united in our memories and in the automatic gestures intrinsic to our craft. These technical principles essential to painting have been our guides in creating this book.

Painting was in existence well before the invention of writing: it adorned the cave walls of Altamira, Lascaux, and Chauvet, as well as a wide variety of moveable objects and supports. Over thousands of years, the craft of painting and the gestures it employed were passed on from one era to the next, from observation to observation, studio to studio, master to apprentice, fresco to canvas, illumination to watercolor, notebook to manual. This precious store of information has allowed us to become painters, and observers of painting.

The figures early man painted, intended to be hidden and secret, were swallowed up by time and totally forgotten. Rediscovered in our own era, they demonstrate that early man's imagination already contained the constituents of what we know as representative art: lines, drawings, layerings, dabbings, sprayings, and reliefs. Man's instinct for art emerged with absolute clarity in his earliest forms of expression.

His sense of secrecy was obvious in the way he went about his work. His first paintings were done on the walls of pitch-dark cave galleries that could be reached only by wriggling through the narrowest of tunnels—then, as now, a prerequisite of painting was that the right to view it had to be won with great effort. Today, the beam of a flashlight may extract some kind of message from these ancient masterpieces, but it can never penetrate their mystery, which is all the more unfathomable for having been lost in oblivion for so many thousands of years.

The oblivion that cloaked these images for so long reflects something of our own modern condition. Children draw, color, and paint freely until they are eight or ten years old, only to have their spontaneity smothered under thick blankets of academic knowledge as they enter adulthood. In this book we set out to preserve (or resurrect) the childhood thrill of using color crayons and a box of watercolors.

As a would-be painter, you are free to banish inhibitions, arousing in yourself a genuine desire to paint, inducing the eye and hand to work together, creating the kind of awareness that can transform you from a passive onlooker to an active participant. Once you understand the techniques of painting, you will be able to read textures. Your vision will penetrate the very flesh of the pictures you are looking at. Similarly, working at drawings will sharpen your eye, and you will find that you have never actually seen many things you thought you already knew. You will come to understand that painting is a clear and definite language in itself, one that can be learned and used in a practical way just like any other.

Your initial errors and awkwardness, normally so discouraging, will take on a different complexion in these pages. We do not want you to be at all concerned with accuracy or perfection and we hope this fact will help you to overcome any doubts you may have about your ability to draw and paint.

Our approach is not unlike that of a workbook filled with illustrated plates. In these pages, the meanderings of the text are treated as part of a larger image, the arrows that lead from one block of words to the next are used not only as indicators but also as agents of color and movement. The design of each spread was dictated by the theme we were writing about. In many cases, the text carries the messages of painters (there is no painting, after all, without painters). Our aim has been to make these artists come alive through anecdotes, to some extent, but much more through their actions, their methods. These methods represent for us many paths, which we have sign-posted with the same enthusiasm our own friends have shown us when they set out to explain art forms whose rules and laws we might grasp, but whose "essence" we could never learn.

The messages, sent down to us by such masters as Giotto, Piero della Francesca, Titian, Leonardo da Vinci, Caravaggio, Rembrandt, Dürer, Velázquez, Poussin, Chardin, Goya, Turner, Ingres, Cézanne, Hopper, and so many others, constantly remind us of the heights to which painting can rise, provided it is united with real vision. Each painting reveals a unique experience, and the light of that experience has touched this book from beginning to end.

In their own times, the great painters of history were quintessentially modern. Through this book we have carried their baggage, for time is incapable of traveling light. Will that baggage prove as useful as it once was? Will its sheer volume weigh on our ability to move forward? Can other trunks be added to the load, and if so, which?

The photographer's case, the cameraman's equipment, the computer screen have little in common with the traditional tools of painting. The adaptation of the working habits and skills of earlier artists to techniques spawned by modern materials (such as the use of glues, plastics, or cold welding) offers a whole range of fresh delights—joy at seeing something tired and old come back into its own as a unique

achievement and satisfaction when great but disregarded works from the past re-appear as new and different ways of envisioning the world and describing it in images.

There can never be enough representational art. Contemporary techniques in painting do not drive out their predecessors; rather they merge with them, challenging painters to express themselves with all the means their trade has to offer. Day after day painters of every type from all over the planet still breathe the intoxicating scent of turpentine and resin and wonder at their strange powers. These vapors remind us all that the whole world is still out there, waiting to be painted.

Introduction to Painting and Drawing

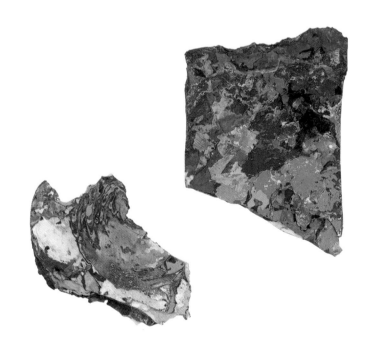

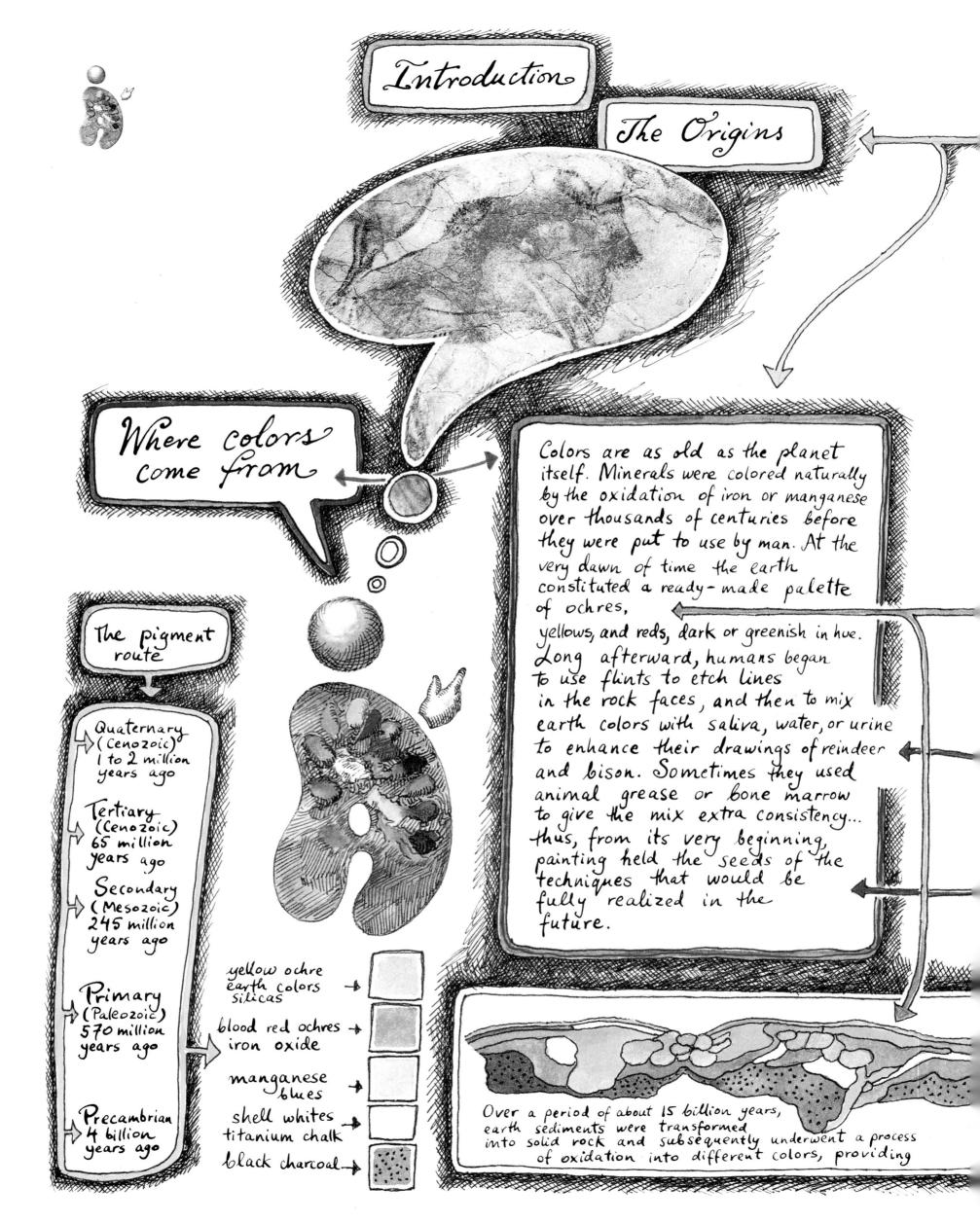

Introduction

The Origins

Where colors come from

Colors are as old as the planet itself. Minerals were colored naturally by the oxidation of iron or manganese over thousands of centuries before they were put to use by man. At the very dawn of time the earth constituted a ready-made palette of ochres, yellows, and reds, dark or greenish in hue. Long afterward, humans began to use flints to etch lines in the rock faces, and then to mix earth colors with saliva, water, or urine to enhance their drawings of reindeer and bison. Sometimes they used animal grease or bone marrow to give the mix extra consistency... thus, from its very beginning, painting held the seeds of the techniques that would be fully realized in the future.

The pigment route

Quaternary (Cenozoic) 1 to 2 million years ago

Tertiary (Cenozoic) 65 million years ago

Secondary (Mesozoic) 245 million years ago

Primary (Paleozoic) 570 million years ago

Precambrian 4 billion years ago

yellow ochre earth colors silicas →

blood red ochres iron oxide →

manganese blues →

shell whites titanium chalk →

black charcoal →

Over a period of about 15 billion years, earth sediments were transformed into solid rock and subsequently underwent a process of oxidation into different colors, providing

Very long ago, artists in what is now southwestern France were already making full use of illusion. A bulge on a rock face served to imitate the abdomen of a mammoth or a wild horse, and relief was emphasized in its contours. The human hand that appears silhouetted on the cave walls of Gargas in France did more than supply the outline for the first stenciled images; it had acquired sufficient expertise to paint in subtle gradations of color. Relief, as a technique to deceive the eye, had been invented.

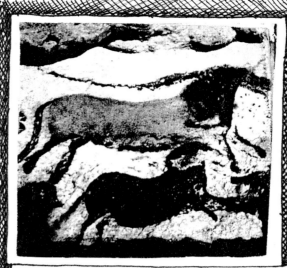

Wild horses at Lascaux

The Magdalenian palette

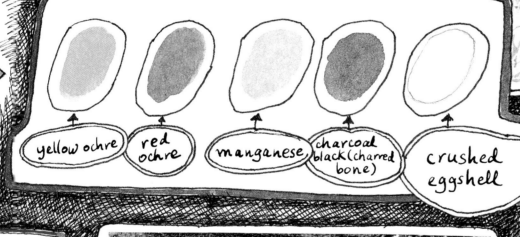

yellow ochre red ochre manganese charcoal black (charred bone) crushed eggshell

Hands outlined with hematite powder blown through a pipe at the Gargas cave

Thin paint

Oily paint

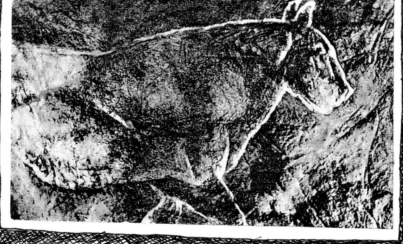

The lion in the Cambarelles cave at Dordogne shows a strategy of stone engraving that uses the oblique angles of the light to emphasize relief, giving a powerful impression of a living animal. The artists who did this were extraordinarily gifted; they were the first in their field and they invented techniques that are used to this day.

e first artists th what we call Magdalenian palette.

The pigment route

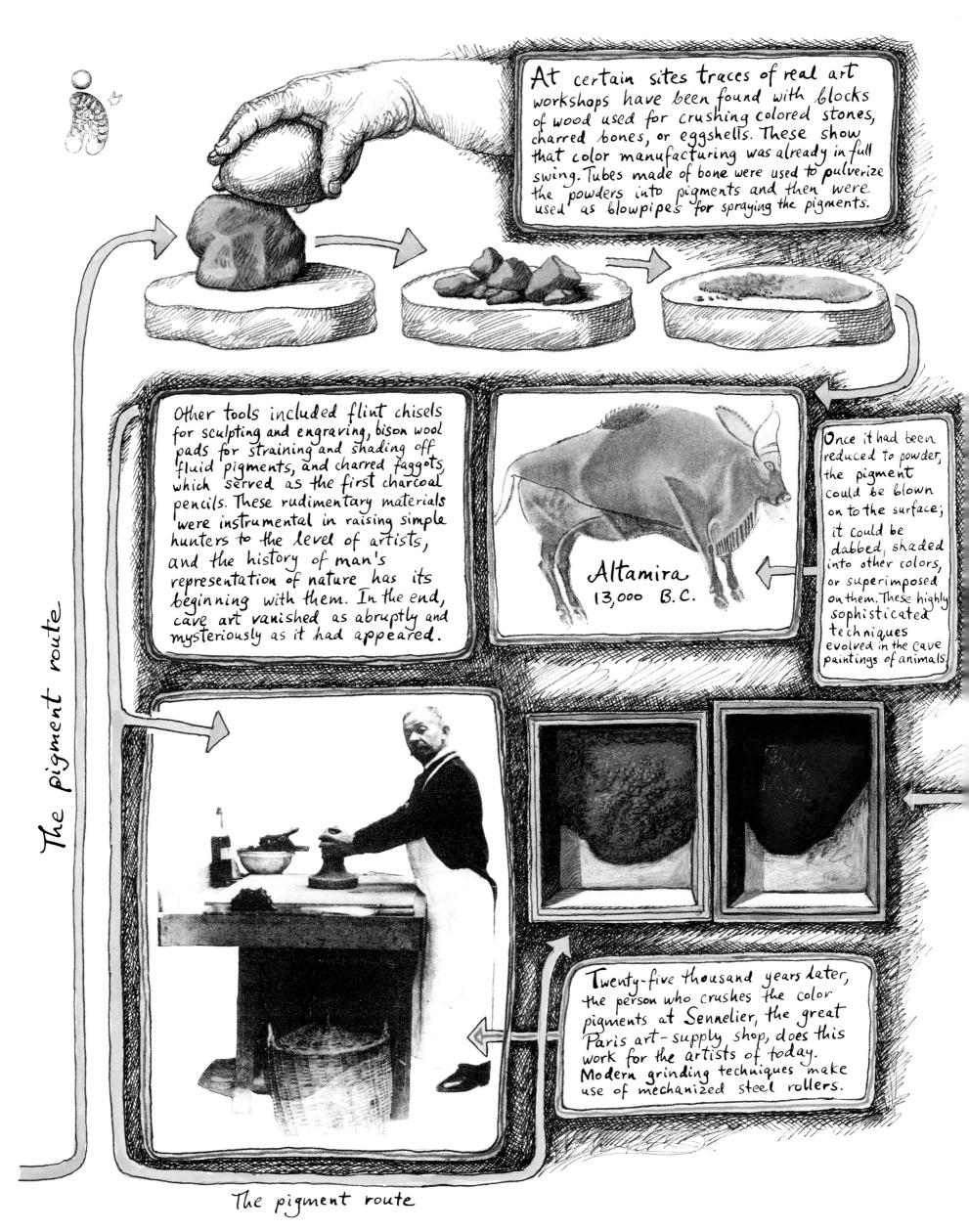

At certain sites traces of real art workshops have been found with blocks of wood used for crushing colored stones, charred bones, or eggshells. These show that color manufacturing was already in full swing. Tubes made of bone were used to pulverize the powders into pigments and then were used as blowpipes for spraying the pigments.

Other tools included flint chisels for sculpting and engraving, bison wool pads for straining and shading off fluid pigments, and charred faggots, which served as the first charcoal pencils. These rudimentary materials were instrumental in raising simple hunters to the level of artists, and the history of man's representation of nature has its beginning with them. In the end, cave art vanished as abruptly and mysteriously as it had appeared.

Altamira
13,000 B.C.

Once it had been reduced to powder, the pigment could be blown on to the surface; it could be dabbed, shaded into other colors, or superimposed on them. These highly sophisticated techniques evolved in the cave paintings of animals.

Twenty-five thousand years later, the person who crushes the color pigments at Sennelier, the great Paris art-supply shop, does this work for the artists of today. Modern grinding techniques make use of mechanized steel rollers.

The pigment route

The pigment route

The pigments

A pigment is a coloring powder that an artist spreads across a surface. To do this, he must first disperse the powder in some kind of liquid, creating a "binder."
The binder has two functions:
1. Its fluidity allows the artist to draw with his brush.
2. It affixes the color to the support. To do this it must contain sticky molecules to hold the color in place after the solvent has evaporated.

Egyptian binders eggs (albumens)

yolk and white + rain water = tempera (and its palette of colors)

copper carbonate or lapis lazuli | arsenic sulfite | mercury of cinnabar | hydrated silicate | iron oxide | arsenic sulfite of cobalt | charred bones | calcium carbonate and sulfite (shells)

The first light binders

fish bladder (isinglass)

boiled bone proteins (collagen)

↓

serums made up of dead and decomposed animals, vegetable gums (gum arabic)

What does a nut contain?

vegetable oil

wax

The first oily binders

animal bone marrow and fats

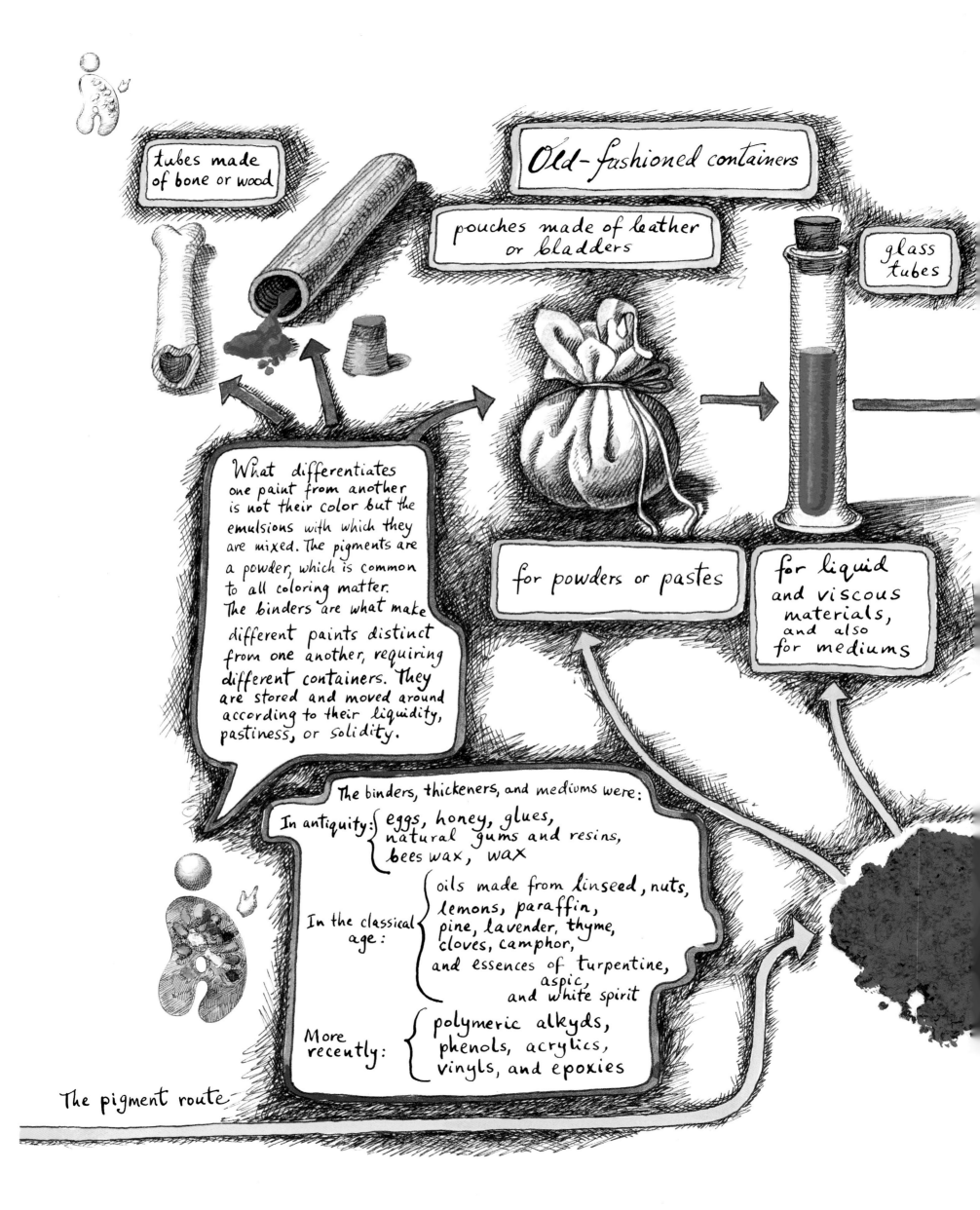

tubes made
of bone or wood

Old-fashioned containers

pouches made of leather
or bladders

glass
tubes

What differentiates one paint from another is not their color but the emulsions with which they are mixed. The pigments are a powder, which is common to all coloring matter. The binders are what make different paints distinct from one another, requiring different containers. They are stored and moved around according to their liquidity, pastiness, or solidity.

for powders or pastes

for liquid
and viscous
materials,
and also
for mediums

The binders, thickeners, and mediums were:

In antiquity: { eggs, honey, glues,
natural gums and resins,
beeswax, wax

In the classical
age: { oils made from linseed, nuts,
lemons, paraffin,
pine, lavender, thyme,
cloves, camphor,
and essences of turpentine,
aspic,
and white spirit

More
recently: { polymeric alkyds,
phenols, acrylics,
vinyls, and epoxies

The pigment route

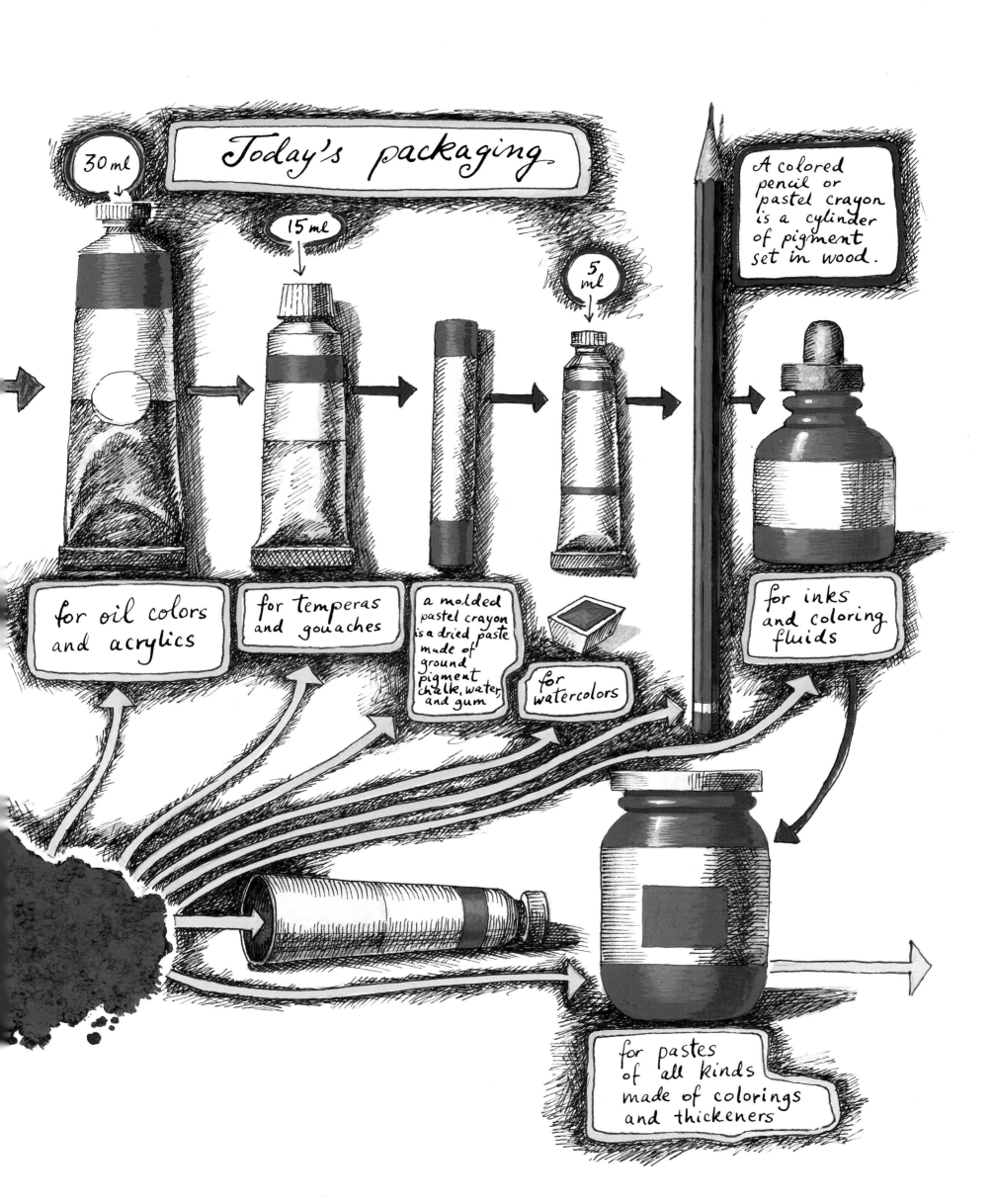

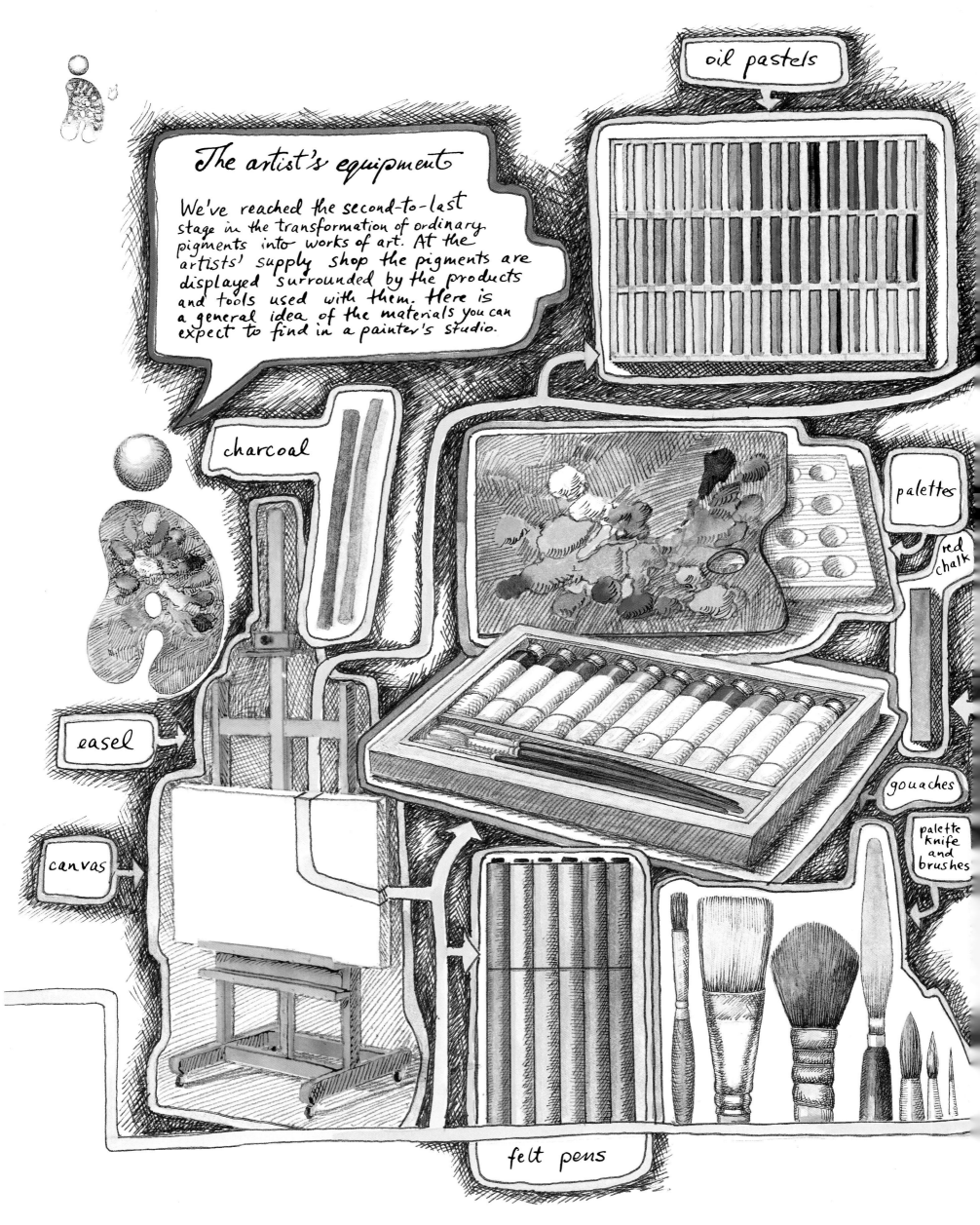

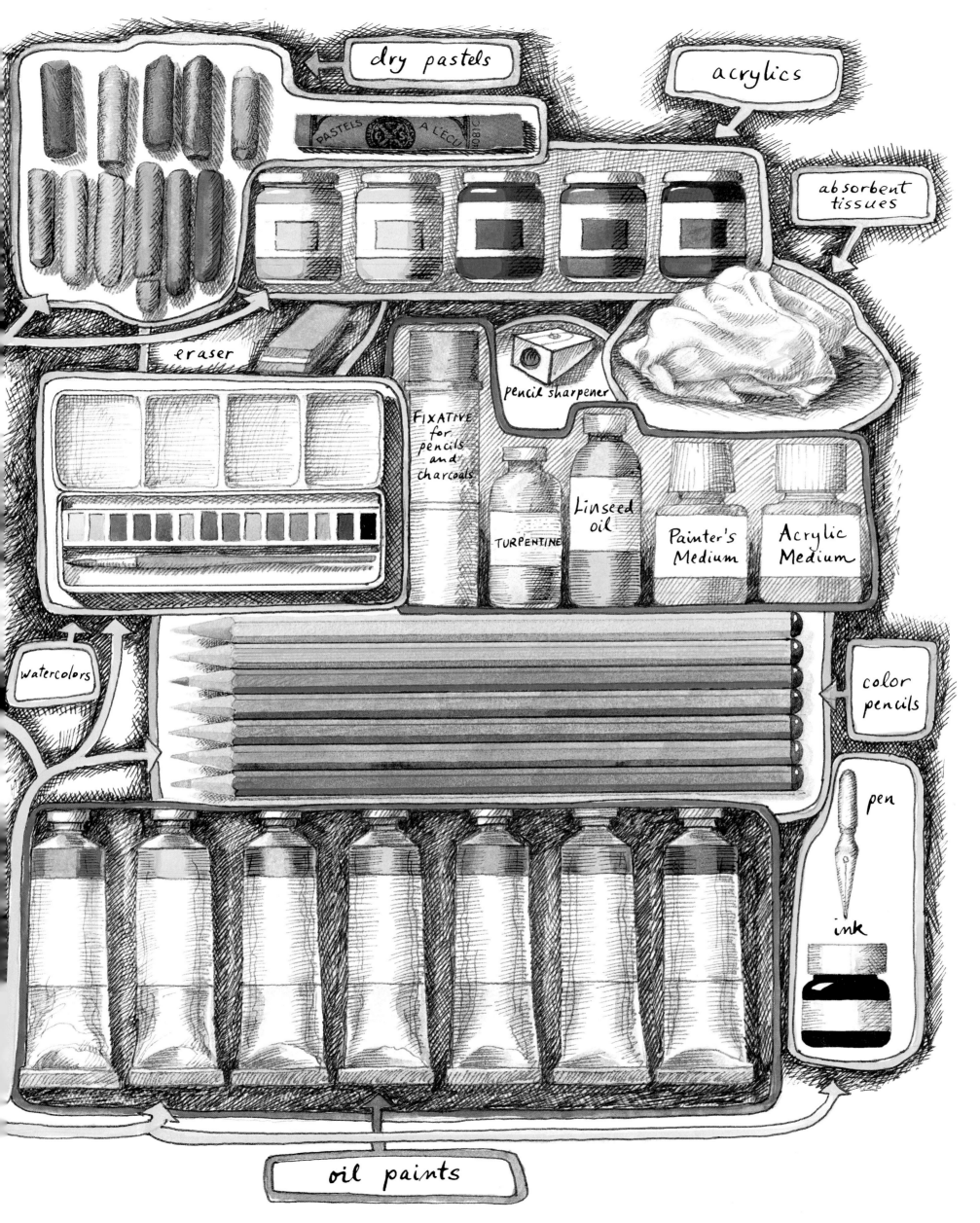

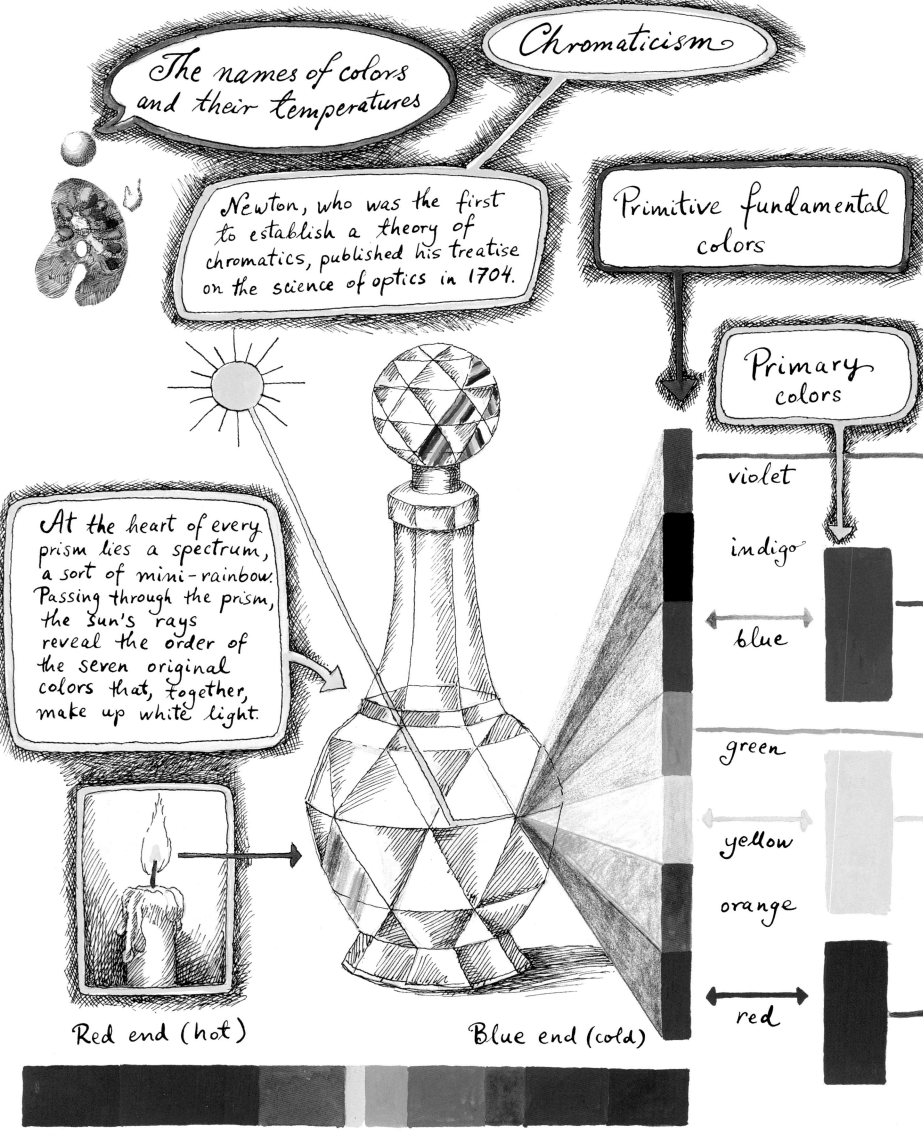

The names of colors and their temperatures

Chromaticism

Newton, who was the first to establish a theory of chromatics, published his treatise on the science of optics in 1704.

Primitive fundamental colors

Primary colors

At the heart of every prism lies a spectrum, a sort of mini-rainbow. Passing through the prism, the sun's rays reveal the order of the seven original colors that, together, make up white light.

violet

indigo

blue

green

yellow

orange

red

Red end (hot)

Blue end (cold)

The temperatures of the colors of the spectrum

Secondary colors

In the time of Ingres and Delacroix, it was a matter of fierce dispute whether color or line was the chief element in art. We take the view that the two are interdependent.

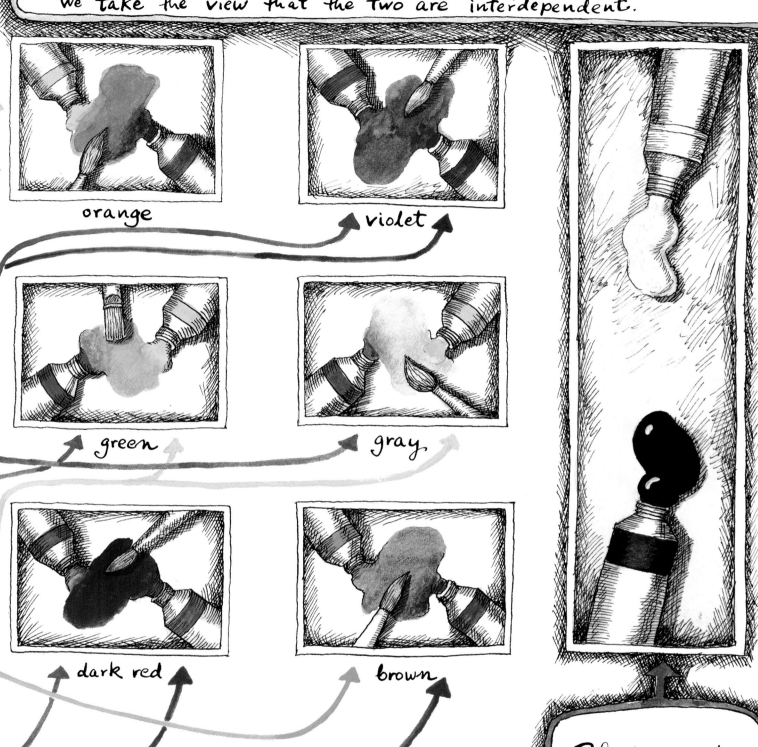

orange

violet

green

gray

dark red

brown

"Colors affect the soul, where they can excite sensations and arouse emotions and ideas which soothe or agitate us by provoking sadness or gaiety."
On Colors, Goethe

Black and white, when added to colors, serve to multiply combinations, introducing the notion of value. Black mixed with a color creates a tone. White mixed with a color creates a tint.

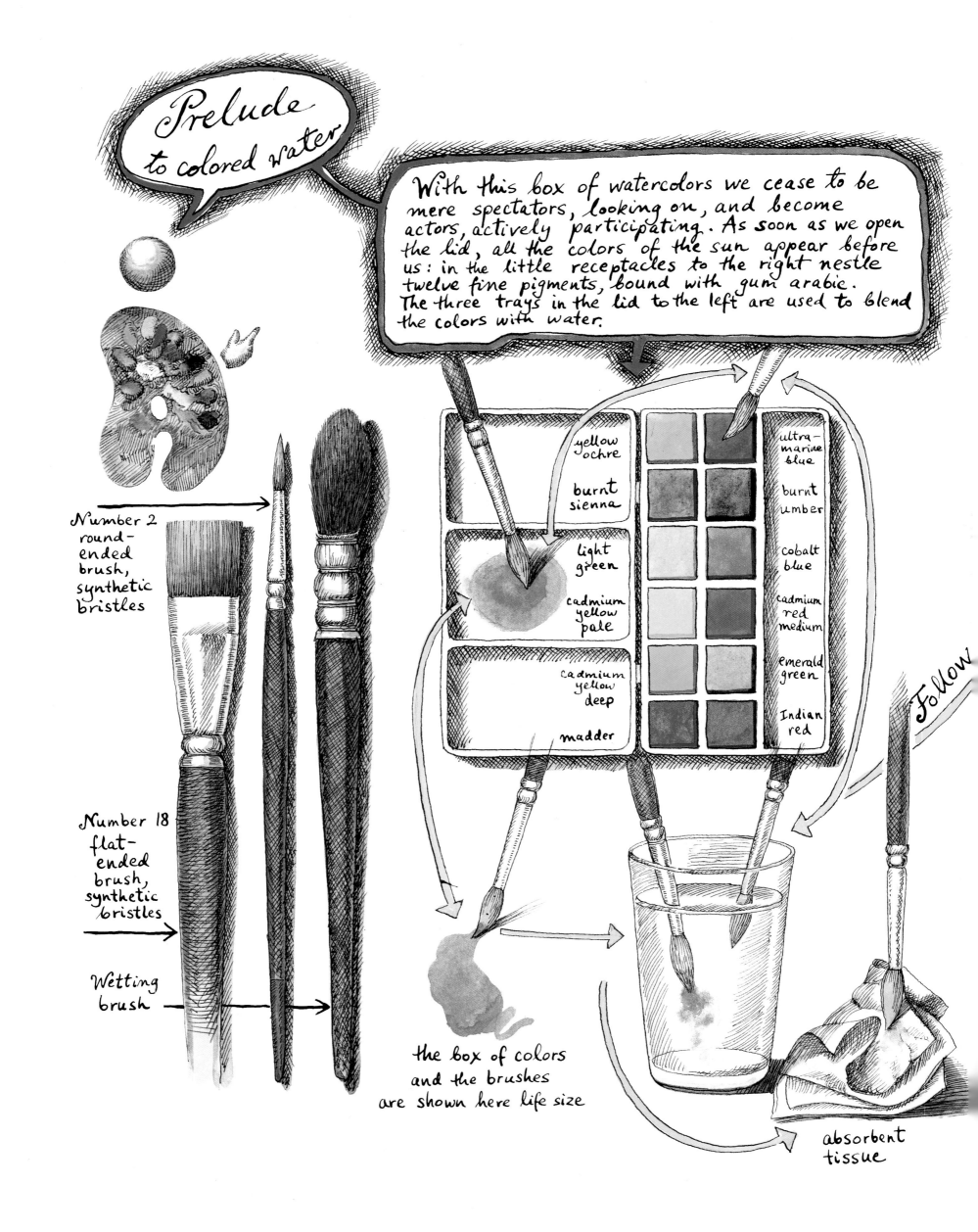

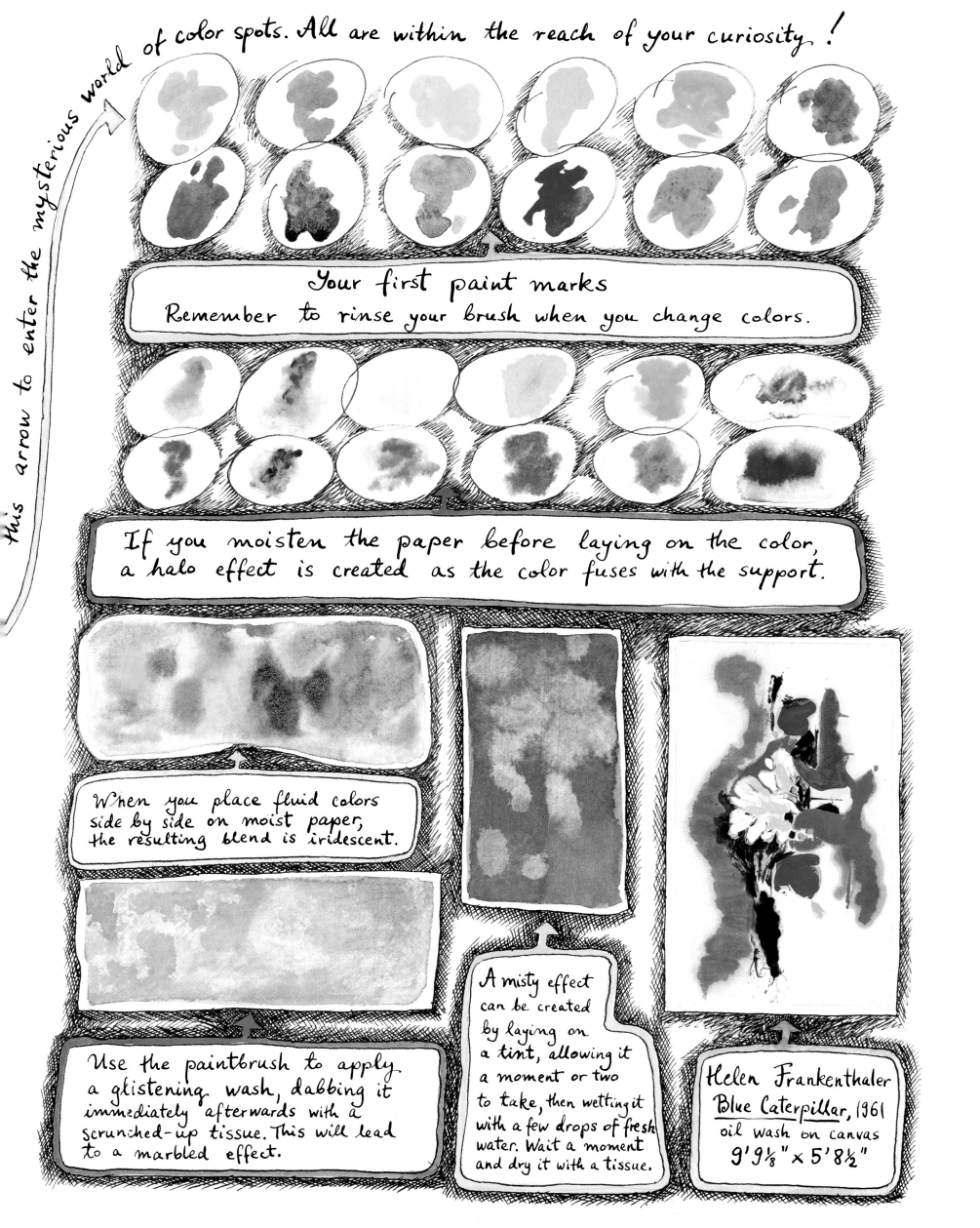

world of color spots. All are within the reach of your curiosity!

this arrow to enter the mysterious

Your first paint marks
Remember to rinse your brush when you change colors.

If you moisten the paper before laying on the color, a halo effect is created as the color fuses with the support.

When you place fluid colors side by side on moist paper, the resulting blend is iridescent.

Use the paintbrush to apply a glistening wash, dabbing it immediately afterwards with a scrunched-up tissue. This will lead to a marbled effect.

A misty effect can be created by laying on a tint, allowing it a moment or two to take, then wetting it with a few drops of fresh water. Wait a moment and dry it with a tissue.

Helen Frankenthaler
Blue Caterpillar, 1961
oil wash on canvas
9'9⅛" × 5'8½"

A practical page

How to paint an apple?

According to Cézanne, the basic shapes in the illustrator's and painter's repertoire are the sphere, the cone, the cylinder, and the cube.

"If you ask an apple, "Who are you?" It will answer, "I am a CIRCLE", and, "I am also it will add, a SPHERE".

direction of the light

thick white paper (for washes)

easel or tilting table

the apple, on a stand or table

On a low table place your paintbox, your bowl of water, your pencils, brushes, eraser, pencil sharpener, a sheet of paper, and absorbent tissues.

If you have been trying to make watercolors in the way we have explained on the previous pages, you will be familiar with the effects caused by the flow of colors across blank sheets of paper.

You may now wish to try this exercise, which involves placing an apple in the light. Once you have done this, make everything ready for your attempt to create your first image.

If you are left-handed, place the table on your left.

Like this figure painted by Magritte, 1898-1967, look hard at the apple, but maybe from a little farther away!

The Story of the Pope and Giotto's Circle

Pope Benoit IX asked one of his courtiers to find out if Giotto deserved his reputation as a great master. The courtier visited several different painters and mosaic makers in Sienna to see their drawings, then traveled to Florence to see Giotto. He explained why he had come and asked the painter for a drawing to show His Holiness. Giotto instantly laid out a sheet of paper, leaned his elbow on his hip to make a kind of compass, and by pivoting on himself drew a perfect circle with a single stroke of his pencil. Unhappy that he had come so far for so little, the pope's envoy nevertheless returned to Rome bearing with him Giotto's circle, which immediately won the confidence of the pontiff...

light

Caillebotte 1848-1894

Monet 1840-1926

light

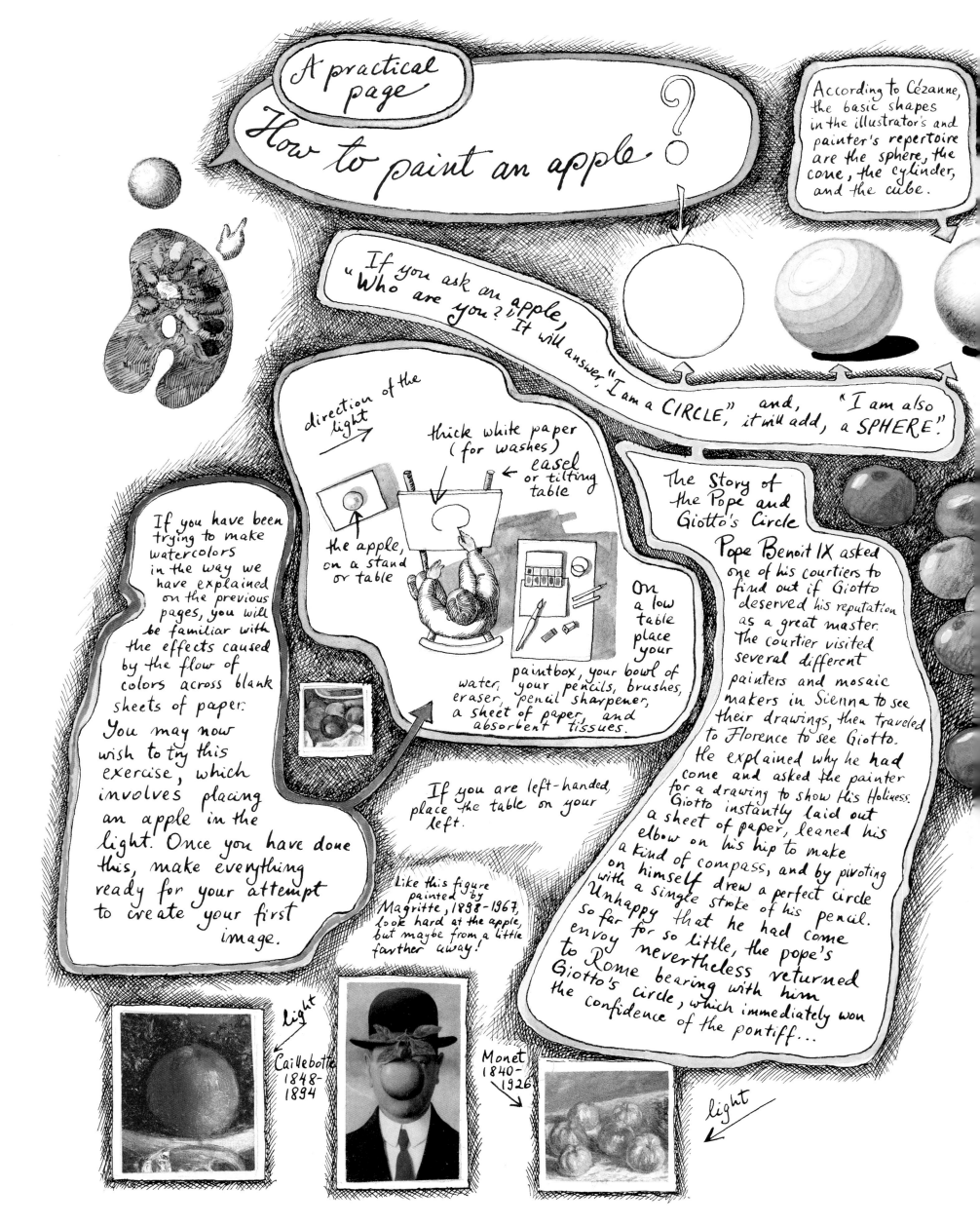

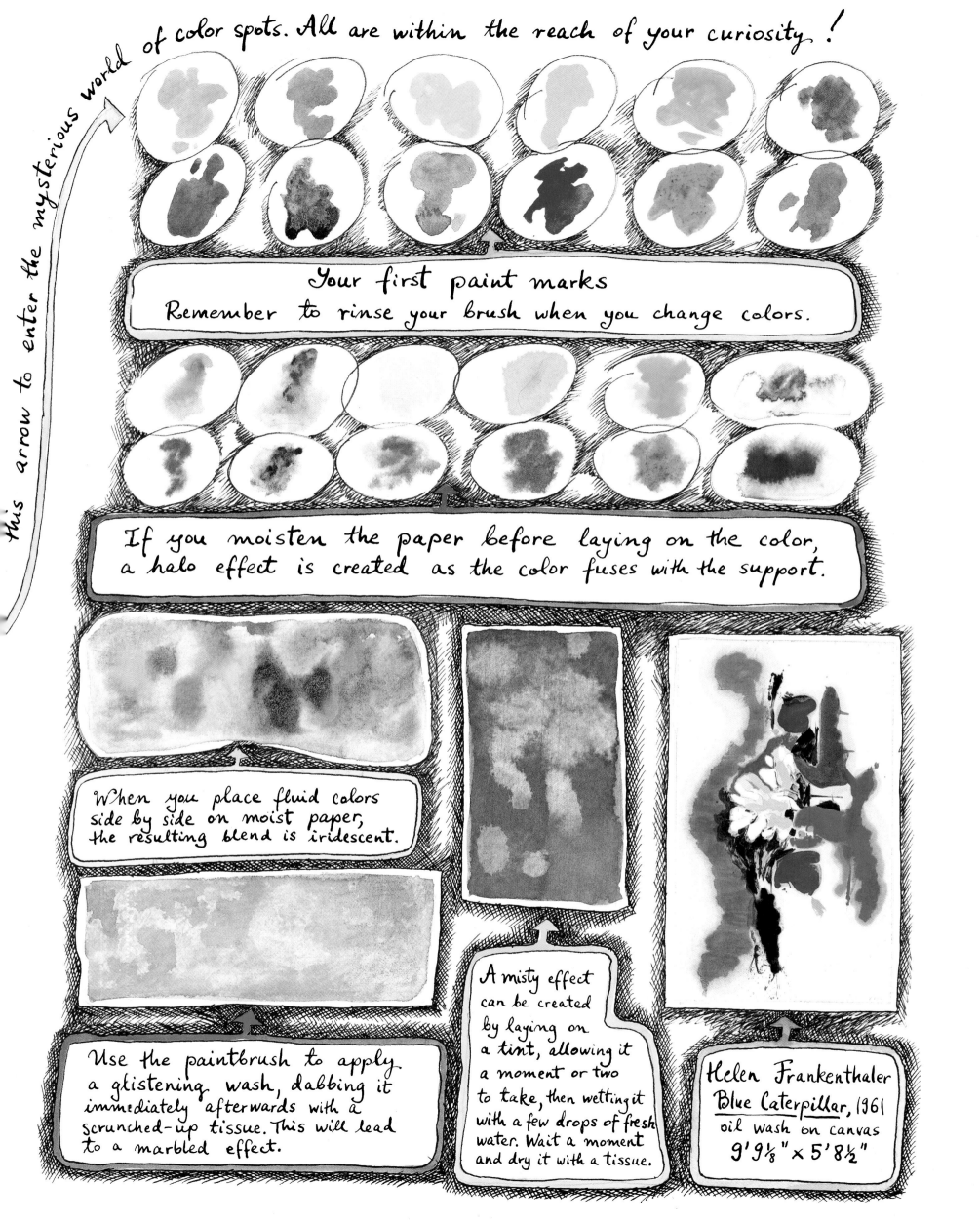

This arrow to enter the mysterious world of color spots. All are within the reach of your curiosity !

Your first paint marks
Remember to rinse your brush when you change colors.

If you moisten the paper before laying on the color, a halo effect is created as the color fuses with the support.

When you place fluid colors side by side on moist paper, the resulting blend is iridescent.

Use the paintbrush to apply a glistening wash, dabbing it immediately afterwards with a scrunched-up tissue. This will lead to a marbled effect.

A misty effect can be created by laying on a tint, allowing it a moment or two to take, then wetting it with a few drops of fresh water. Wait a moment and dry it with a tissue.

Helen Frankenthaler
Blue Caterpillar, 1961
oil wash on canvas
9'9⅛" × 5'8½"

Washes

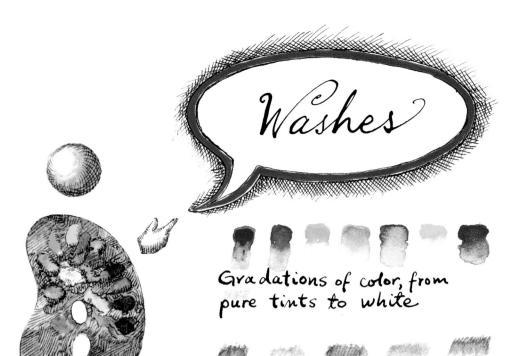

Gradations of color, from pure tints to white

Soluble crayon, rubbed on then smudged with water

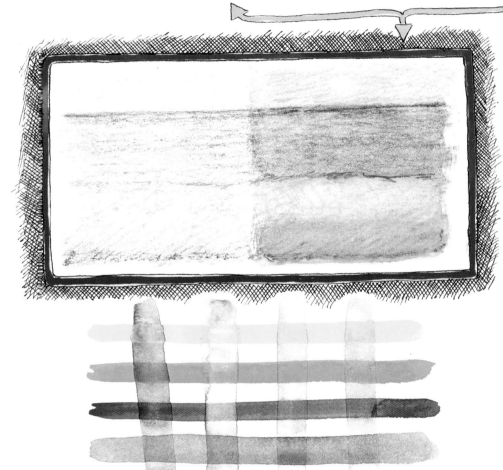

These superimposed light washes show how you can create different iridescent effects by crossing one brushstroke with another.

Like the French painter Seurat, who painted different colored dots close together, you'll acquire your own language in painting.

What's a wash, to a painter? A transparent tint diluted with plenty of water, then laid on paper with round- or flat-ended brushes. For example, this text is written over a blue wash. Washes are the basis for all expression in watercolors.

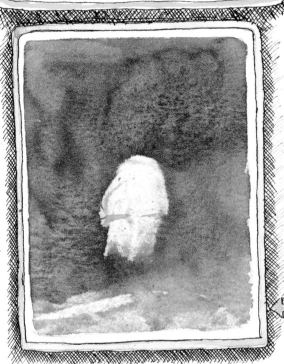

Apply a uniform tint to a moist surface – here the tint happens to be a cadmium red medium. The light smudge in the middle comes from pressing a fingertip wrapped in tissue against the wet wash. Try a few more like this...

The first contours

"Line and color are not separate and distinct. The more one paints, the more one draws. The more the colors come together in harmony, the clearer the lines will be. When the color is at its richest the shape is at its clearest and you have a painting." *Cézanne*

Cézanne, 1839–1906
<u>Apples on a Dresser</u> (detail), 1902–1906

You can draw with charcoal, like the Lascaux artists, or with a pencil, a scraper, a pen, or (like here) a paintbrush.

Edgar Degas, 1834–1917 <u>Racehorses</u>, c. 1879

This drawing by Michelangelo was done on a yellowish brown wash.

When you pick up a pencil to draw something, you're very nearly painting.

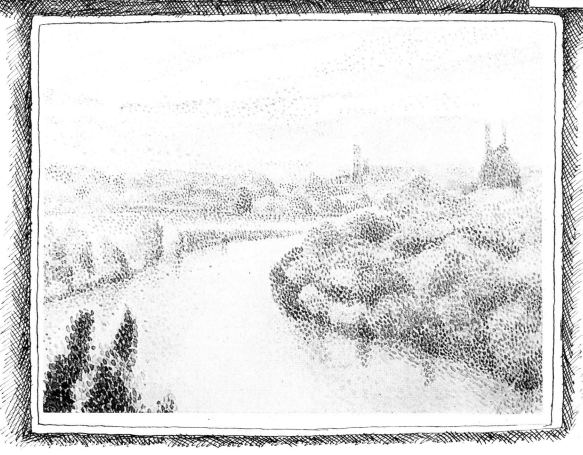

Petitjean was a neo-Impressionist, as were Seurat, Signac, Cross, Augrand, Luce, Dubois-Pillet, and Pissarro, among others. Seurat was influenced by Charles Blanc (<u>La Grammaire des Arts et du Dessin</u>) and by Ogden Rood (<u>Modern Chromatics</u>). In Seurat's view a mixture on the palette could result only in smudged colors on paper, while the division of tints into small but distinct touches become mixed to the eye, thus producing new colors.

Hippolyte Petitjean, 1854–1929
The Seine at Mantes (detail)
16¼" x 24½"

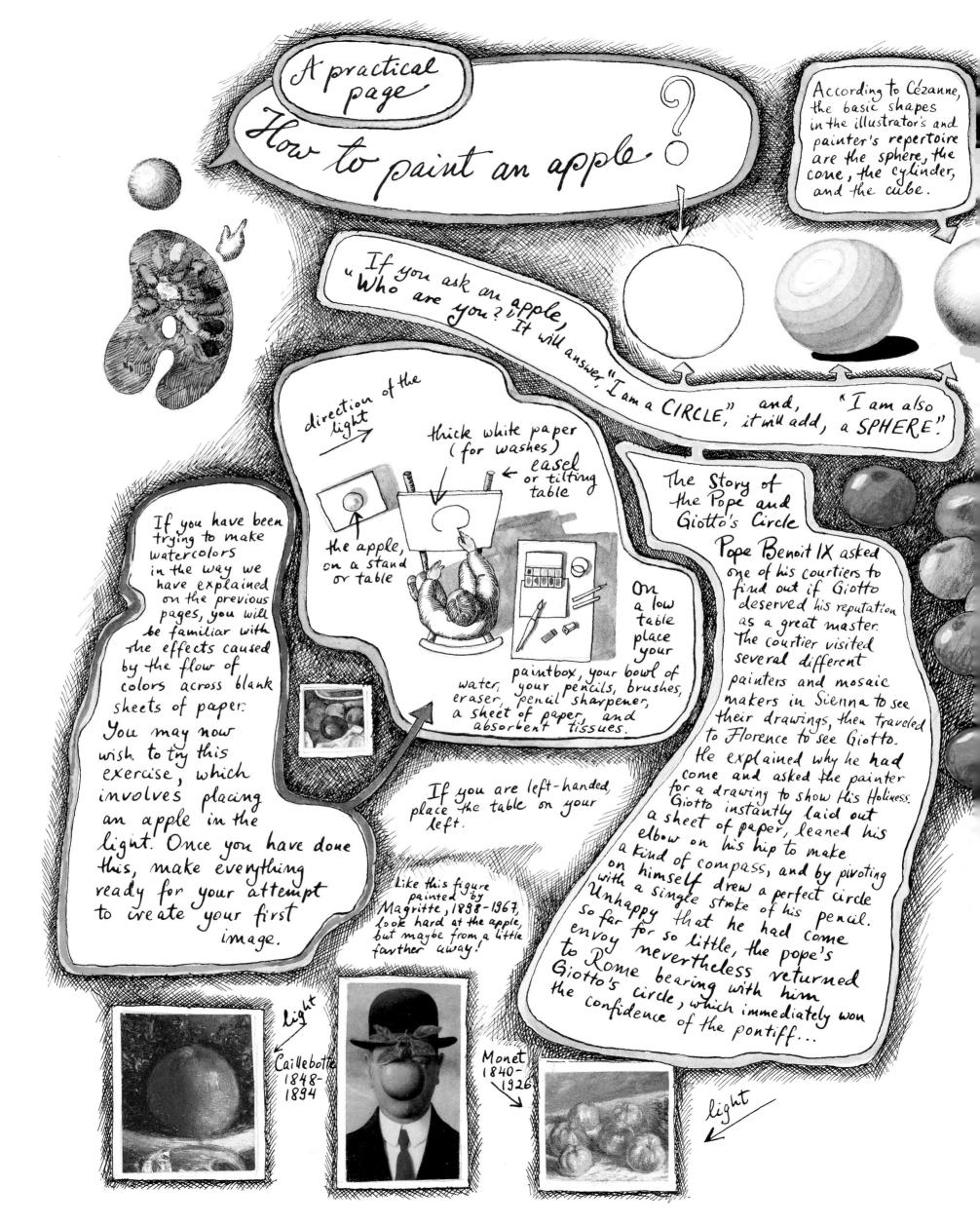

A practical page

How to paint an apple?

According to Cézanne, the basic shapes in the illustrator's and painter's repertoire are the sphere, the cone, the cylinder, and the cube.

"If you ask an apple, "Who are you?" It will answer, "I am a CIRCLE," and, "I am also a SPHERE."

If you have been trying to make watercolors in the way we have explained on the previous pages, you will be familiar with the effects caused by the flow of colors across blank sheets of paper. You may now wish to try this exercise, which involves placing an apple in the light. Once you have done this, make everything ready for your attempt to create your first image.

direction of the light

thick white paper (for washes)

easel or tilting table

the apple, on a stand or table

On a low table place your paintbox, your bowl of water, your pencils, brushes, eraser, pencil sharpener, a sheet of paper, and absorbent tissues.

If you are left-handed, place the table on your left.

Like this figure painted by Magritte, 1898–1967, look hard at the apple, but maybe from a little farther away!

The Story of the Pope and Giotto's Circle

Pope Benoit IX asked one of his courtiers to find out if Giotto deserved his reputation as a great master. The courtier visited several different painters and mosaic makers in Sienna to see their drawings, then traveled to Florence to see Giotto. He explained why he had come and asked the painter for a drawing to show His Holiness. Giotto instantly laid out a sheet of paper, leaned his elbow on his hip to make a kind of compass, and by pivoting on himself drew a perfect circle with a single stroke of his pencil. Unhappy that he had come so far for so little, the pope's envoy nevertheless returned to Rome bearing with him Giotto's circle, which immediately won the confidence of the pontiff…

light

Caillebotte 1848–1894

Monet 1840–1926

light

a watering can to water apple trees

Not all artists rely on the same basic formula. The idea of Cézanne puzzling over his cones and cylinders gave Dubuffet the shivers. "Ah, mais non! I would never paint a face like I'd paint an apple! When I paint ears I think of noises, when I paint lips I think of words, and when I paint teeth I think of food..."

① Draw a circle with a pencil

sphere cone cylinder cube ↑

② Refine your circle with your eraser, erasing all unnecessary lines

Make a couple small dots where the light hits

③

In watercolors, the color white is the part of the paper you haven't painted over

You will find the colors for your apple in your paint box

④ Now lay on your yellow, avoiding the point where the light hits

Warning! Instead of using paint to make an apple, you are using an apple to make a painting — an exact reproduction of nature isn't what we are after here. When you go to the ballet what you see is a different way for people to walk and move, called dancing. <u>Swan Lake</u> isn't about the death of an aquatic bird, it's about dance.

Likewise Cézanne's apples aren't fruits to be made into applesauce — they are an oil painting and your apple will be a watercolor. Forget about strict accuracy. Try instead to create an approximation of your apple, to make it "appear."

⑤ The moment the yellow is dry, brush diluted red over it with a circular motion

⑥ Now lay your green on top of the yellow and red (superimposing it)

Once you've done that, start asking the apple a few questions and translate its answers with your brush. Whatever comes of this may not be technically correct, but is likely to give you pleasure.

⑦ Draw an ellipse under the apple and fill it with a blend of blue and brown. This is the apple's shadow, connecting it with its stand.

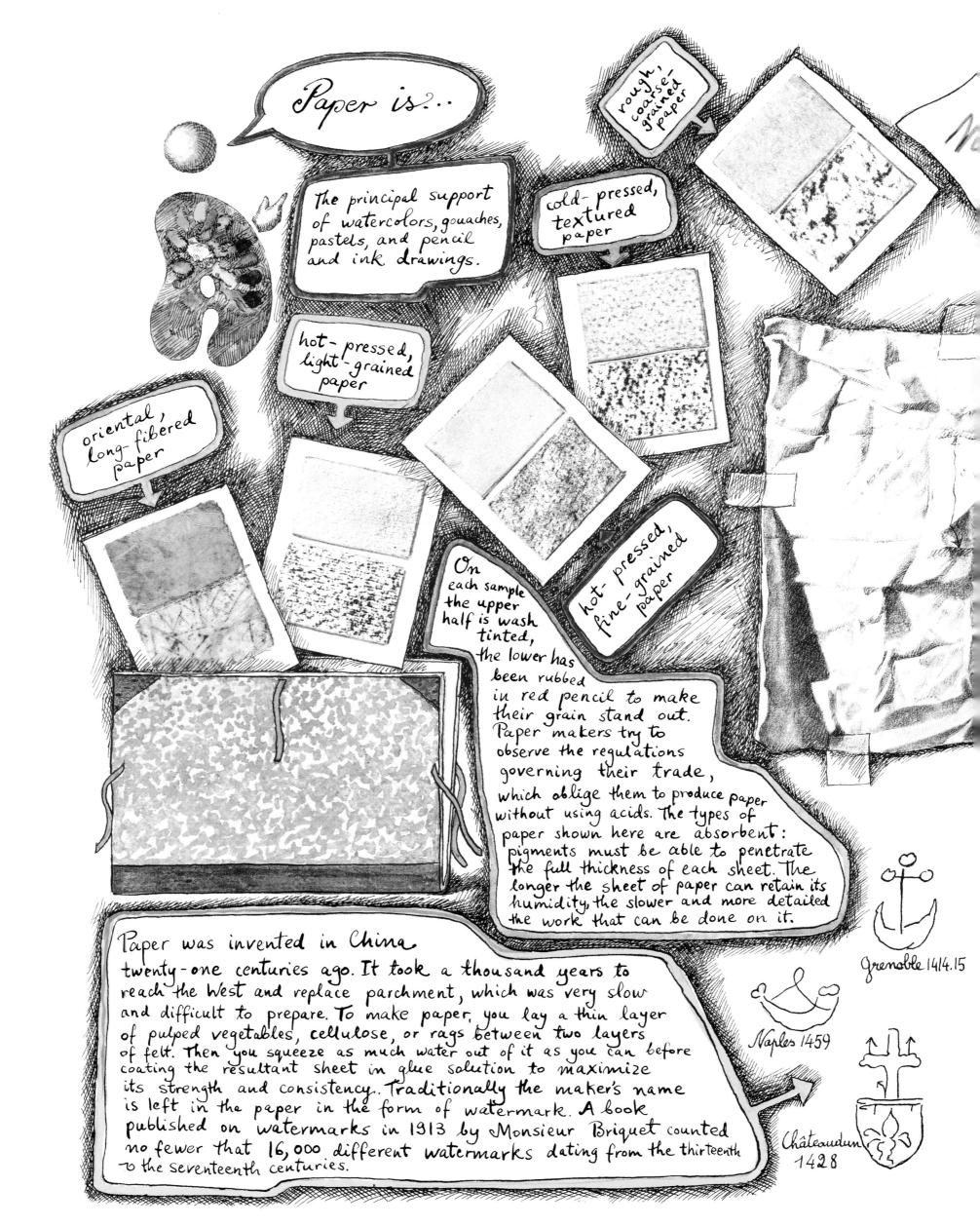

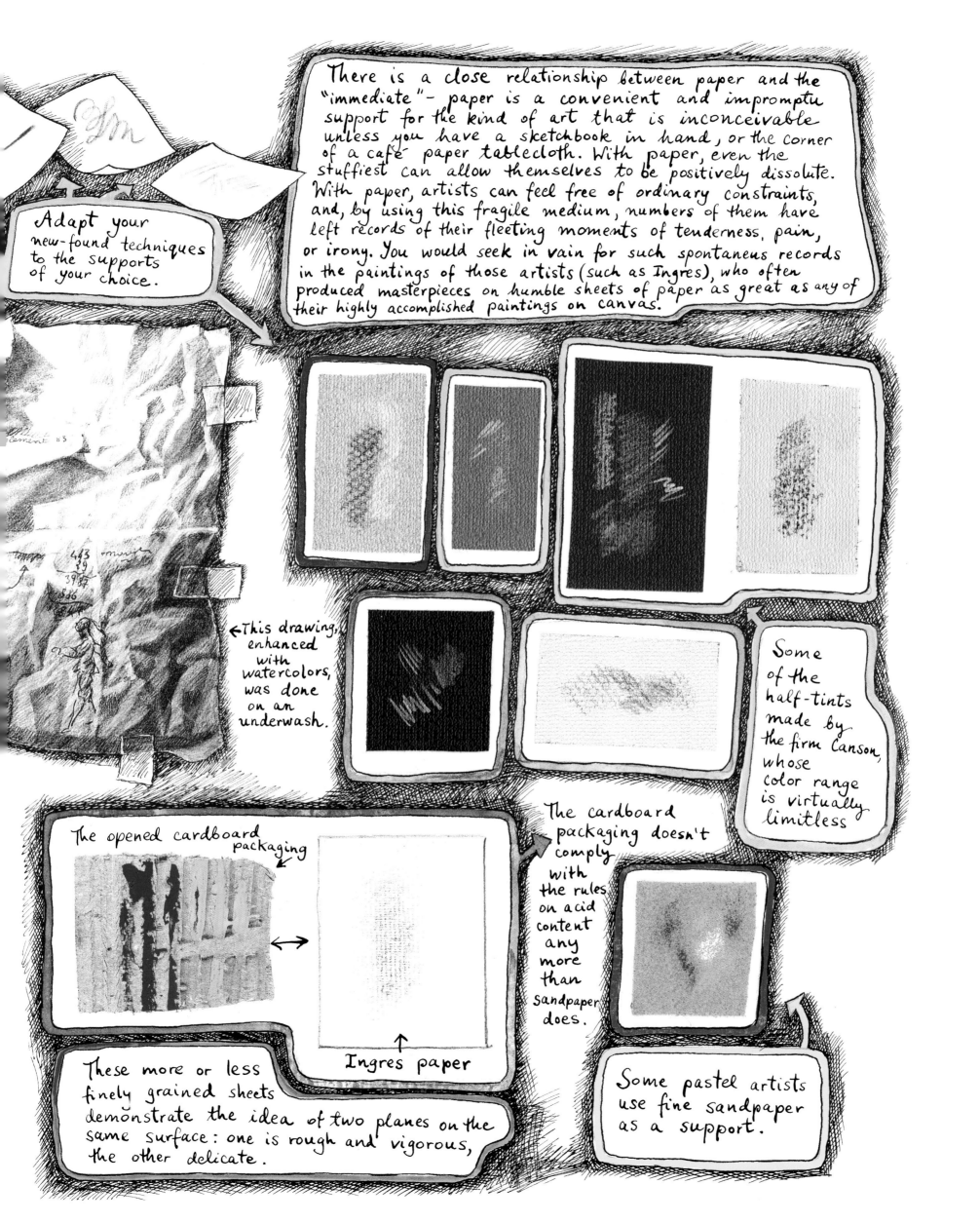

There is a close relationship between paper and the "immediate" - paper is a convenient and impromptu support for the kind of art that is inconceivable unless you have a sketchbook in hand, or the corner of a café paper tablecloth. With paper, even the stuffiest can allow themselves to be positively dissolute. With paper, artists can feel free of ordinary constraints, and, by using this fragile medium, numbers of them have left records of their fleeting moments of tenderness, pain, or irony. You would seek in vain for such spontaneus records in the paintings of those artists (such as Ingres), who often produced masterpieces on humble sheets of paper as great as any of their highly accomplished paintings on canvas.

Adapt your new-found techniques to the supports of your choice.

←This drawing, enhanced with watercolors, was done on an underwash.

Some of the half-tints made by the firm Canson, whose color range is virtually limitless

The opened cardboard packaging

Ingres paper

The cardboard packaging doesn't comply with the rules on acid content any more than sandpaper does.

These more or less finely grained sheets demonstrate the idea of two planes on the same surface: one is rough and vigorous, the other delicate.

Some pastel artists use fine sandpaper as a support.

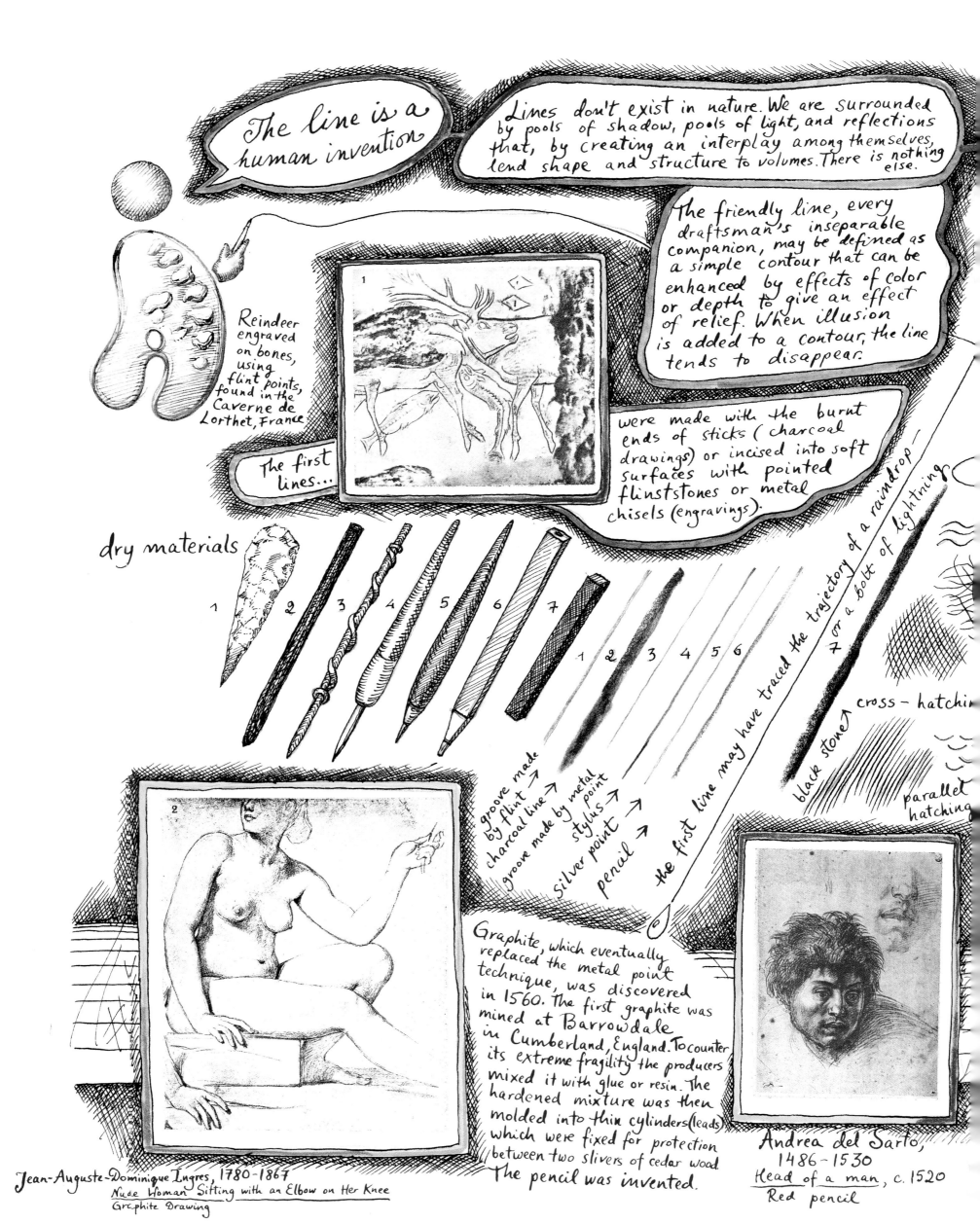

The line is a human invention

Lines don't exist in nature. We are surrounded by pools of shadow, pools of light, and reflections that, by creating an interplay among themselves, lend shape and structure to volumes. There is nothing else.

The friendly line, every draftsman's inseparable companion, may be defined as a simple contour that can be enhanced by effects of color or depth to give an effect of relief. When illusion is added to a contour, the line tends to disappear.

Reindeer engraved on bones, using flint points, found in the Caverne de Lorthet, France

The first lines...

...were made with the burnt ends of sticks (charcoal drawings) or incised into soft surfaces with pointed flintstones or metal chisels (engravings).

dry materials

1 2 3 4 5 6 7

1 2 3 4 5 6 7

groove made by flint →
charcoal line →
groove made by metal point stylus →
silver point →
pencil →

the first line may have traced the trajectory of a raindrop — or a bolt of lightning

black stone → cross-hatching

parallel hatching

Graphite, which eventually replaced the metal point technique, was discovered in 1560. The first graphite was mined at Barrowdale in Cumberland, England. To counter its extreme fragility the producers mixed it with glue or resin. The hardened mixture was then molded into thin cylinders (leads) which were fixed for protection between two slivers of cedar wood. The pencil was invented.

Jean-Auguste-Dominique Ingres, 1780-1867
Nude Woman Sitting with an Elbow on Her Knee
Graphite Drawing

Andrea del Sarto, 1486-1530
Head of a man, c. 1520
Red pencil

The drawing is the first script of human thought, the basis for all other plastic arts.

Leonardo da Vinci thought that the first drawing was done by a man who saw his own shadow thrown against a rock surface and traced its contours with charcoal.

LEONARDO·A·VINCI

Chinese ink consists of oily carbon derived from trees, vegetable oils, and fats, dissolved in glue. Sepia ink comes from the stomach sacs of cuttlefish. The use of such fluids opened the door to fresh notions of drawing and painting.

sinuous

crow

goose

swan

reed

Plumes and Pens

Tools for use with fluids

By the end of the 18th century, Terry of Birmingham, England, was manufacturing steel-nibbed pens

steel nib

brush

When, by order of a court of justice, Rembrandt's collections were put up for sale, it was found they included engravings of all the works of Mantegna and three volumes of prints copied from Raphael.

Hercules Segers
1589-1638
Mountain
Landscape
etching

Rembrandt van Rijn
1606-1669
Rembrandt, Wild-eyed

A "line drawing" is a drawing in which no line is shaded

Niklaus Manuel Deutsch
1484-1530 Wise Virgin, detail 1510-1520

Reginald Marsh 1898-1954
Sidewalk
Chinese ink

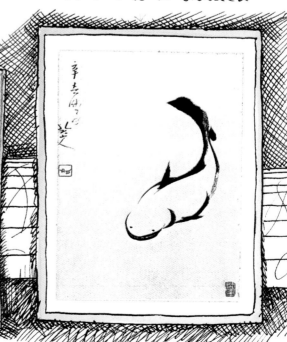

Chu Ta 1626-1705
A Player in the Waves

A line is a practical means of expression with which we can write on, trace over, or surround a surface, or capture a shape. The line can be used to modify perspective – hatching, streaks, and dots can give an illusion of space and volume. The possibilities of line are immense, and intriguing to explore.

Before we tackle the intricacies of observation, let us look at the simple things we draw without thinking. Our doodles forshadow the instinctive gestures of accomplished draftsmen—you should try methodically to reproduce what you have absentmindedly doodled while you were talking on the telephone, for example. There is every likelihood that what you come up with will be the unconscious work of a draftsman who is unaware that he really is one.

Take a sheet of soft pressed paper, a pen, and some india ink. Shade the paper end to end from dark to light.

In nine separate drawings construct the bases of a cylindrical shape, not allowing your hand to rest on the paper.

① Draw as good a square as you can, freehand

Divide it into four parts ②

Use no ruler, no set square, just your own hand

the horizon line

Practice shading in shapes you've copied or traced. Draw thin parallel or crossed lines, tight or loose. Don't worry about length or straightness—just keep gently crossing them in, moving in the direction that is most comfortable for you. Hatchings of this type can help stark contours look better.

For shading using pencils, use 5H, 2H, HB, B and 2B. The range goes from 9H to 9B, with 9H being the hardest and 9B being the softest. HB is medium. You can use an eraser or a stump to blur the transition from dark to light.

5H 2H HB B 2B 4B

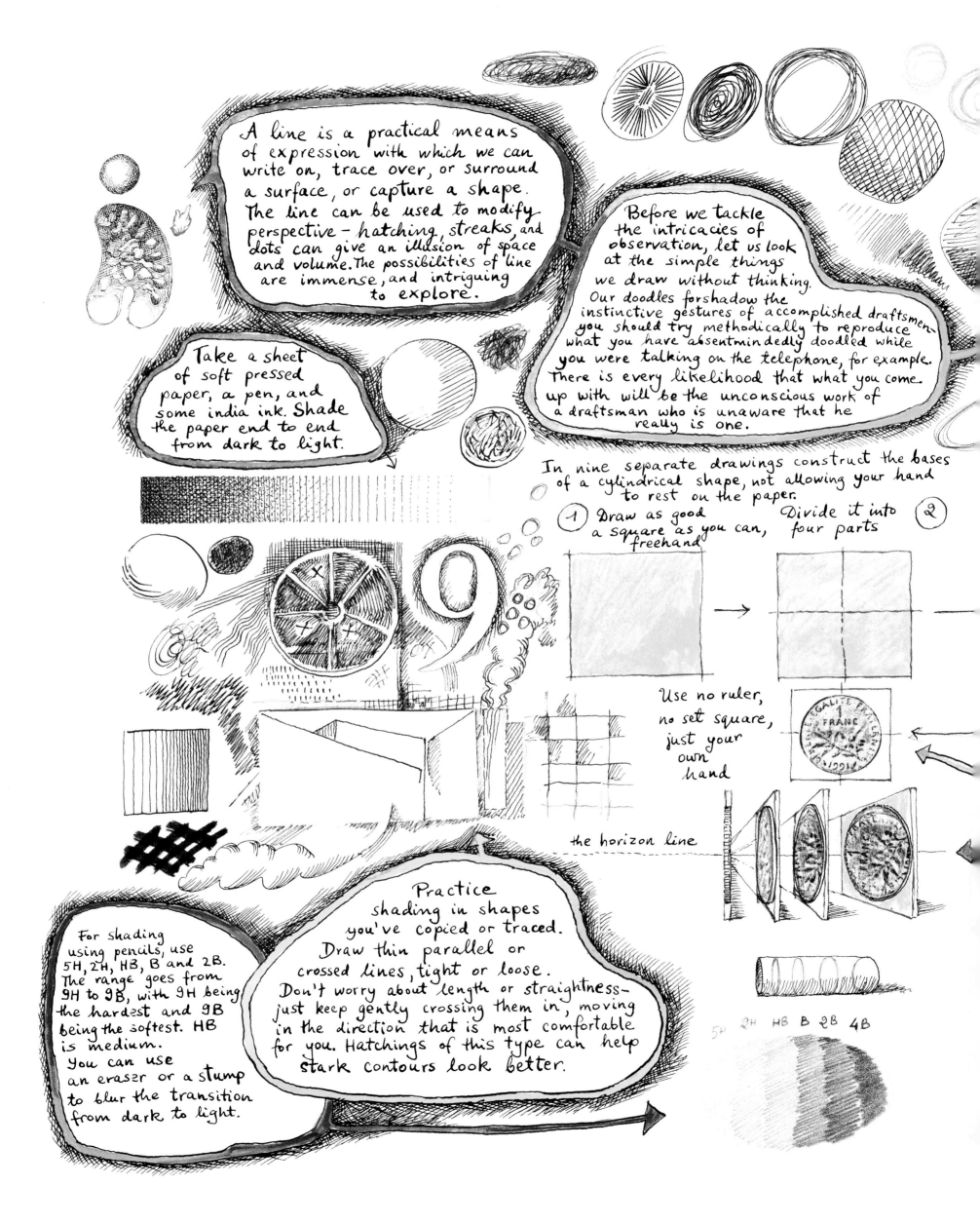

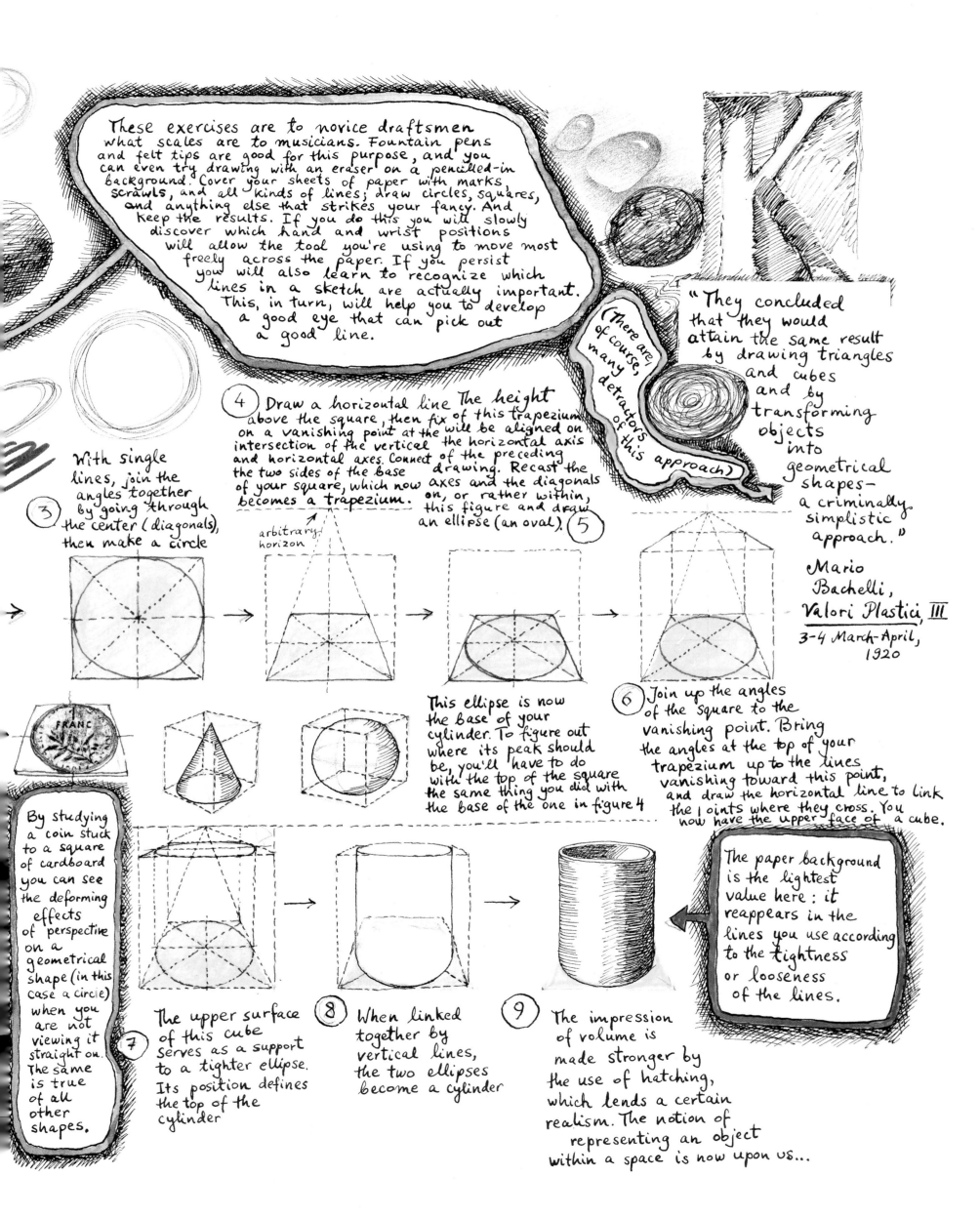

These exercises are to novice draftsmen what scales are to musicians. Fountain pens and felt tips are good for this purpose, and you can even try drawing with an eraser on a pencilled-in background. Cover your sheets of paper with marks, scrawls, and all kinds of lines; draw circles, squares, and anything else that strikes your fancy. And keep the results. If you do this you will slowly discover which hand and wrist positions will allow the tool you're using to move most freely across the paper. If you persist you will also learn to recognize which lines in a sketch are actually important. This, in turn, will help you to develop a good eye that can pick out a good line.

(There are, of course, many detractors of this approach)

"They concluded that they would attain the same result by drawing triangles and cubes and by transforming objects into geometrical shapes — a criminally simplistic approach."

Mario Bachelli, Valori Plastici, III

3-4 March-April, 1920

③ With single lines, join the angles together by going through the center (diagonals), then make a circle

④ Draw a horizontal line above the square, then fix on a vanishing point at the intersection of the vertical and horizontal axes. Connect the two sides of the base of your square, which now becomes a trapezium.

The height of this trapezium will be aligned on the horizontal axis of the preceding drawing. Recast the axes and the diagonals on, or rather within, this figure and draw an ellipse (an oval). ⑤

arbitrary horizon

This ellipse is now the base of your cylinder. To figure out where its peak should be, you'll have to do with the top of the square the same thing you did with the base of the one in figure 4

⑥ Join up the angles of the square to the vanishing point. Bring the angles at the top of your trapezium up to the lines vanishing toward this point, and draw the horizontal line to link the points where they cross. You now have the upper face of a cube.

FRANC

⑦ By studying a coin stuck to a square of cardboard you can see the deforming effects of perspective on a geometrical shape (in this case a circle) when you are not viewing it straight on. The same is true of all other shapes.

The upper surface of this cube serves as a support to a tighter ellipse. Its position defines the top of the cylinder

⑧ When linked together by vertical lines, the two ellipses become a cylinder

⑨ The impression of volume is made stronger by the use of hatching, which lends a certain realism. The notion of representing an object within a space is now upon us...

The paper background is the lightest value here: it reappears in the lines you use according to the tightness or looseness of the lines.

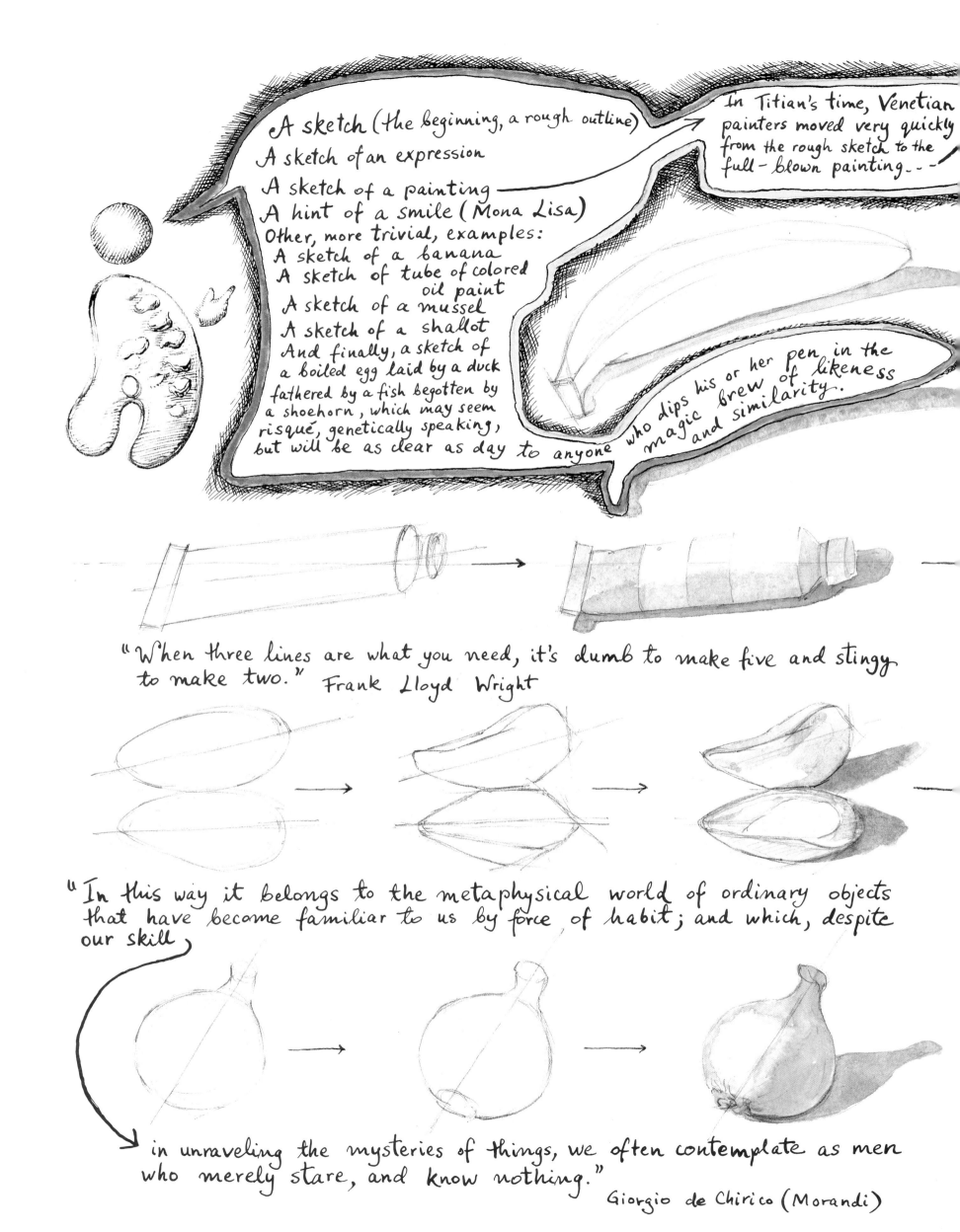

A sketch (the beginning, a rough outline)

A sketch of an expression

A sketch of a painting

A hint of a smile (Mona Lisa)

Other, more trivial, examples:

A sketch of a banana

A sketch of tube of colored oil paint

A sketch of a mussel

A sketch of a shallot

And finally, a sketch of a boiled egg laid by a duck fathered by a fish begotten by a shoehorn, which may seem risqué, genetically speaking, but will be as clear as day to anyone who dips his or her pen in the magic brew of likeness and similarity.

In Titian's time, Venetian painters moved very quickly from the rough sketch to the full-blown painting...

"When three lines are what you need, it's dumb to make five and stingy to make two." Frank Lloyd Wright

"In this way it belongs to the metaphysical world of ordinary objects that have become familiar to us by force of habit; and which, despite our skill, in unraveling the mysteries of things, we often contemplate as men who merely stare, and know nothing."

Giorgio de Chirico (Morandi)

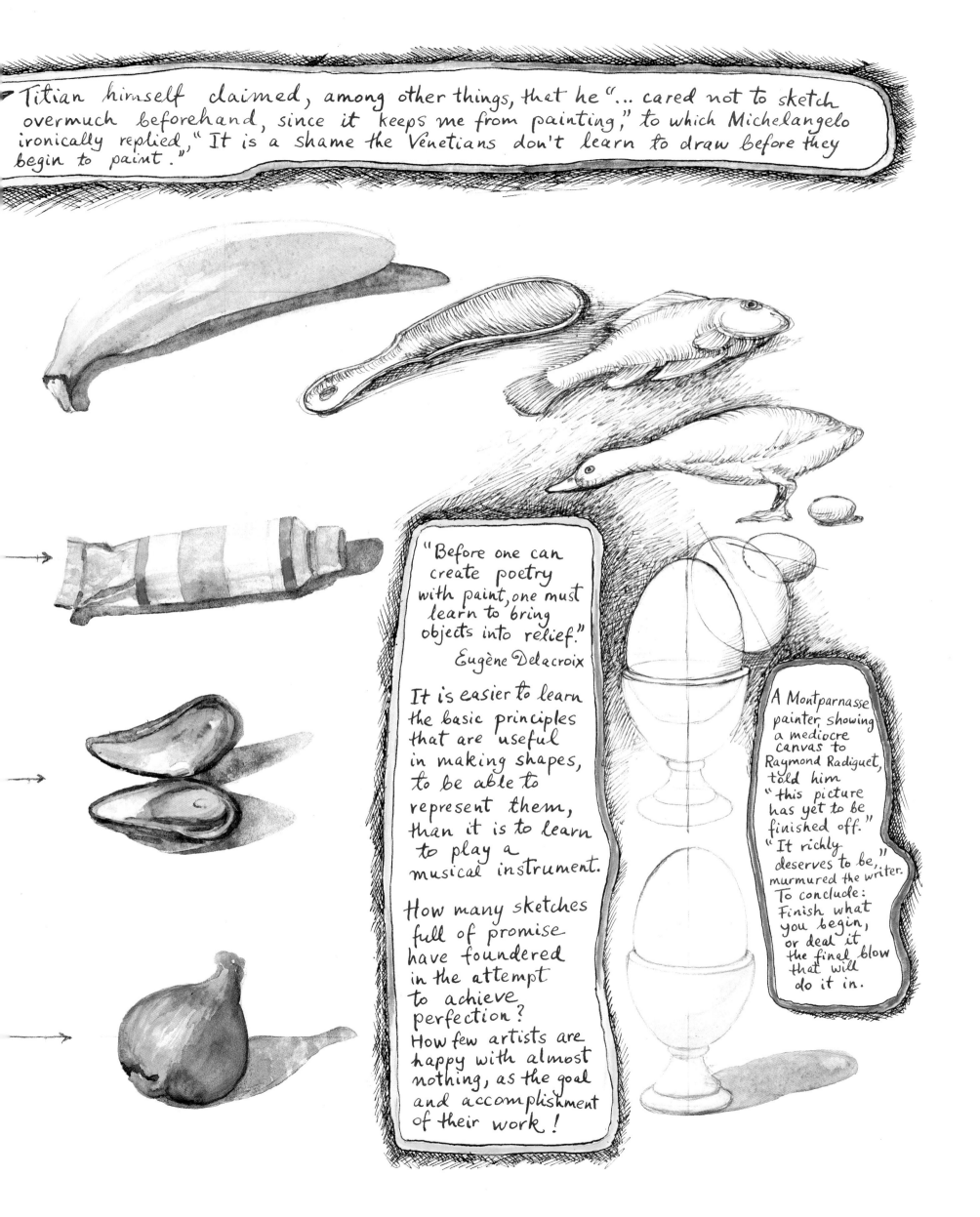

Titian himself claimed, among other things, that he "... cared not to sketch overmuch beforehand, since it keeps me from painting," to which Michelangelo ironically replied, "It is a shame the Venetians don't learn to draw before they begin to paint."

"Before one can create poetry with paint, one must learn to bring objects into relief."
Eugène Delacroix

It is easier to learn the basic principles that are useful in making shapes, to be able to represent them, than it is to learn to play a musical instrument.

How many sketches full of promise have foundered in the attempt to achieve perfection? How few artists are happy with almost nothing, as the goal and accomplishment of their work!

A Montparnasse painter, showing a mediocre canvas to Raymond Radiguet, told him "this picture has yet to be finished off." "It richly deserves to be," murmured the writer. To conclude: Finish what you begin, or deal it the final blow that will do it in.

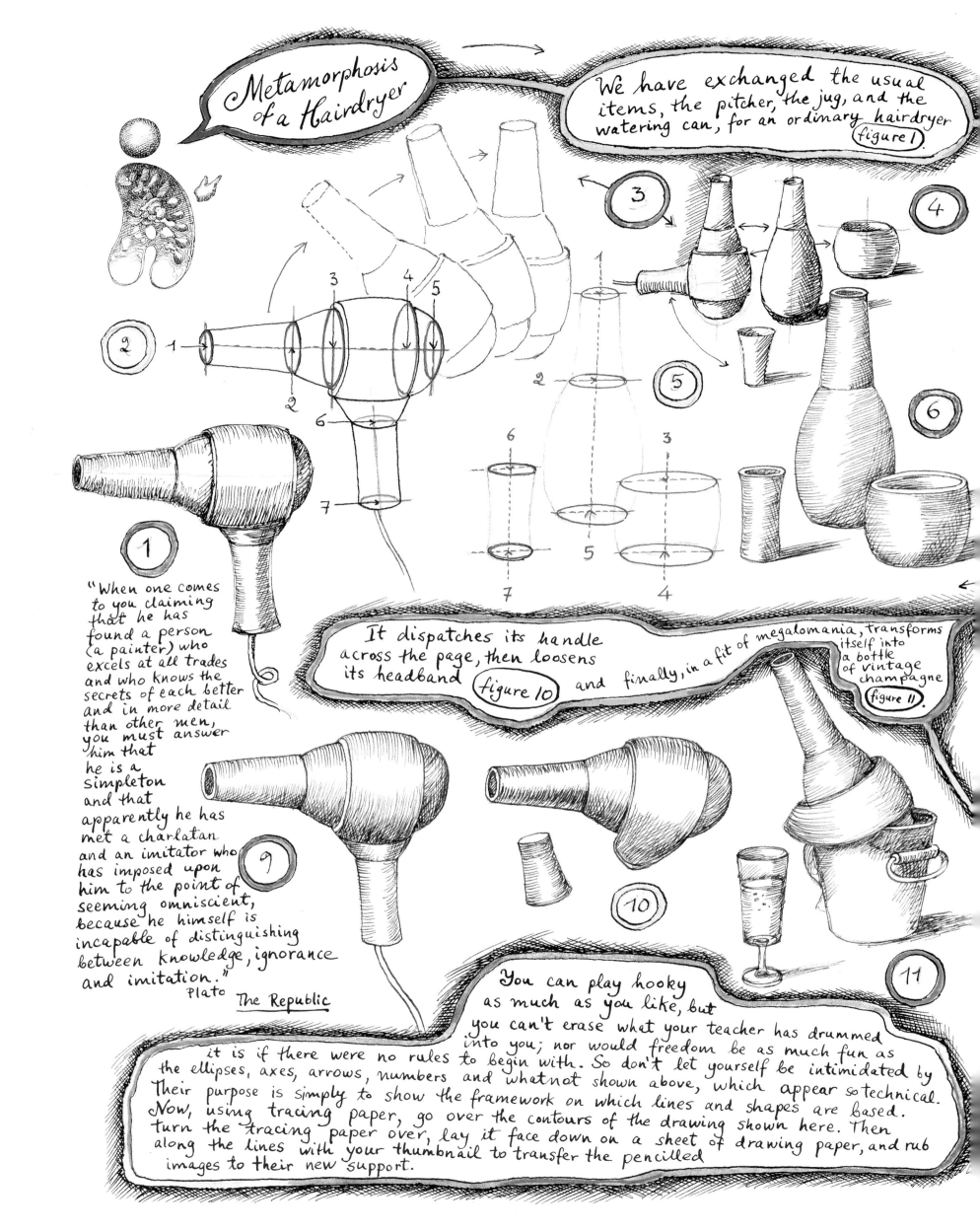

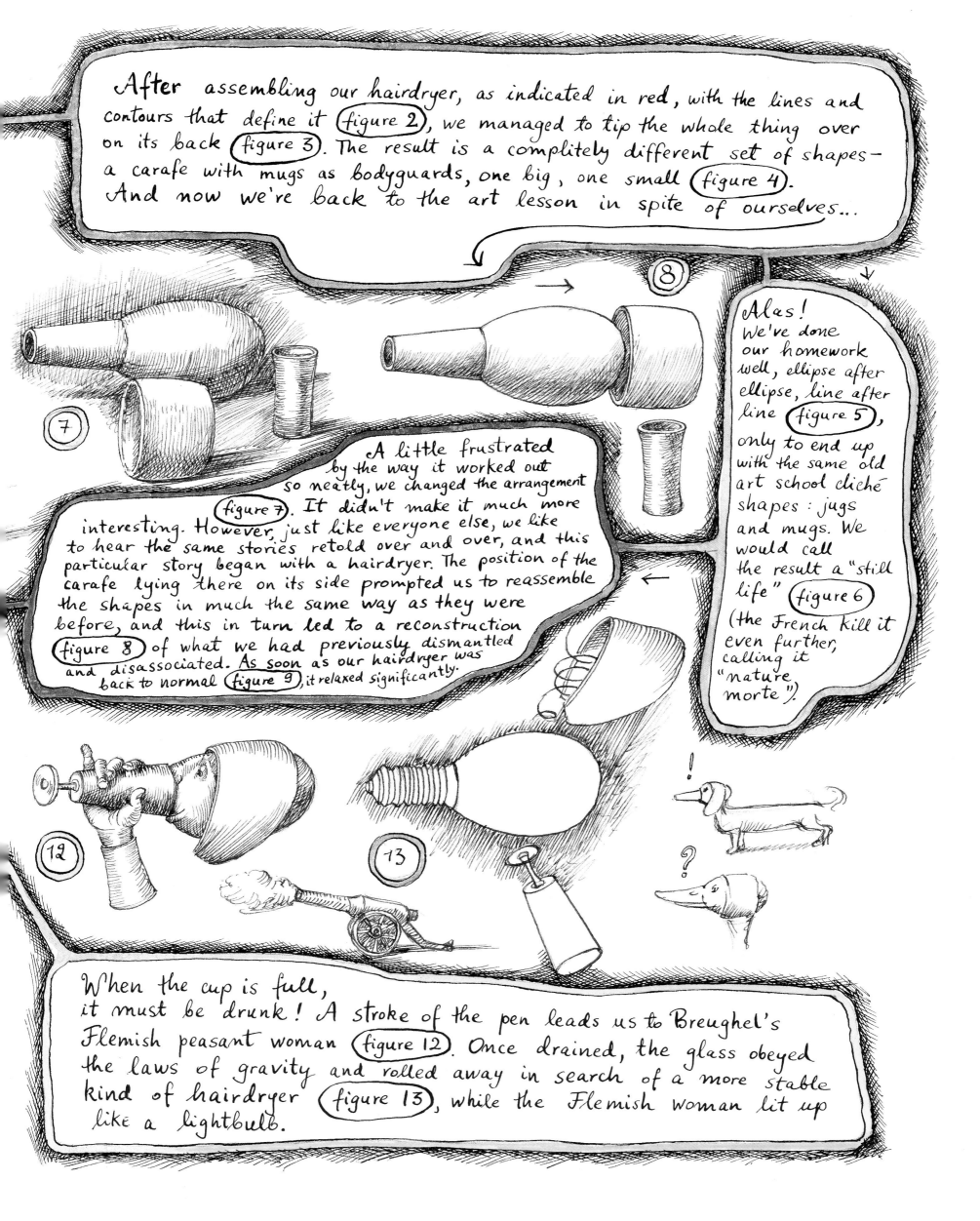

After assembling our hairdryer, as indicated in red, with the lines and contours that define it (figure 2), we managed to tip the whole thing over on its back (figure 3). The result is a completely different set of shapes— a carafe with mugs as bodyguards, one big, one small (figure 4). And now we're back to the art lesson in spite of ourselves...

⑧

⑦

A little frustrated by the way it worked out so neatly, we changed the arrangement (figure 7). It didn't make it much more interesting. However, just like everyone else, we like to hear the same stories retold over and over, and this particular story began with a hairdryer. The position of the carafe lying there on its side prompted us to reassemble the shapes in much the same way as they were before, and this in turn led to a reconstruction (figure 8) of what we had previously dismantled and disassociated. As soon as our hairdryer was back to normal (figure 9), it relaxed significantly.

Alas! We've done our homework well, ellipse after ellipse, line after line (figure 5), only to end up with the same old art school cliché shapes : jugs and mugs. We would call the result a "still life" (figure 6) (the French kill it even further, calling it "nature morte").

⑫

⑬

When the cup is full, it must be drunk! A stroke of the pen leads us to Breughel's Flemish peasant woman (figure 12). Once drained, the glass obeyed the laws of gravity and rolled away in search of a more stable kind of hairdryer (figure 13), while the Flemish woman lit up like a lightbulb.

Pastels and Watercolors

Pastels

Pastel, a medium for both drawing and painting, appeared in the fifteenth century as a helpful technique for straightforward drawing. It really came into its own in eighteenth-century Venice, when Rosalba Carriera won fame throughout Europe with her pastel portraits.

Maurice Quentin de la Tour, Jean-Baptiste Perroneau, and Jean-Baptiste Siméon Chardin came along soon after, raising this fragile, velvety technique to unequaled heights of refinement...

Quentin de La Tour
self-portrait. 1704-1788

Dry pastels are made with finely ground powdery pigments bound with gum and water and sometimes with clay or methyl glue. Supports for pastels need to be rough to retain the powder, which you crush on the sheet as you draw.

Sticks of pastel are ready to use, with tones ranging in color from the deepest to the palest – white chalk is used to lighten them. This technique involves rubbing or superimposing lines, which you can then soften with your fingertips so they don't leave a pasty effect on the paper.

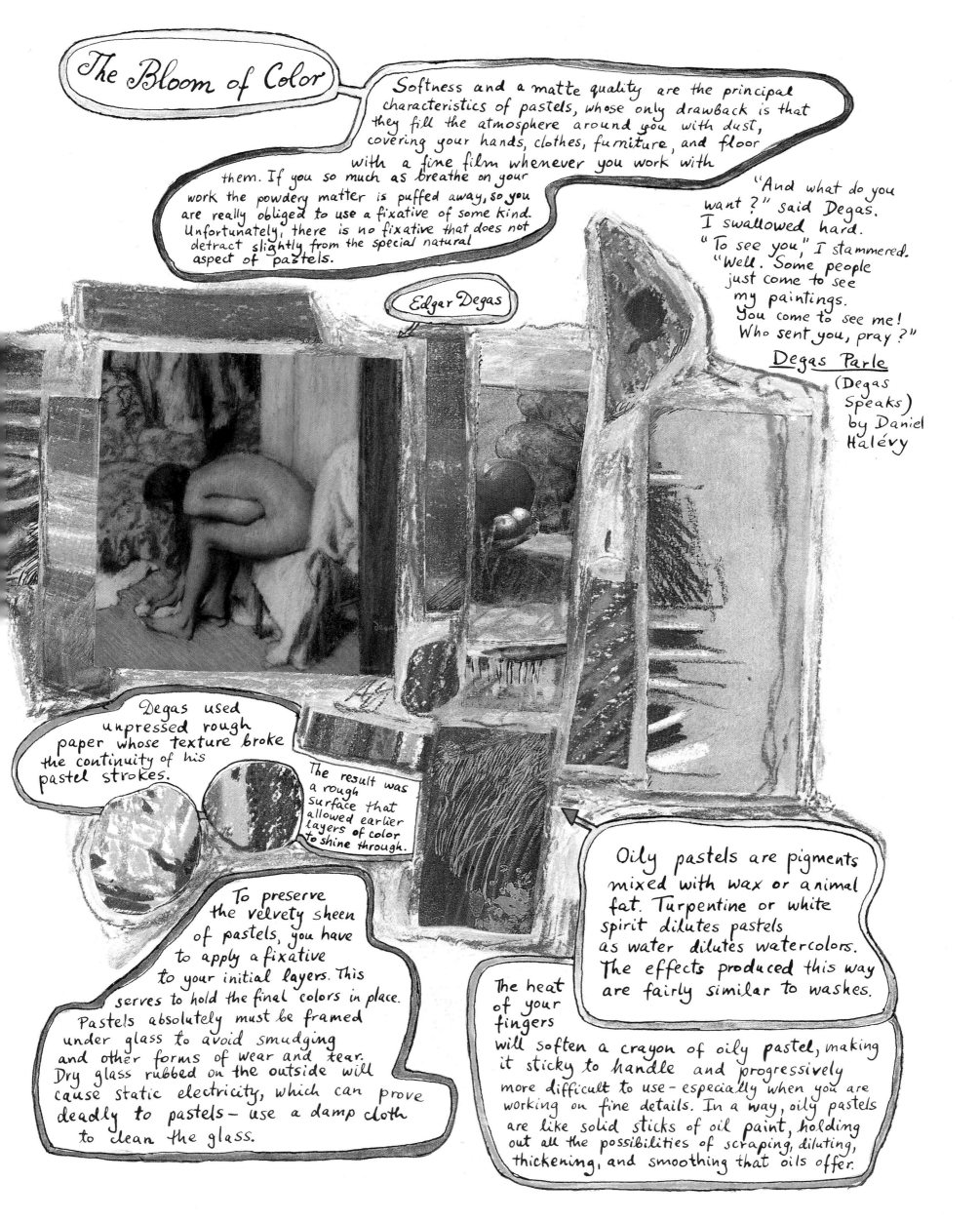

The Bloom of Color

Softness and a matte quality are the principal characteristics of pastels, whose only drawback is that they fill the atmosphere around you with dust, covering your hands, clothes, furniture, and floor with a fine film whenever you work with them. If you so much as breathe on your work the powdery matter is puffed away, so you are really obliged to use a fixative of some kind. Unfortunately, there is no fixative that does not detract slightly from the special natural aspect of pastels.

Edgar Degas

"And what do you want?" said Degas. I swallowed hard. "To see you," I stammered. "Well. Some people just come to see my paintings. You come to see me! Who sent you, pray?"

Degas Parle (Degas Speaks) by Daniel Halévy

Degas used unpressed rough paper whose texture broke the continuity of his pastel strokes.

The result was a rough surface that allowed earlier layers of color to shine through.

To preserve the velvety sheen of pastels, you have to apply a fixative to your initial layers. This serves to hold the final colors in place. Pastels absolutely must be framed under glass to avoid smudging and other forms of wear and tear. Dry glass rubbed on the outside will cause static electricity, which can prove deadly to pastels – use a damp cloth to clean the glass.

Oily pastels are pigments mixed with wax or animal fat. Turpentine or white spirit dilutes pastels as water dilutes watercolors. The effects produced this way are fairly similar to washes.

The heat of your fingers will soften a crayon of oily pastel, making it sticky to handle and progressively more difficult to use – especially when you are working on fine details. In a way, oily pastels are like solid sticks of oil paint, holding out all the possibilities of scraping, diluting, thickening, and smoothing that oils offer.

The colored pastel stick will bewitch you, without question. It is particularly satisfying to the minds of those curious types for whom the eye is an agent of purest joy. When you use pastels, what you see becomes even odder than you expected. Pastels are a source of mystery and wonder; while you work with them you add continuously to the sum of beautiful colors and textures that have gone before. As your dry, powdery strata give way to more delicate shadings, your pastels steadily distribute their quota of wayward dust all around, coating your fingers, your cuffs, and even your nostrils. This propensity serves to reclaim your attention when you are listening to yourself instead of to the imperatives of pastel technique; the tamed, so to speak, becomes the tamer.

At the close of the eighteenth century, pastels temporarily fell out of fashion with the arrival of neo-classicism, only to return in 1835, when an entire room at the Paris Salon was devoted to the medium.

Delacroix used pastels for his preliminary studies. His interest in the technique was sparked by the Encyclopedia of Diderot and D'Alembert, which established that of all the methods of painting, pastel was the simplest and the most practical, and that at the end of the day you could leave it as it was, retouch it, go back to it later, or be done with it altogether, just as you chose.

The cigarette-sized stick of pastel waits in its tight paper jacket for your fingers to send it skidding across a sheet of paper. When Diderot asked Chardin "By what magic do you create these things?" the reply was, "All I do is to take it off and put it on again, adding things until it's easy on the eye." This remark of a master speaks volumes about his art and manner. We should cherish it far above the other more practical principles of pastel work.

And if by a stroke of fortune, your eye, like Chardin's, should meet with the image of your face reflected in the mirror, try to view it as an image in pastels. Look well at the image shown here, and you will find it is looking with equal intensity at you. Look, above all, at the things around you — the flowers, the people, the windows, and the fruit — and let your eye believe that they too are pastels.

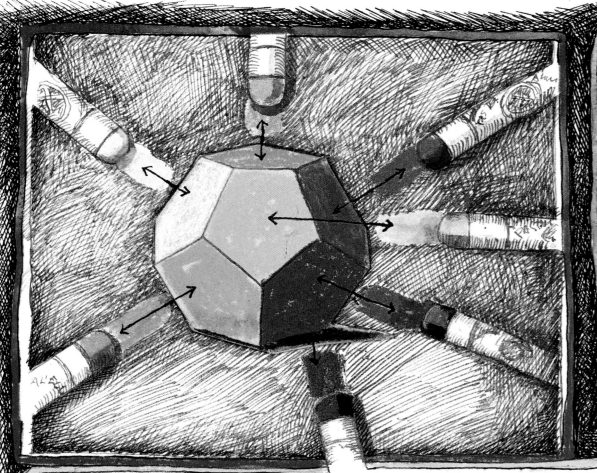

Each one of these pastel crayons is a brush without bristles, and each facet of the polygon corresponds to a stick of the same color, though of modulated value. The boxes of pastels you buy contain gradations of color that fade from darker to lighter shades. So, unlike with gouaches, you don't need to add white each time you want to make the tone a trifle paler.

Here seven different sticks have been used to color the six facets in the image and the shading.

Pastels blended with a brush

Streaked and blended pastels

Pastels rubbed in then crossed with a single stroke

Pastels shaded to the edge

A circle on a background of pastels

Pastels with ink hatching

Pastels with a pencil border

Pastels as a background for an ink drawing

Pastels with a watercolor border

Exercise: As you did on the page about lines, take sheets of different types of paper, cover them with pastel strokes, hatchings, rubbings, and assorted powdery effects. After that, try to make an exact copy of the polygon, above.

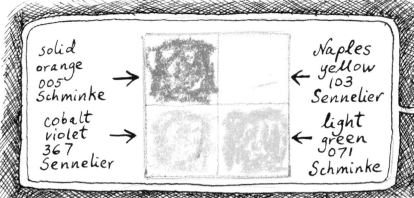

solid
orange
005
Schminke
→

← Naples
yellow
103
Sennelier

cobalt
violet
367
Sennelier
→

← light
green
071
Schminke

lemon
yellow
602
Sennelier

red
orange
40
Sennelier

yellow
ochre
119
Sennelier

madder
violet
312
Sennelier

cadmium
orange
yellow
196
Sennelier

Verona
green
276
Sennelier

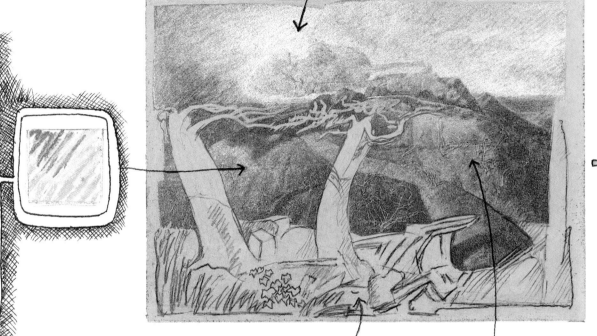

gray-
green,
slightly
grainy,
acrylic
support
(gesso)

The principle lines
of this landscape were
sketched against a mostly
green background
composed of a mixture
of fluid acrylic (gesso)
and marble powder to
make it more eye-catching.
The colored surfaces of the sky
and the distance were rubbed
flat - from top to bottom - and then immediately
immobilized with fixative. Prepared in this
way they served as a base on which to
superimpose broad, unshaded rubbings, which
allows for a juxtaposition of colors, with zones
of hot and cold adding extra vibrancy.
The exact pastel colors used are listed
here, illustrating the composition of each
tonal area of the picture.*

gray beige
473
Sennelier

red
orange
41
Sennelier

green
blue
065
Schminke

cerulean
blue
257
Sennelier

vermilion
86
Sennelier

cobalt
violet
366
Sennelier

madder
lacquer
045
Schminke

* Serge Clément, Olmus Montana, 1993.
4 ft. 4" × 3 ft. 4"

Working methods and techniques

of soft pastels

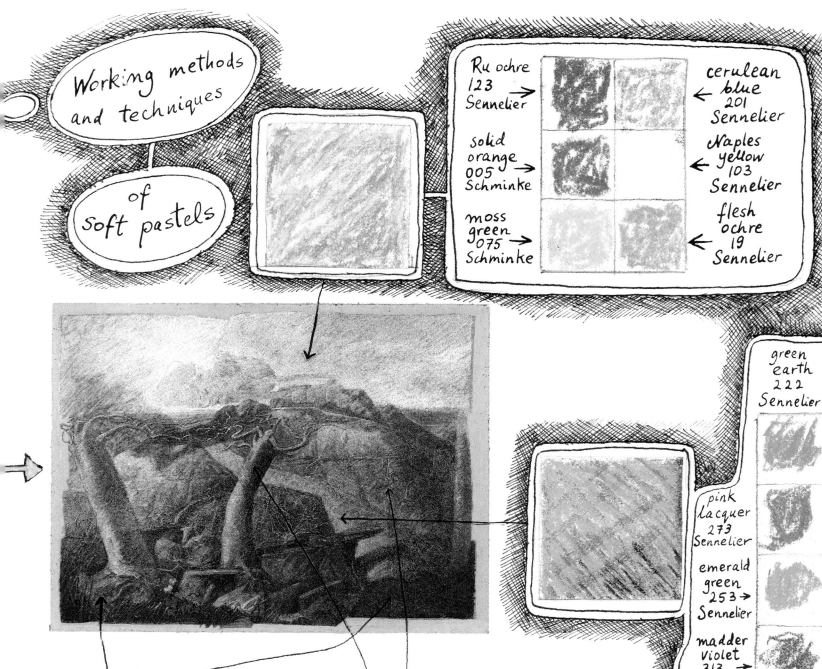

Ru ochre 123 Sennelier →			← cerulean blue 201 Sennelier
solid orange 005 Schminke →			← Naples yellow 103 Sennelier
moss green 075 Schminke →			← flesh ochre 19 Sennelier

levels of color stability:

☆ low stability

☆☆ stable

☆☆☆ high stability

☆☆☆☆ very high stability

green earth 222 Sennelier	light green 071 Schminke
pink lacquer 273 Sennelier	cerulean blue 261 Sennelier
emerald green 253 → Sennelier	cadmium yellow orange 197 Sennelier
madder violet 313 → Sennelier	cerulean blue 297 Sennelier
green ash 348 → Sennelier	

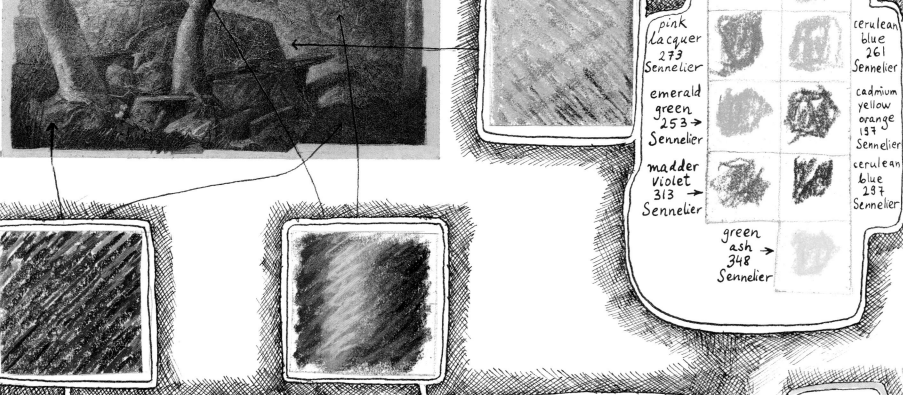

cadmium yellow orange 198 Sennelier	ruby red 674 Sennelier	blue purple 284 Sennelier	Helios red 684 Sennelier
	purple 049 Schminke	burnt sienna 460 Sennelier	scarlet lacquer 305 Sennelier

reseda green 319 Sennelier	hot brown 191 Sennelier	cadmium yellow deep 611 Sennelier	olive green 238 Sennelier
gray beige 473 Sennelier	yellow ochre 013 Schminke	Venetian red 93 Sennelier	

BEWARE! Working with soft pastels creates a highly volatile dust. A mask is essential. Also, try to use non-toxic pigments whenever possible.

The other pastel broken sticks

oil pastels are pigments plus wax plus oil matter

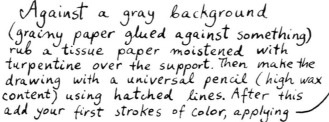

Against a gray background (grainy paper glued against something) rub a tissue paper moistened with turpentine over the support. Then make the drawing with a universal pencil (high wax content) using hatched lines. After this add your first strokes of color, applying

them progressively, without taking any particular precautions. The first applications, in which the color trends can already be distinguished, are shown here – yellows for the light on the nose, blues for the brow, oranges for the cheekbone, ochres for the cheek itself.

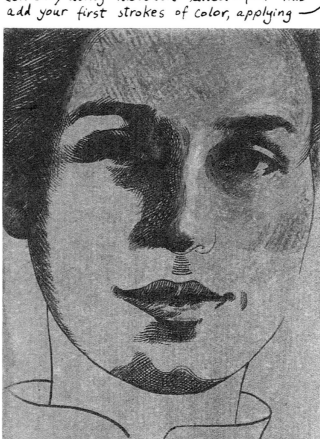

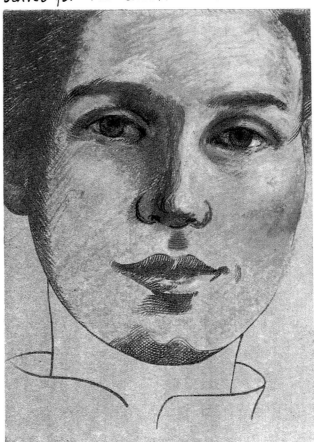

Like sticks of oil paint, oil pastels lend themselves to superimposition using the same techniques as one uses with soft pastels. Their viscosity produces an intermingling of rubbings, which accumulate in supple, matte vibrations. The main drawback of oil pastels is their sensitivity to heat – they tend to go soft after you've held them in your fingers for a while. But the fact that they don't change their quality when they dry, like oils, is a major point in their favor. Also they're dust-free, they won't drip, and they're easy to manipulate. These qualities make them attractive to beginners and seasoned pros alike.

rub fill in

smooth shade

scrape polish

superimpos

draw

thin

The composition of blends for the first applications of color.

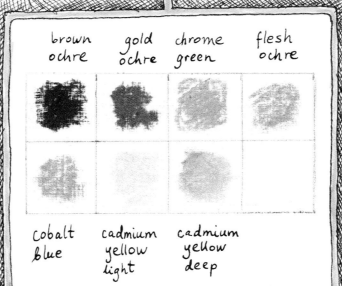

brown ochre | gold ochre | chrome green | flesh ochre

cobalt blue | cadmium yellow light | cadmium yellow deep

These colors are added to the earlier ones as the work progresses

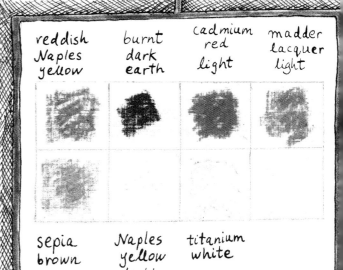

reddish Naples yellow | burnt dark earth | cadmium red light | madder lacquer light

sepia brown | Naples yellow light | titanium white

The colors applied at the beginning aren't buried by the following colors—they shine through them, creating rich, light-filled chromatic effects. If you're looking for greater mellowness, you may wish to shade off your work with a short-bristled dry brush.

When you are nearly finished (an equivocal term that merely defines the stage when you decide to stop working), you may wish to buff the surface with your fingernail to give it an extra patina—although this hasn't been done in our illustration. The darkest areas, in this case the eyes, are dealt with in the final stages, as are the white areas.

Oil pastels lend themselves to a variety of techniques because they are soluble in turpentine (we prefer turpentine to white spirit as it's less toxic). Toned-down effects like washes can be obtained in this way and used for backgrounds. Brushes, Q-tips, and scrapers can also be used by pastelists looking for special effects. As with all other color products, the best oil pastels are those in which the maker has incorporated the highest concentration of pigment. It's a bad idea to varnish oil pastels—their appearance won't alter over time if the pigments are of good quality—but because they remain malleable they should be protected under glass, even though the covering may detract a little from their beautiful matte texture.

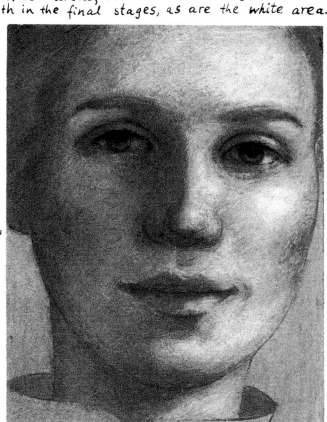

emphasize

streak paint

Marina Kamena, Study of Odetta, 1993

to lightly saturate the texture and define the portrait's character by giving it a delicate, satiny sheen.

yellow ochre	cadmium red deep	blue gray	gold ochre
burnt sienna	English red	chrome green	caput mortem

neutral gray	solid yellow	white	Sèvres blue
black	chrome green	cadmium orange red	permanent pink light
English red light	dark brown ochre	cadmium red light	fixed carmine lacqeur

If you like this approach to creating a portrait, your best and most immediately available model is, of course, yourself—in whom there's every chance you may discover something unexpected. Otherwise, flowers, fruits, or other objects or colored things will do very well. Bon voyage!

Whatever you do, don't smoke cigarettes or bite your nails while working with oil pastels.

The fountainhead

In the artist's pantheon, watercolor is the most suprising, the most spontaneous, the least cumbersome, and the least forgiving of the goddesses.

To push her expressiveness too far is to strike her dumb. To hold her in check is to deprive her of life.

When she first appeared in about 1413, she gamboled in the waters of the Limbourg brothers. Later she lay amid the tall grasses of Albrecht Dürer (1471- 1528). She was christened "Watercolor" at the end of the eighteenth century, when she was at last promoted from her position as a lady of the court laboring over illuminated manuscripts. Indeed she was raised to the dignity of royalty, when the English crowned her as their queen...

Her most gifted courtiers were Paul Sandby (1731-1809), John Robert Cozens (1752-1797), Thomas Girtin (1775-1802), and the giants J.M.W. Turner (1775-1851), and John Sell Cotman (1789-1842) —

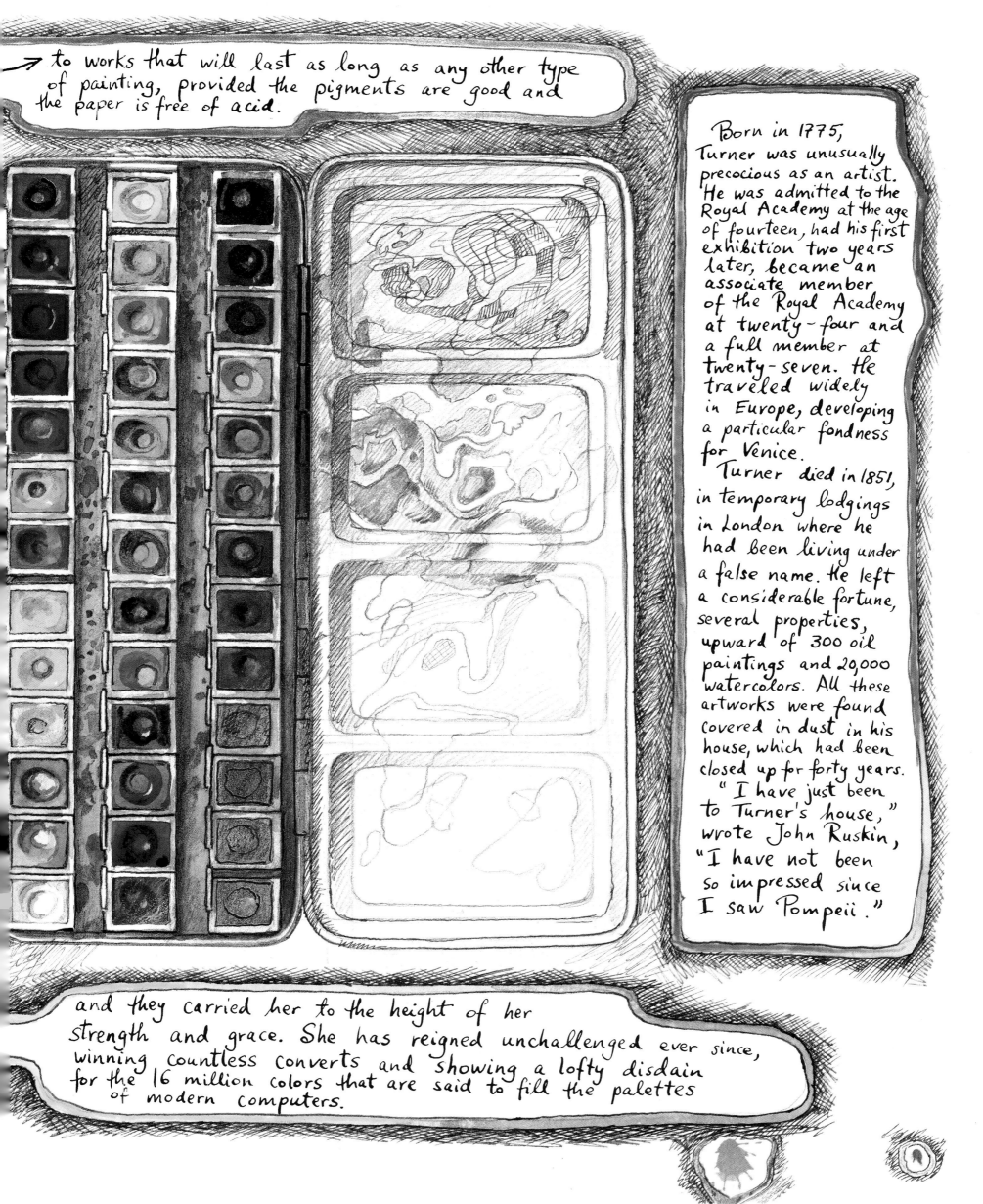

to works that will last as long as any other type of painting, provided the pigments are good and the paper is free of **acid**.

Born in 1775, Turner was unusually precocious as an artist. He was admitted to the Royal Academy at the age of fourteen, had his first exhibition two years later, became an associate member of the Royal Academy at twenty-four and a full member at twenty-seven. He traveled widely in Europe, developing a particular fondness for Venice.

Turner died in 1851, in temporary lodgings in London where he had been living under a false name. He left a considerable fortune, several properties, upward of 300 oil paintings and 20,000 watercolors. All these artworks were found covered in dust in his house, which had been closed up for forty years.

"I have just been to Turner's house," wrote John Ruskin, "I have not been so impressed since I saw Pompeii."

and they carried her to the height of her strength and grace. She has reigned unchallenged ever since, winning countless converts and showing a lofty disdain for the 16 million colors that are said to fill the palettes of modern computers.

watercolor, or the memory of water

To cover a surface, drawing, texture with **watercolors** is neither very simple nor particularly complicated. There are a few basic, inescapable principles. One is that you should use thick sheets of paper, well flattened over a hard surface (a drawing board or a draftsman's table). Around the table you should assemble plenty of absorbent tissues, paper for wiping off your brush when it is over-saturated, a sponge, and glasses to prepare large quantities of colored water. All of these things will prove most useful, one way or another.

There are a number of clever recipes and procedures, too, which should on no account be ignored. They can add unusual touches to the ordinary spreading of color with a brush, touches to which most watercolorists aspire. In this craft every stroke, every mark, and every note of diluted color is proof of the artist's light and rapid technique, for when the liquid evaporates it leaves behind only the most delicate of colored veils, the merest memory of water.

With this more inclined plane the paint border is thicker when it dries

2

In the old days drips were viewed as regrettable accidents. Now it's a technique in common use. To achieve this effect, you need a steeply tilted surface. Mastering the weight of your drop of liquid color, the direction of its drip, and the speed of its slide requires constant practice, and each time you repeat the exercise you will discover something new and enriching.

The brightness of the colors largely depends on how clean the wa...

Brush a deeper color o a light wash that has yet dried - the two will immediately fuse into a kind of cloud.

In this space several undefined blotches were made right next to each other. Some of them were pressed with tissues before being left to dry and the spaces between them were filled with denser color (designers and decorators often use watercolors in their work).

Spray water on to a nearly dry wash, then sponge it off with tissue.

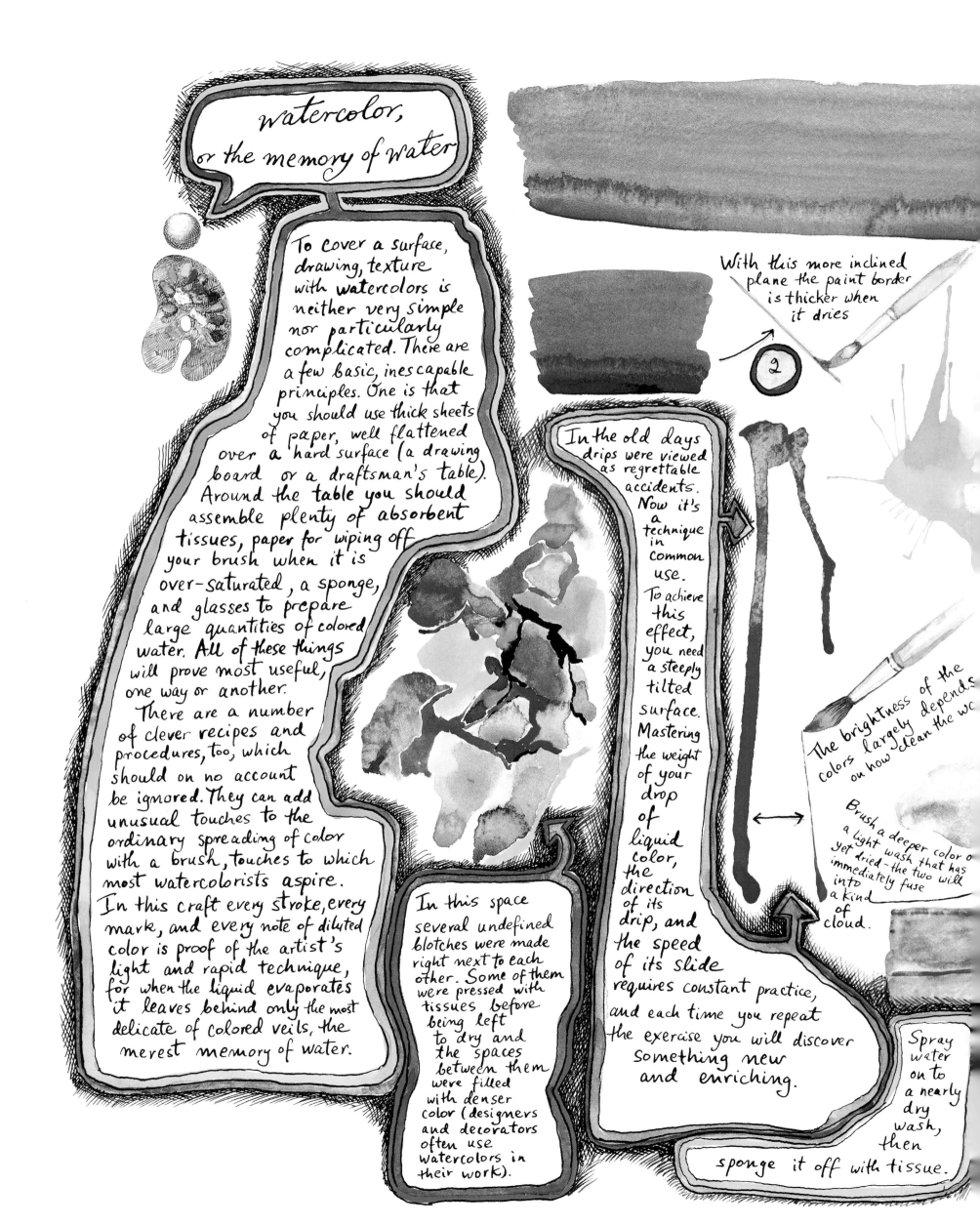

When the work surface is sloped more gently, the border seeps upward into the wash and creates a kind of capillary halo that you can use in various ways.

①

On this steeply sloped surface the color has ebbed away from the border

③

From the moment the first band of color is brushed on, the slope of the worktable will determine how far downward the wash will spread. Because of its relative weight, colored water forms a fringelike border over which you can pass the brush in a quick, horizontal motion. Now that it is saturated with liquid, you should move the brush downward in regular strokes. When the surface is covered, squeeze the brush dry and use it to suck up the water collected at the border.

To shade colors, begin with very thin color content and enrich it little by little.

On a horizontal surface, blow your blob of water through a straw

On this checkerboard, which you can draw freehand with a pencil, cover each square with a colored wash, then sponge it lightly with a tissue while the tint is still wet. then practice some hatching with a pen, if you wish.

A sponge impregnated with color and lightly pressed on paper leaves interesting marks: when the point is dry, fill in the little holes with deeper colors, as the mood takes you. After that try cross-hatching or shading with pen and Chinese ink.

Draw a few shapes (circles or something else) and fill them with color, using different tints to make contours. Wait until each application is dry before you move on to the next. Every one of these basic exercises will be useful to you in the future.

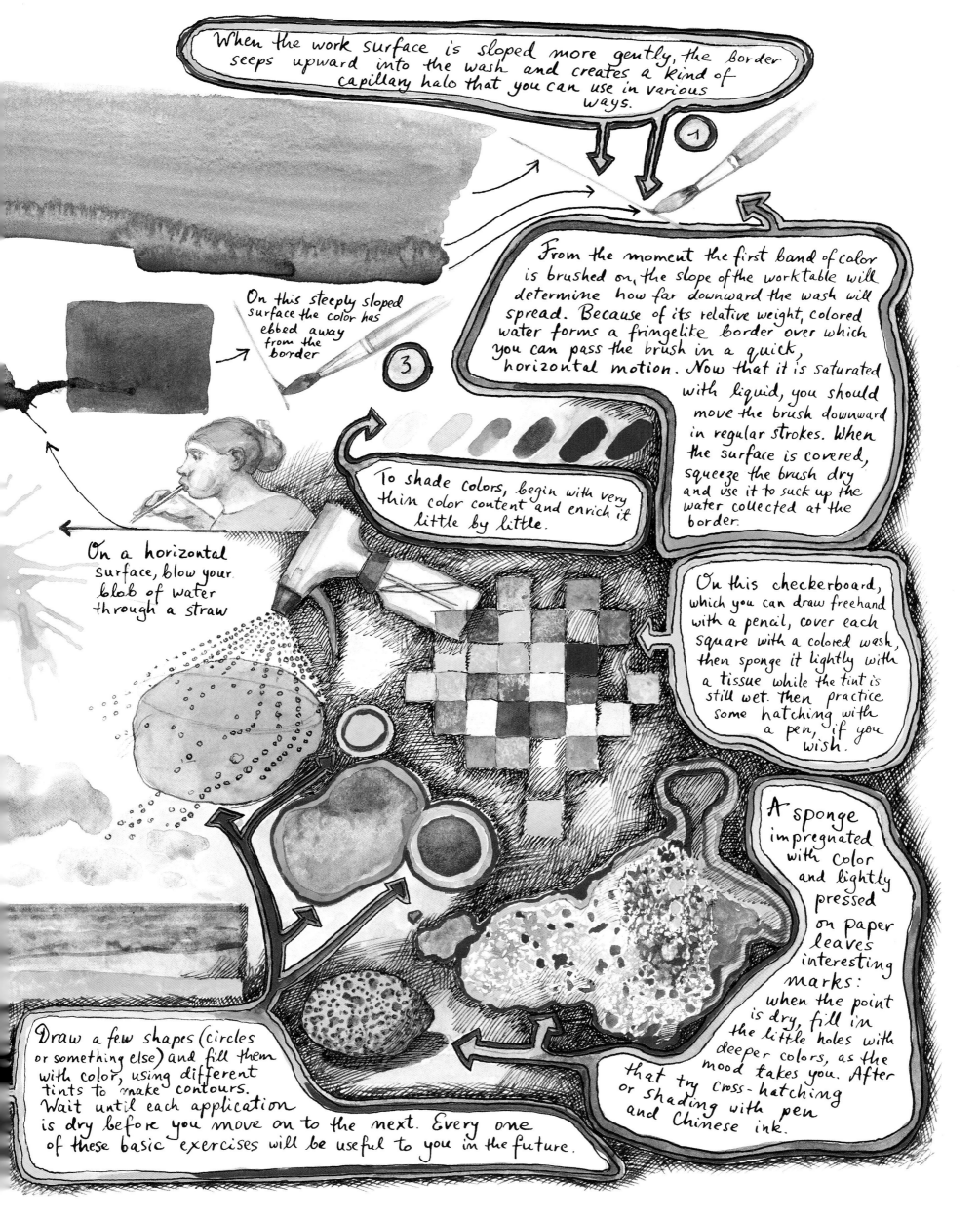

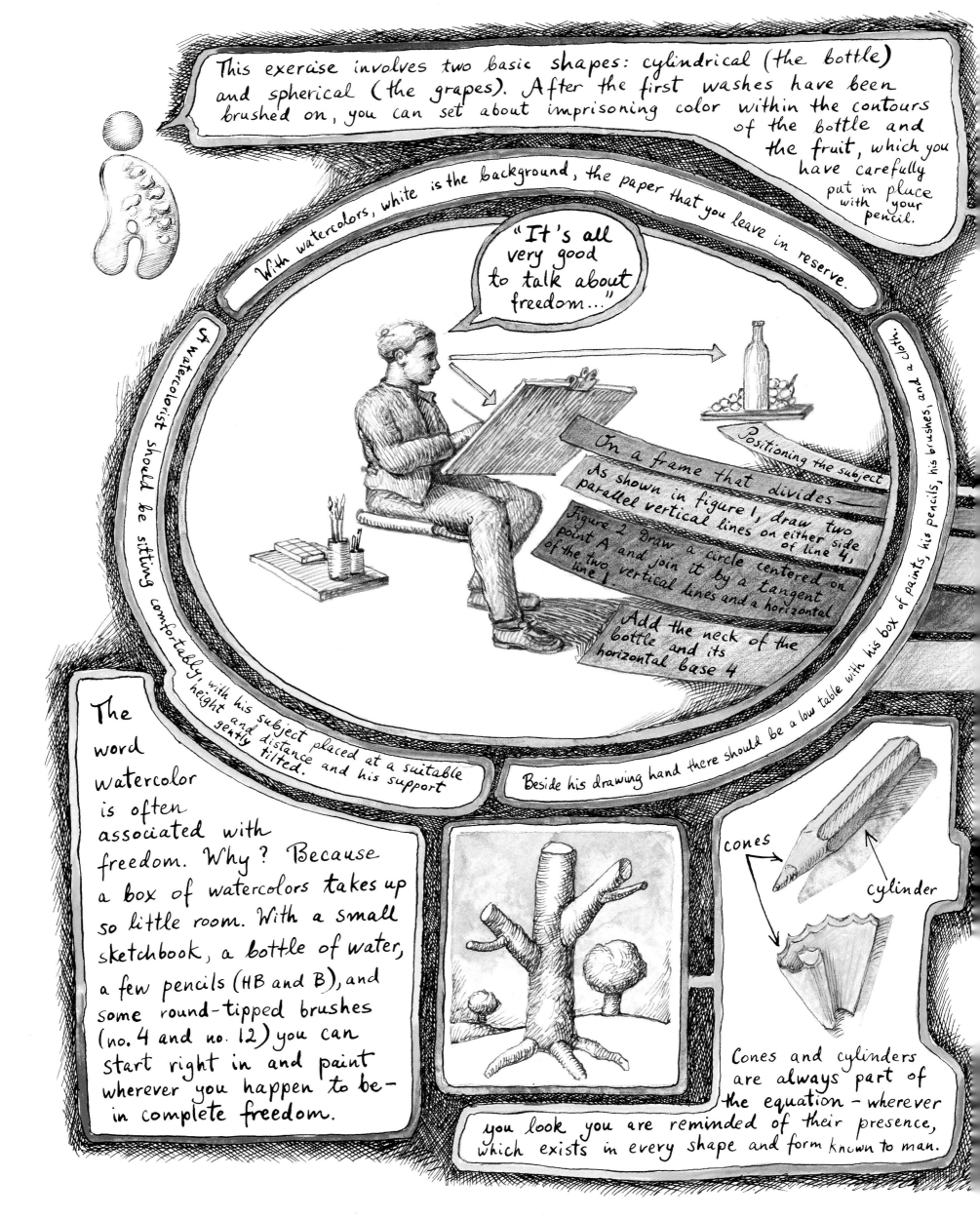

This exercise involves two basic shapes: cylindrical (the bottle) and spherical (the grapes). After the first washes have been brushed on, you can set about imprisoning color within the contours of the bottle and the fruit, which you have carefully put in place with your pencil.

With watercolors, white is the background, the paper that you leave in reserve.

A watercolorist should be sitting comfortably, with his subject placed at a suitable height and distance and his support gently tilted.

"It's all very good to talk about freedom..."

Positioning the subject

On a frame that divides — As shown in figure 1, draw two parallel vertical lines on either side of line 4.

Figure 2 Draw a circle centered on point A and join it by a tangent of the two vertical lines and a horizontal line 1.

Add the neck of the bottle and its horizontal base 4

Beside his drawing hand there should be a low table with his box of paints, his pencils, his brushes, and a cloth.

The word watercolor is often associated with freedom. Why? Because a box of watercolors takes up so little room. With a small sketchbook, a bottle of water, a few pencils (HB and B), and some round-tipped brushes (no. 4 and no. 12) you can start right in and paint wherever you happen to be — in complete freedom.

cones

cylinder

Cones and cylinders are always part of the equation — wherever you look you are reminded of their presence, which exists in every shape and form known to man.

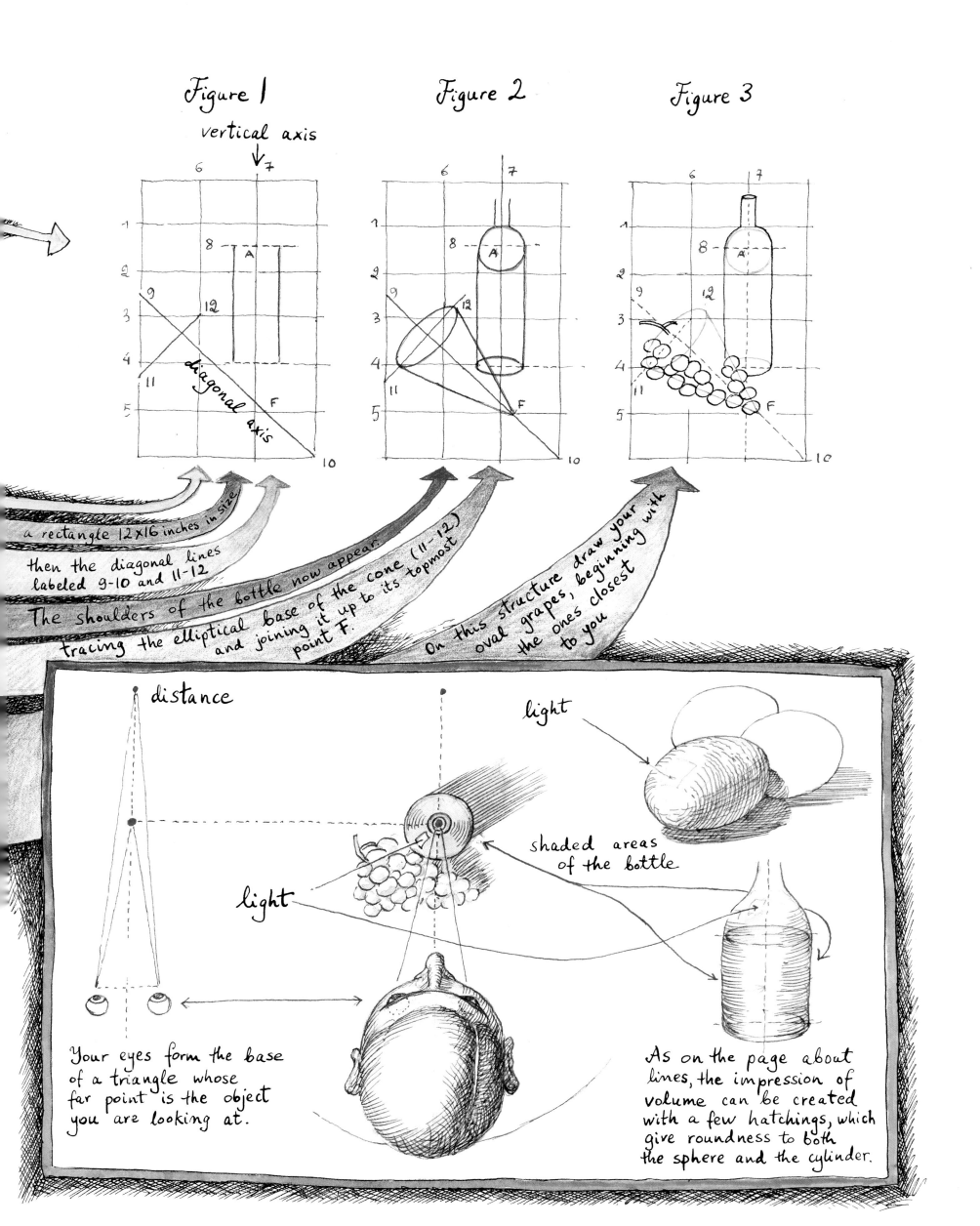

Figure 1

vertical axis

6 7

A

9 12

diagonal axis

11

F

Figure 2

6 7

A

9 12

11

F

Figure 3

6 7

A

9 12

11

F

a rectangle 12×16 inches in size,
then the diagonal lines
labeled 9-10 and 11-12

The shoulders of the bottle now appear.
tracing the elliptical base of the cone (11-12)
and joining it up to its topmost
point F.

On this structure draw your
oval grapes, beginning with
the ones closest
to you

distance

light

light

shaded areas
of the bottle

Your eyes form the base
of a triangle whose
far point is the object
you are looking at.

As on the page about
lines, the impression of
volume can be created
with a few hatchings, which
give roundness to both
the sphere and the cylinder.

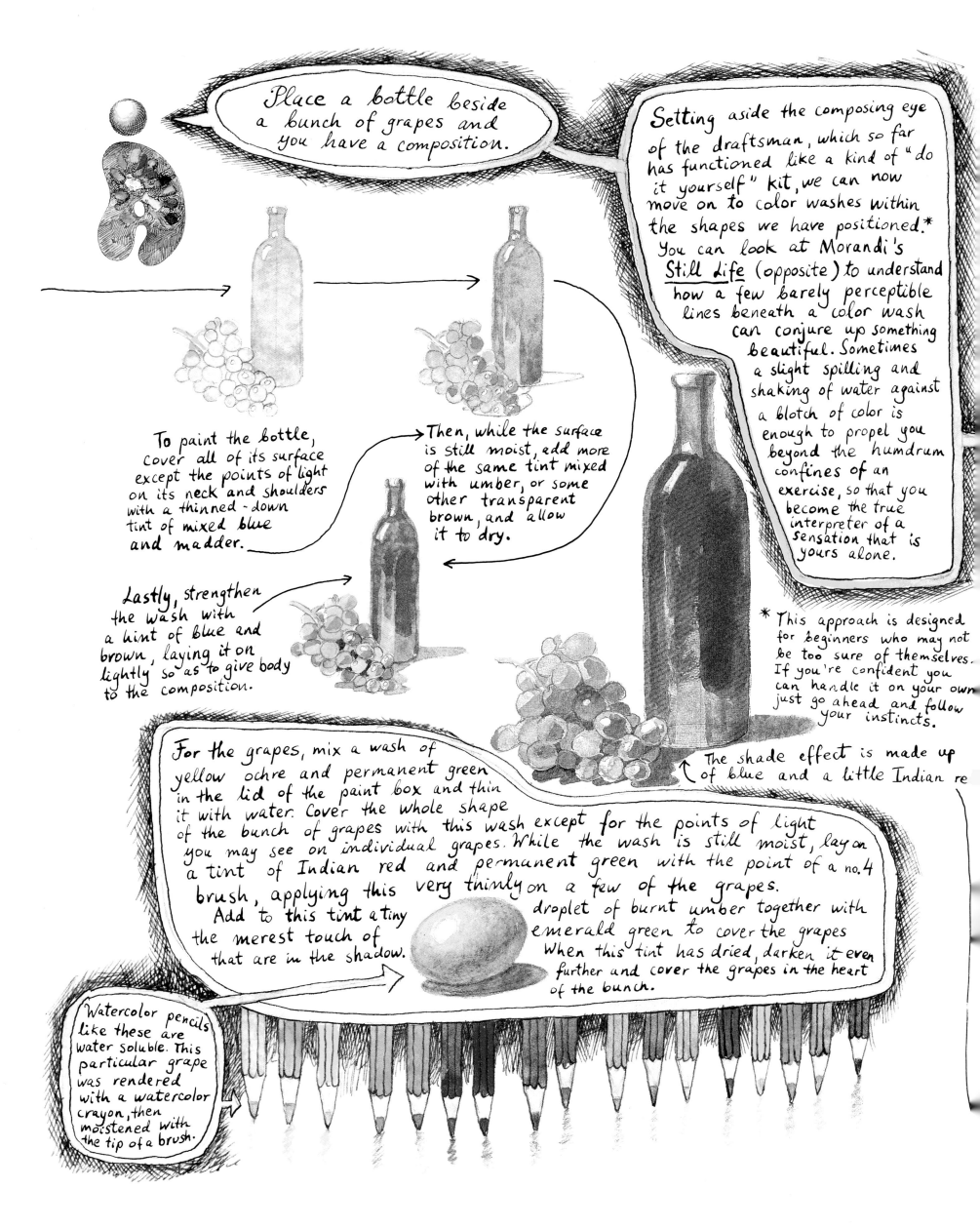

Place a bottle beside a bunch of grapes and you have a composition.

Setting aside the composing eye of the draftsman, which so far has functioned like a kind of "do it yourself" kit, we can now move on to color washes within the shapes we have positioned.* You can look at Morandi's Still Life (opposite) to understand how a few barely perceptible lines beneath a color wash can conjure up something beautiful. Sometimes a slight spilling and shaking of water against a blotch of color is enough to propel you beyond the humdrum confines of an exercise, so that you become the true interpreter of a sensation that is yours alone.

To paint the bottle, cover all of its surface except the points of light on its neck and shoulders with a thinned-down tint of mixed blue and madder.

Then, while the surface is still moist, add more of the same tint mixed with umber, or some other transparent brown, and allow it to dry.

Lastly, strengthen the wash with a hint of blue and brown, laying it on lightly so as to give body to the composition.

* This approach is designed for beginners who may not be too sure of themselves. If you're confident you can handle it on your own just go ahead and follow your instincts.

The shade effect is made up of blue and a little Indian re[d]

For the grapes, mix a wash of yellow ochre and permanent green in the lid of the paint box and thin it with water. Cover the whole shape of the bunch of grapes with this wash except for the points of light you may see on individual grapes. While the wash is still moist, lay on a tint of Indian red and permanent green with the point of a no. 4 brush, applying this very thinly on a few of the grapes.
Add to this tint a tiny the merest touch of that are in the shadow. droplet of burnt umber together with emerald green to cover the grapes When this tint has dried, darken it even further and cover the grapes in the heart of the bunch.

Watercolor pencils like these are water soluble. This particular grape was rendered with a watercolor crayon, then moistened with the tip of a brush.

At the opening session of his art history course at the University of Bologna in 1934-35, Roberto Longhi concluded a closely reasoned review of the crucial moments of Bolognese painting from the fourteenth century to the present with the following sensational pronouncement:

Giorgio Morandi
Still Life, 1960

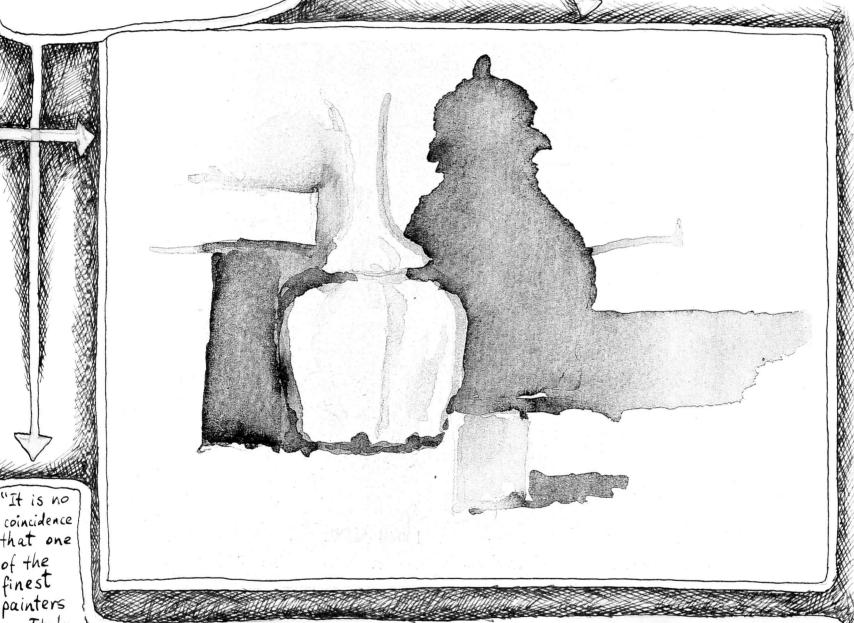

"It is no coincidence that one of the finest painters in Italy, Giorgio Morandi, although he has sailed in the most treacherous waters of modern art, has nonetheless proceeded with meticulous care. His love of the study of the method of his art seems to be spawning a completely new genre. In our contemporary world the confusion of imagery conspires to overwhelm the longer silences and meditations of art in such a way that the mere love of study has seemed incapable of withstanding the bombardment of a million other distractions. Yet the presence of Morandi, who remains loyal to the highest forms of individual expression both in his feelings and in his art, is becoming strangely familiar; he offers us an unimaginable certainty- a model that not only is holding up, but is affirming itself as something genuinely new."

→ When you have finished this exercise, take a clean sheet of paper and start all over again, using lighter washes throughout.

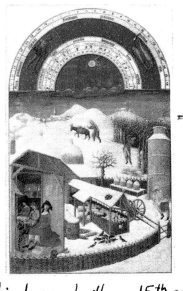

The Limbourg brothers, 15th century
February, from the Book of Hours for the Duc
de Berry, 1413
illuminated manuscript

Albrecht Dürer, 1471-1528
Landscape, c. 1495

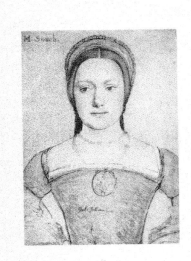

Hans Holbein, 1465-1534
Mademoiselle Souch

J. M. W. Turner, 1775-1851
The Seelisberg Moonlight, 1842-43

John Sell Cotman, 1782-1842
Duncombe Park, 1806

Paul Cézanne, 1836-1909
Study of Rocks and Trees, 1890-95

"Some of you may have heard of a painter named Bird. I don't know his work, personally, but Turner was on the admissions committee when a painting of his was submitted. The piece was a good one, but there was really nowhere to hang it. Turner spoke out in favor, but the thing was judged quite impossible. Turner sat down, stared for a while at Bird's picture, then returned to the attack, insisting that a place be found. Still the answer was no. Upon which, without a word, he took down one of his own canvases, sent it back to his house, and hung Bird's in its place!..."

"I would also have you know that I got it into my head to learn how to dance. I went twice to the dancing school, where I had to pay a ducat to the master. You know me well enough to understand that after that no human power could ever make me return there – why fritter away the money I've earned and end up none the wiser?... I will inform you, as you request me to do, of the day of my departure, so that my masters can make the necessary arrangements. I will go to Bologna on an artistic errand – somebody there has promised to reveal to me the secret of a certain kind of perspective. I shall stay eight or ten days in that city and then return to Venice, after which I shall post to Nuremberg. Alas, I have made my bed and now must lie in it. How I shall miss the sunshine of Venice! Here I am a prince, at home I'm just another poverty-stricken wretch!"
Albrecht Dürer

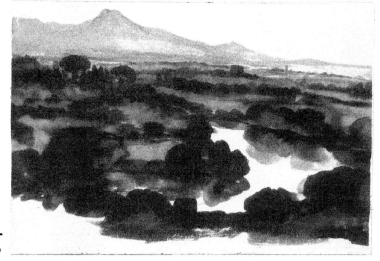

Claude Lorrain, 1600-1682, Landscape

J.M.W. Turner, Lausanne, 1842-1843

Maurice Pendergast, 1858-1924, Central Park, 1901

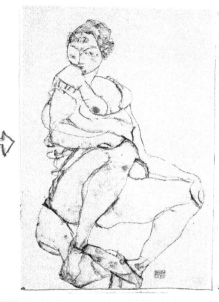

Egon Schiele, 1890-1918 A Dreaming Woman, 1911

Edward Hopper, 1882-1967 Reclining Nude, 1925-30 →

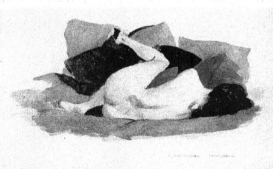

Anselm Kiefer, 1945- A Book by Anselm Kiefer, 1988

"In the 17th century two French artists, Nicolas Poussin and Claude Lorrain were living in Rome, where they met in a tavern every night to talk about painting. Lorrain, with no formal education, had built himself a giant reputation in the world of art. When he was a boy his parents apprenticed him to a pastry chef, because he seemed to be getting nowhere in school. Having mastered his profession, Claude traveled to Rome in search of work, only to find that a hundred other French pastry chefs were already

making cakes for the Romans. As a result, the only post he could find was that of a servant to the painter Tasi. Claude did the cooking and housekeeping, as well as grinding Tasi's colors and cleaning his brushes. His master taught him the art of perspective, but he soon found that the study of drawing did not suit him at all. Undeterred, he launched himself into the life of a painter,

impoverished but fascinated by the light, which he would observe for many long hours before settling down to paint it. With time, Claude acquired a solid reputation and grew wealthy; being a bachelor he wrote home to France, asking his cousin to come and keep house for him, grind his colors, and clean his brushes. And so the two men lived together, one very happy to be unburdened of domestic tasks, and the other hoping that one day a rich inheritance would be his..."*

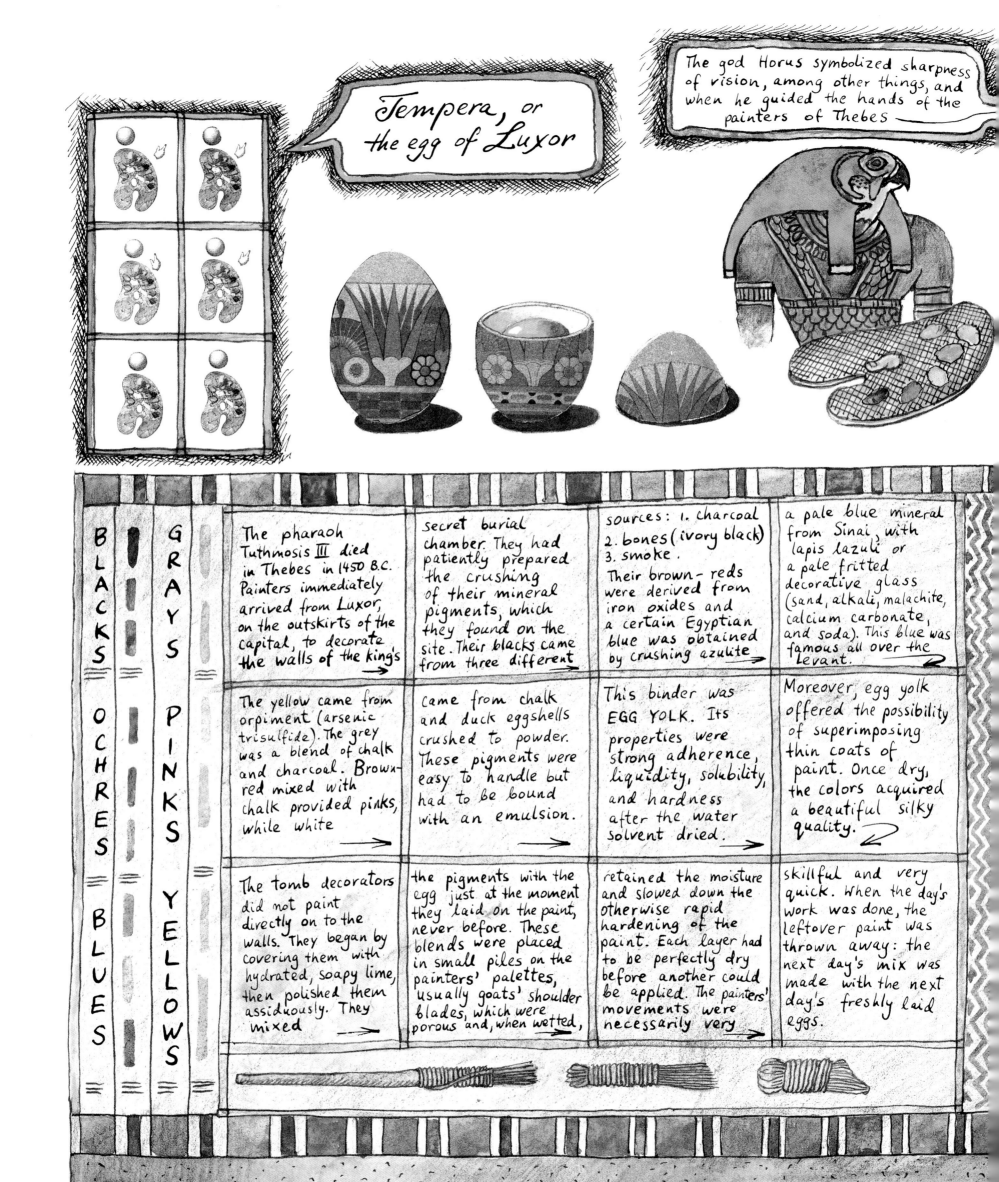

Tempera, or the egg of Luxor

The god Horus symbolized sharpness of vision, among other things, and when he guided the hands of the painters of Thebes

BLACKS OCHRES BLUES

GRAYS PINKS YELLOWS

The pharaoh Tuthmosis III died in Thebes in 1450 B.C. Painters immediately arrived from Luxor, on the outskirts of the capital, to decorate the walls of the king's secret burial chamber. They had patiently prepared the crushing of their mineral pigments, which they found on the site. Their blacks came from three different sources: 1. charcoal 2. bones (ivory black) 3. smoke. Their brown-reds were derived from iron oxides and a certain Egyptian blue was obtained by crushing azulite a pale blue mineral from Sinai, with lapis lazuli or a pale fritted decorative glass (sand, alkali, malachite, calcium carbonate, and soda). This blue was famous all over the Levant.

The yellow came from orpiment (arsenic trisulfide). The grey was a blend of chalk and charcoal. Brown-red mixed with chalk provided pinks, while white came from chalk and duck eggshells crushed to powder. These pigments were easy to handle but had to be bound with an emulsion. This binder was EGG YOLK. Its properties were strong adherence, liquidity, solubility, and hardness after the water solvent dried. Moreover, egg yolk offered the possibility of superimposing thin coats of paint. Once dry, the colors acquired a beautiful silky quality.

The tomb decorators did not paint directly on to the walls. They began by covering them with hydrated, soapy lime, then polished them assiduously. They mixed the pigments with the egg just at the moment they laid on the paint, never before. These blends were placed in small piles on the painters' palettes, usually goats' shoulder blades, which were porous and, when wetted, retained the moisture and slowed down the otherwise rapid hardening of the paint. Each layer had to be perfectly dry before another could be applied. The painters' movements were necessarily very skillful and very quick. When the day's work was done, the leftover paint was thrown away: the next day's mix was made with the next day's freshly laid eggs.

...he bestowed on them his gift of ubiquity, which inspired them in their work and enabled them to devise a bestiary of wonderful expressivness and dazzling simplicity.

from the book of the Amduat, tomb of Tuthmosis III

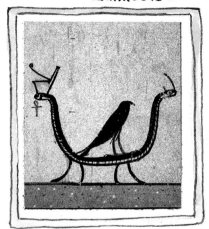

Geese (detail), from a Mastaba tomb, tempera on plaster, 2600-2550 B.C.

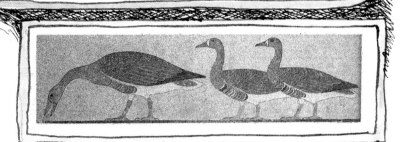

The greatest enemies of tempera were neither fires nor grave robbers, but insects such as cockroaches or mites, which consumed the preparation voraciously.

These obliterators of art, as unexpected as they were undesirable, provided a good reason to keep an eye on the fresh paintings for the first few months after their completion.

Other intruders would also appear, such as fungi, of which there exist more than 2,500 species. These parasites could be neutralized with varnish.

The craft of egg tempera reigned supreme until the advent of oil painting, made popular by Jan van Eyck in the 1400s. For over 3,500 years egg tempera was associated with the names of the greatest painters, many of whose works are now lost, such as the ancient Greek painters Apelles, Protogenes and Aetion. In the course of time, tempera came to be mixed with wax and with certain oils. The portraits from the El Faiyum period, between 100 B.C. and 300 A.D. are made with a blend of egg and polish, and they date from the period of greatest Greek influence in Egypt.

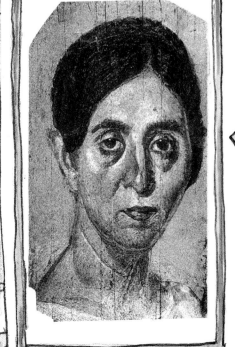

Antinoe, Egypt, 2nd century

Working with a kind of clay that blanches when baked, this Crete painter etched his motif in the fresh surface of the pithos, then enhanced it after firing with a brightly colored tempera (early 7th century).

Although the El Faiyum portraits were painted in Egypt, they hark back to earlier Greek antecedents. The tempera here was bound with hot wax, and the model was painted from life. When she died, her portrait was attached to the bandages that were wrapped around her embalmed face as she mummified.

"Although I've never laid an egg, I'm better qualified than any hen to judge an omelette."
Champfort

After 1,000 years of Greek painting in Byzantium, thirteenth-century Italian painters Cimabue and his pupil Giotto gave the painterly tradition a shot in the arm, liberating their art from Byzantine convention, and, in the process, giving birth to Italian painting.

Although some of us may never have used tempera, it doesn't make us unable to appreciate a work in that medium. And if ⟶

1

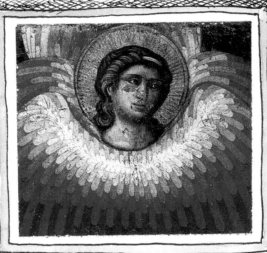

Giotto di Bondone,
The Last Judgment (detail)
Campo Santo, 15th century.

2

3

The construction of a Byzantine Romanesque motif, outlined here, offers a good reason to paint, in tempera, its geometric shapes.

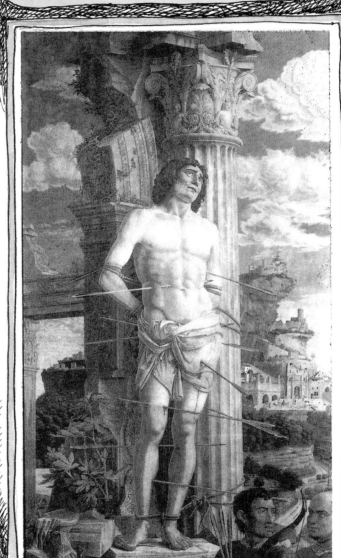

4 → 5

This sublime canvas by Andrea Mantegna (San Sebastian, early 1480s, 9 ft × 5 ft 5", the Louvre, Paris) is doubtless one of the greatest masterpieces of Western art. The richness of the grays, both in the sky and in the architecture, complements the tragedy of the tortured body with a subtlety never before seen.

> out of curiosity, we try out some of the approaches to this technique, the way we look at Cimabues, Giottos, Piero della Francescas, Mantegnas, Bellinis, and Raphaels will never be quite the same again. Contrary to certain fashionable ideas, we would **say** that a little bit of knowledge is not a dangerous thing...

Piero della Francesca, Virgin and Child with Saints (detail), 1472-74, Pinacoteca de la Brera, Milan

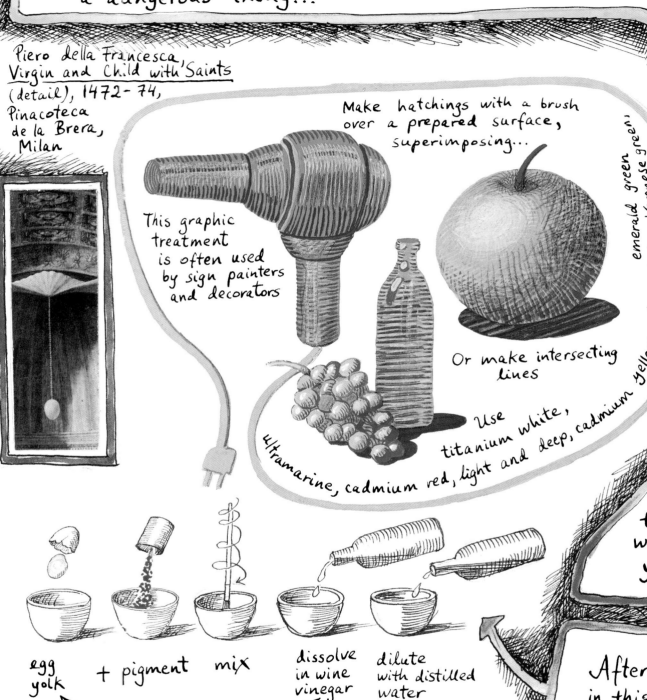

Make hatchings with a brush over a prepared surface, superimposing...

This graphic treatment is often used by sign painters and decorators

Or make intersecting lines

ultramarine, cadmium red, light and deep, cadmium yellow, pale and deep, emerald green, Veronese green

Use titanium white,

Use an HB pencil and tracing paper to make copies of the shapes with which you are already familiar from the preceding pages. When you've done that, turn the tracing paper over and retrace on its other side the lines you see through it, line on line. Then, lay the tracing paper on your support and rub along the lines with your thumbnail - this will leave pale marks on the sheet beneath, on which you will paint. Then lightly retrace the lines and the shapes will be ready for your brush.

egg yolk + pigment mix dissolve in wine vinegar dilute with distilled water

equal quantities

After preparing your color in this way, take a round, tapered no. 6 brush and lay a little of it on a sample sheet before moving on to the subject itself.

Take heart! Few people achieve on their first attempt such a highly accomplished tempera painting as the one done by this feisty Italian.

This mayonnaise-like mixture requires a drying period after each application. An effect of relief is created by applying the tempera in slender streaks, using a round, pointed no. 4 brush.

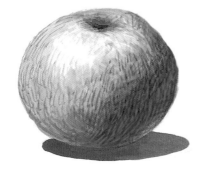

Texture in Paintings

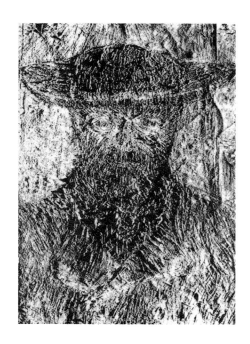

A wind from the north

blew across Flanders in the 1430's carrying with it the reek of dissolved amber and turpentine.

One day, having just finished a painting on which he had worked for a very long time with infinite care, Jan van Eyck varnished it as usual and set it in the sun to dry. The heat made the surface crack. When he saw what had happened the artist was beside himself with grief.

Almost immediately the emphasis shifted from this

to this

He then began to wonder whether it might not be possible to come up with another kind of coating, one that would dry in the shade. Van Eyck had a wide knowledge of chemistry, and drawing on this he came up with the following innovation. First he boiled linseed and nut oils to rid them of humidity and give them drying properties. Then he added essential solvents, thereby obtaining the first medium for drying paint that did not rely on the sun's rays. It is also rumored that van Eyck successfully dissolved yellow amber, a fossilized resin dating from the Oligocene period.

After benefiting greatly from the patronage of the Flemish burghers, van Eyck attached himself to the court of Burgundy, where he was appointed court painter and valet to Duke Philip the Good, accomplishing several diplomatic missions.

Jan van Eyck, 1395-1441, Man in a Red Chaperon, 1433, a self portrait

Crucifixion, c.1425-30 (detail)

a piston

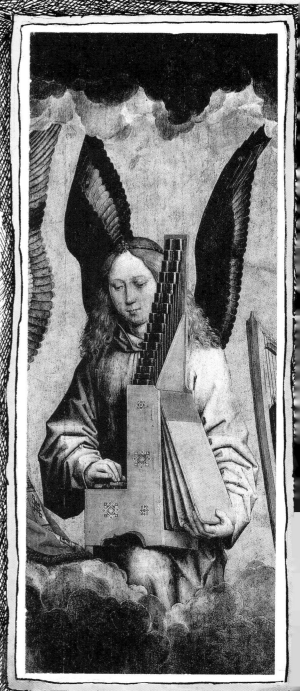

ivory black | burnt umber | raw umber | burnt sienna | raw sienna | dark yellow ochr

Hans Memling

The painter Memling squandered a fortune on the pleasures of the flesh before enlisting as an ordinary foot soldier in the army of Charles the Rash. The king was killed shortly afterwards at the battle of Nancy, and the bedraggled, starving remnants of Charles's army made their way back to Flanders.

Memling arrived in Bruges in 1477 in the middle of the night, and was just able to drag himself to the gate of the hospital of St. Jan before collapsing. There the nuns nursed him back to health, prompting such gratitude in the artist that he dedicated to them all the paintings that are still seen hanging on the walls of the hospital.

Within a few years of his recovery he was running a major studio, owned three houses, and was numbered among the 140 burghers of Bruges who paid the highest taxes.

Hans Memling, 1440-1494
← <u>Christ and Music-making Angels</u> (detail), c.1492

Rogier van der Weyden was a pupil of the Tournai painter Robert Campin, becoming the master of the Tournai guild in 1432 and the town painter of Brussels in 1435. On several occasions he worked for Philip the Good, and in 1450 he visited Rome and Ferrara, where he was in the service of Leonello d'Este, Marquis of Ferrara. Van der Weyden received commissions from the Medicis and the Sforzas, and was much influenced → by Fra Angelico and Gentile de Fabriano. A characteristic example of the blend of northern and southern traditions, he transformed the somewhat icy glaze of Flemish painting into dramatic sentiment, handling color in such a way as to impart tension ← to his figures. He worked at a time when chemists and alchemists were hard at work distilling new colors, and, instead of tempera, he used resin, copal, lavender essence, and linseed oil. Van der Weyden influenced Dieric Bouts and Jan Memling in Flanders and Cosimo Tura and Francesco del Cossa in Italy.

Rogier van der Weyden <u>Descent from the Cross</u>, c.1442

lapis lazuli

sulphur yellow

madder

Pozzuoli earth

carmine

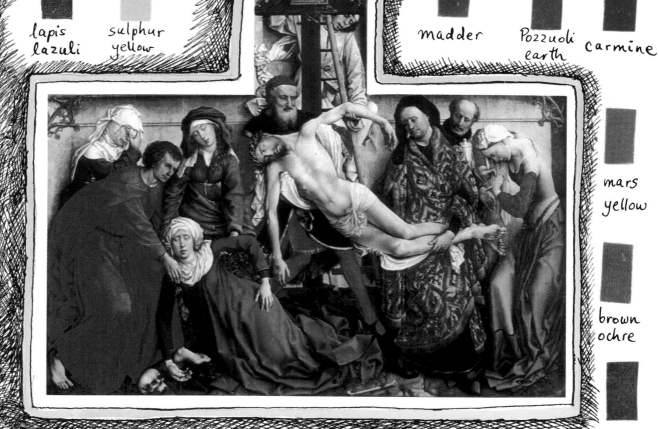

mars yellow

brown ochre

green earth

cobalt green

These new techniques brought new ways of painting, brush strokes were laid on "fresh", the colors mixed smooth with the brush itself. The resultant tints could sometimes be as transparent as watercolors and could even be used in glazes.

Naples yellow | dark chrome yellow | light chrome yellow | Flanders yellow | vermilion | carmine | madder | cobalt violet | Prussian blue | cobalt blue | manganese blue | ultramarine blue | chrome oxide green | emerald green

Flemish Glaze and how to use it

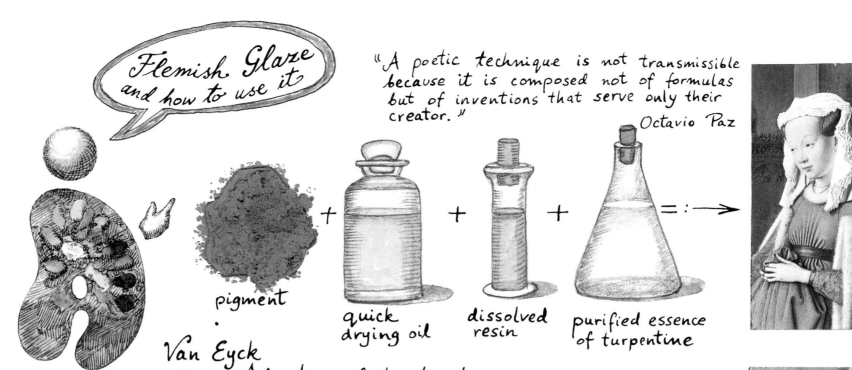

"A poetic technique is not transmissible because it is composed not of formulas but of inventions that serve only their creator."

Octavio Paz

pigment + quick drying oil + dissolved resin + purified essence of turpentine = :→

Van Eyck and The Adoration of the Lamb

Art restorers in Belgian museums have taken cross sections from picture fragments that have fallen away from their supports. These fragments have yielded important information about painters' techniques that are as exact as geological deposits, demonstrating how pictures were built up layer by layer from the ground support to the final coat. Using formulas passed down from the monk Theophilus, who recommended superimposing transparent layers on an initial gouache drawing (i.e. first sketch with shading), van Eyck refined his technique of multiple translucent layering until it became the fundamental principle behind his work. This was no small achievement. The van Eyck process paved the way for the Dutch masters, with the greatest geniuses turning it into a means of expression devoid of narrow realism. Van Eyck introduced two apparently contradictory qualities: systematic sureness and regularity in his work, and the subtle transformation of pure technique into an authentic style offering real freedom and spontaneity of expression. The report on the restoration work carried out on van Eyck's Lamb was published in 1952 and remains a document of great significance to anyone interested in van Eyck's technique.

Final version, varnished after the final application of paint has slowly dried ——→

Transparent film with dark touches to emphasize relief

Second film with opaque highlighted touches worked when wet and then again when half-dry

First translucent film with pictorial matter worked when wet ——→

First applications of thin, diluted colors ——→

Gouache drawing ——→

Buffed primer, consisting of blanc de Meudon mixed with animal-skin glue

Oak support ——→

The laboratory report submitted after the restoration of the Lamb painting states that "... van Eyck's binder was based on a siccative (quick-drying) oil, plus ingredient x. We cannot positively identify the substance added to the oil, but we believe it had similar properties to those of certain natural resins and was probably a substance that could be completely dissolved in the siccative, combining with it to form an evenly structured film. We do not think that these characteristics can be found in any known emulsion."

Thus, at the time the marriage of oils and with emulsions (thick and thin). This combination Breughel, Jordaens, Rembrandt, Hals, van Dyck, Caravaggio, Velázquez, Ribera, and Zurbarán, possible to do later work on areas that had been for the development of color gradation, relief, and greater freedom with brushwork.

The dipper now made its appearance on the painter's palette. Attached by a grip, these little goblets contained siccative oil in one and medium in the other. Sometimes the two would be mixed together in the same container, according to the painter's own formula.

The greatest painters of the past raised themselves to the level of poetry by scrupulously applying basic formulas that gave them access to style. Others, using exactly the same formulas, merely drowned themselves in irremediable boredom.

The absolute principle of all oil painting is that it begins with a hard base, to which a softer coat is added, and so on.

Completed on May 6, 1432, the twenty-panel polyptych can still be seen at the church of Saint Bavon in Ghent, Belgium

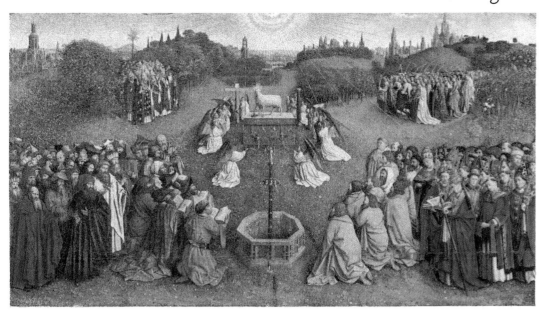

The Adoration of the Lamb
central panel

Soft

← Final coat of varnish: oil + resin + solvent

← Pigment + siccative oil = augmentation of the medium, restriction of flexibility

← Pigment + siccative oil with the arrival of the more flexible medium

← Pigment + siccative oil with binder and a little solvent

← Pigment with very low oil content under a binder liquified with solvent, such as turpentine

Zones of migration

Hard

The great skill of van Eyck lay in his mechanical procedures, which established inevitable laws governing the sense and freedom of pictorial method. In his book Le Métier du Peintre, Pierre Garcia describes the essentials of painterly technique as applied to a work of this kind. "If the pictorial layers are to bond together, every fresh coating must partially migrate into the one before, while providing a similarly porous surface to the layer that comes after." He adds, "This construction is intelligent because it offers a 'force of anchoring' proportional to the mechanical needs of the work."

pigments was announced, other unions were already in the making, notably that of oily pigments found favor with the Dutch masters because it offered a thickening effect that not only and Rubens were able to use, but also the southern European greats such as Titian, Tintoretto, among others. Technically, because of its slower drying properties, the new material made it painted many days before. Thus, as surface unevenness became easier to control, the way was opened smoothing procedures. And as so often happens, these new technical constraints engendered

The painter, having delved into various blobs of color with his brush, proceeds to squash them against his palette, adding a carefully calculated quality of medium to the blend he is creating. The mixture will then be applied to the painting. Here, precisely, is the point at which technique is transformed into expression.

Turpentine takes the place of water as a brush-cleaner. It can also be used as a paint-thinner.

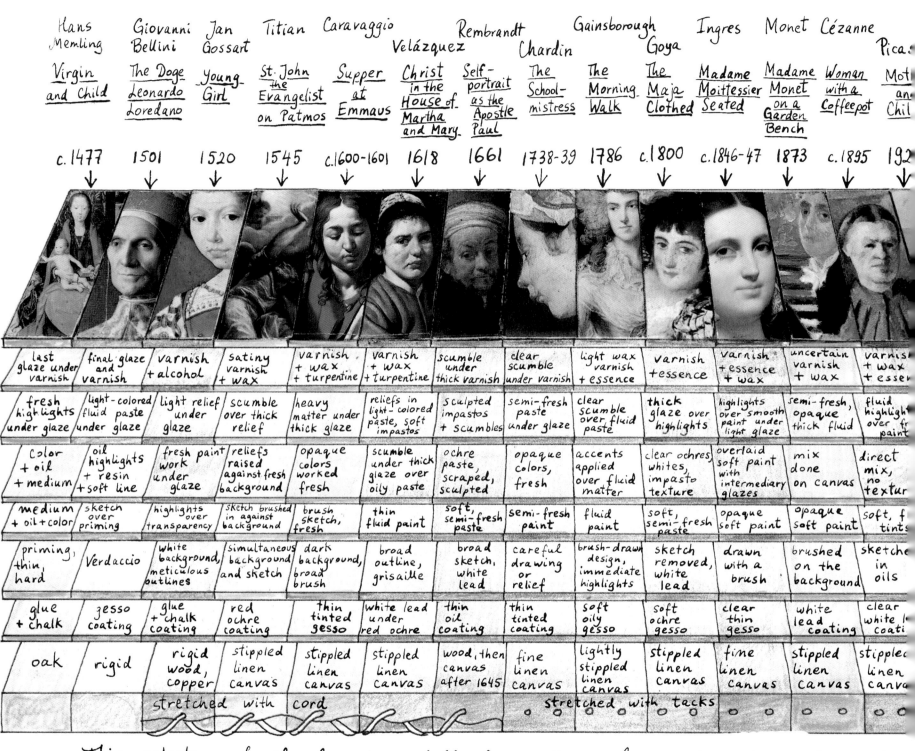

Although van Eyck was an innovator, he was no revolutionary. He made his contribution within the confines of the European tradition, enriching it without breaking with it. Concluding that light and space were major elements of modern awareness, he used them to engender technical adaptations and new forms of expression. The painters who came after him were able to apply his principles to the expression of their own feelings. Thus, the relationship between skill and expression has continued unbroken, from passion to passion and vision to vision, ever since the 15th century.

Hans Memling	Giovanni Bellini	Jan Gossart	Titian	Caravaggio	Velázquez		Rembrandt	Chardin	Gainsborough	Goya	Ingres	Monet	Cézanne	Picas.
Virgin and Child	The Doge Leonardo Loredano	Young Girl	St. John the Evangelist on Patmos	Supper at Emmaus	Christ in the House of Martha and Mary	Self-portrait as the Apostle Paul	The School-mistress	The Morning Walk	The Maja Clothed	Madame Moittessier Seated	Madame Monet on a Garden Bench	Woman with a Coffeepot	Mot an Chil	
c.1477	1501	1520	1545	c.1600-1601	1618	1661	1738-39	1786	c.1800	c.1846-47	1873	c.1895	192	
last glaze under varnish	final glaze and varnish	varnish + alcohol	satiny varnish + wax	varnish + wax + turpentine	varnish + wax + turpentine	scumble under thick varnish	clear scumble under varnish	light wax varnish + essence	varnish + essence	varnish + essence + wax	uncertain varnish + wax	varnish + wax + essen		
fresh highlights under glaze	light-colored fluid paste under glaze	light relief under glaze	scumble over thick relief	heavy matter under thick glaze	reliefs in light-colored paste, soft impastos	Sculpted impastos + scumbles	semi-fresh paste under glaze	clear scumble over fluid paste	thick glaze over highlights	highlights over smooth paint under light glaze	semi-fresh, opaque thick fluid	fluid highligh over fr paint		
Color + oil + medium	oil highlights + resin + soft line	fresh paint work under glaze	reliefs raised against fresh background	opaque colors worked fresh	scumble under thick glaze over oily paste	ochre paste, scraped, sculpted	opaque colors, fresh	accents applied over fluid matter	clear ochres whites, impasto texture	overlaid soft paint with intermediary glazes	mix done on canvas	direct mix, no textur		
medium + oil + color	sketch over priming	highlights over transparency	sketch brushed in against background	brush sketch, fresh	thin fluid paint	soft, semi-fresh paste	semi-fresh paint	fluid paint	soft, semi-fresh paste	opaque soft paint	opaque soft paint	soft, f tints		
priming, thin, hard	Verdaccio	white background, meticulous outlines	simultaneous background and sketch	dark background, broad brush	broad outline, grisaille	broad sketch, white lead	careful drawing or relief	brush-drawn design, immediate highlights	sketch removed, white lead	drawn with a brush	brushed on the background	sketche in oils		
glue + chalk	gesso coating	glue + chalk coating	red ochre coating	thin tinted gesso	white lead under red ochre	thin oil coating	thin tinted coating	soft oily gesso	soft ochre gesso	clear thin gesso	white lead coating	clear white l coati		
oak	rigid	rigid wood, copper	stippled linen canvas	stippled linen canvas	stippled linen canvas	wood, then canvas after 1645	fine linen canvas	lightly stippled linen canvas	stippled linen canvas	fine linen canvas	stippled linen canvas	stippled linen canva		
		stretched with cord						stretched with tacks						

This selection of oil colors is available from all suppliers – it easily meets all the

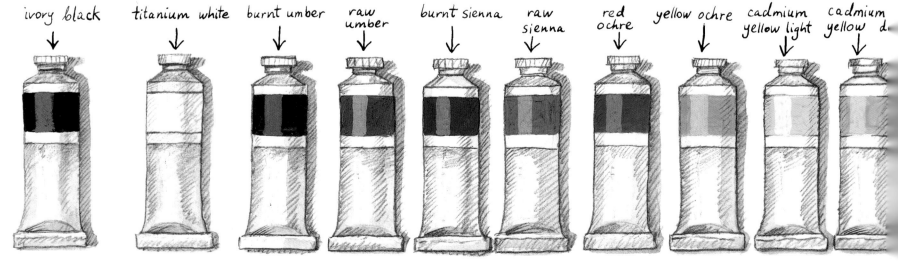

ivory black titanium white burnt umber raw umber burnt sienna raw sienna red ochre yellow ochre cadmium yellow light cadmium yellow d

For a long time (from the mid-19th century to 1960-65), and particularly in Europe, the techniques of painting were viewed as an obstacle to freedom of expression. Mistakes were made, and many of the most important figures in the profession adopted dangerous methods in the handling of colors. Their sloppy organization in the laying on of badly pulverized, badly bound, unstable materials has left a host of almost insoluble problems for restorers, and today many beautiful works are in danger. This is not to say that all the formulas of the old masters were beyond reproach. Luckily, today our color manufacturers are seeing to it that the materials of the past now have worthy equivalents. Modern chemistry produces colors and mediums that, when properly handled, produce sound and durable results for the painting profession.

Pierre Bonnard
The Lunch

Francis Bacon
Three Studies of the Male Back

Lucien Freud
The Big Man

1932 1970 1976-77

Your first painting

There is no reason why a work of yours should not be included in this unbroken chain. All the painters in this list were once apprentices, too.

little or no finishing varnish

Picasso used a classic technique of superimposition, thin + opaque thick fluid; Bonnard, semi-fresh touches; Freud, thick touches

Freud used heavy scumbles and impastos; Bacon used very liquid ones; Freud used thick glazes over reliefs

Bacon used a mixed technique of adding pastels

designs can be made with either pencil, gouache, etc.

Bacon used unbleached canvas, others used clear or white acrylic gesso

the canvas can be fine or grainy, linen or synthetic, or linen and synthetic

stretched with staples

For your first oil painting you will need fine colors pulverized in oil, along with the mediums that can carry them.
- A thinner that can serve as both solvent and cleaning agent (such as turpentine)
- Round or pointed brushes with tips of all sizes
- Round and flat brushes of all sizes and graining brushes
- A nonporous wooden palette
- Absorbent tissues
- A brush washer
- A dip cup
- A medium-sized palette knife
- A support, which might be a fine-grained canvas, purchased ready for use. Thereafter, you should stretch and prime your canvases yourself.
- Finally, a hand-rest may come in useful.

We have seen with van Eyck how mediums allowed painters to choose between fluidity, softness, and brilliance in colors and reliefs. Here are some of the mediums that can be found at artist supply shops.
① Colorless painting medium
This medium has a resin base and allows the paste to take rapidly. It can be thinned with turpentine, and is kept in your dip cup ready to mix with the paints on your palette. The same goes for all other liquid mediums.
② Flemish siccative
Very similar to the old mediums, Flemish siccative allows colors to take very easily, and its resinous consistency yields a fine glaze. It can be diluted 1/3 siccative 2/3 turpentine for thinning colors, and is used undiluted for glazes.
③ Paint mediums
The Flemish medium is used for its translucent quality. For the first layers you use very little, then add more as you go along. Dilute with turpentine.
④ Venetian medium
This gives the paint a fine satiny gloss and facilitates the process of impasto. Dilute with turpentine.
⑤ Dissolved amber - the best
A medium that combines with oil to produce a soft, rich, homogenous mixture. Its glutinous nature forestalls the inter-reactions of colors. Because it is neither brittle nor powdery when dry it lends stability and fixity to your colors. A jewel of a medium.

needs of both beginners and experienced artists.

cadmium red light cadmium red deep Mars red cobalt blue ultramarine phtalo blue emerald green chrome green

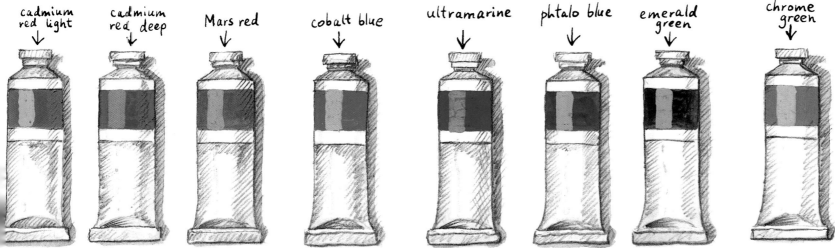

An Egg Done in Oils

1. On canvas primed with acrylic gesso and measuring about 6 × 8 inches, draw a rough outline in watercolor. The vertical background can be a propped-up piece of white cardboard. The source of light (electric) is above right.

2. A little burnt umber, white, and cerulean blue will yield a suitable shade of gray. Using a no. 6 filbert brush, paint over the vertical background. The same tint, combined with ochre and a little white and blue, will supply the horizontal plane. Next, position the light on the egg and egg cup with white and yellow ochre, and then do the shade zones of the egg and egg cup using burnt umber and cerulean blue and red ochre. Rub away the shade thrown by the object so that it fades

For this first experiment we have selected an egg in an egg cup for several reasons: because, unlike a flower, an egg with its cup will continue to look exactly the same for as long as we leave them alone; because their rotundity lends itself to the translation of volume; because we can learn about the placement of light and shade studying their horizontal and vertical planes; and because an application of a glaze or two will introduce us to the effects of atmosphere.

You will need the following colors on your palette:
titanium white
burnt umber
red ochre
yellow ochre
cadmium red medium
cerulean blue
ultramarine blue
In two separate dip-tins, linseed oil and turpentine
A fine, long, pointed brush with synthetic bristles for drawing outlines
2 filbert brushes (nos. 6 and 14)
2 round-tipped, hard-bristle brushes (nos. 4 and 10)
1 fan brush (no. 6)
3 round pointed brushes (nos. 4, 8, and 12)
A stable, tiltable easel
A hand rest
1 absorbent tissue
A corner of the house well away from noise and any kind of hustle and bustle.

Vertical plane

Horizontal plane

The drawing on its primed canvas

The canvas is now covered with fresh oil paint, laid on with a no. 6 round-ended brush. The egg and egg cup are painted with no. 4 brush.

Starting from figure 1, the backgrounds should be well covered, using plenty of paint. After they have dried,* apply an ochre glaze. On the egg and egg cup the colors should be placed in flat zones, following the shadows cast by the two elements. Because these zones are very fresh, they will be receptive to the light brushstrokes

that bring them together, blending the flat tints into each other from light to dark with no unevenness. Immediately afterwards, while the paint is still wet, use a fan-shaped brush to smooth off the surface, caressing away any marks left by bristles. After drying, a warm glaze of red ochre will accentuate the notion of atmosphere. To the left of the egg cup and under it, diffuse the light with touches of white.

* The drying can, perhaps, be accelerated by adding some Flemish siccative to the paint.

3. Rub a mixture of cerulean blue and burnt umber against the background, then do the same to the horizontal plane after adding a little white and yellow ochre to the mixture. Emphasize the shadow cast by the subject, then cover the egg with a slightly opaque glaze of yellow ochre and white; and cover this in turn with another similar glaze, this time made with yellow ochre, red ochre, and a touch of cerulean blue. Then deepen the shade cast by the egg cup and leave to dry.

4. Lay on oily glazes of red ochre and burnt umber over the dried surfaces, beginning with the vertical background and moving on to the horizontal. Then apply an opaque white and red ochre glaze to the left-hand side of the table. Finally, apply a glaze of light yellow ochre to the egg itself. The effect should be somewhat grainy, with a supple texture.

round pointed brush filbert brush flat brush

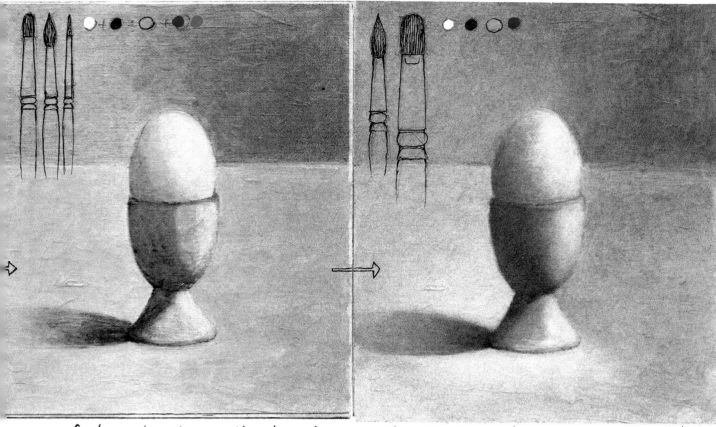

semi-fresh paint under scumble, plus oil filbert brushes, nos. 10 and 6

glaze on dry backgrounds, plus oil filbert brush, no. 12, round brush, no. 8

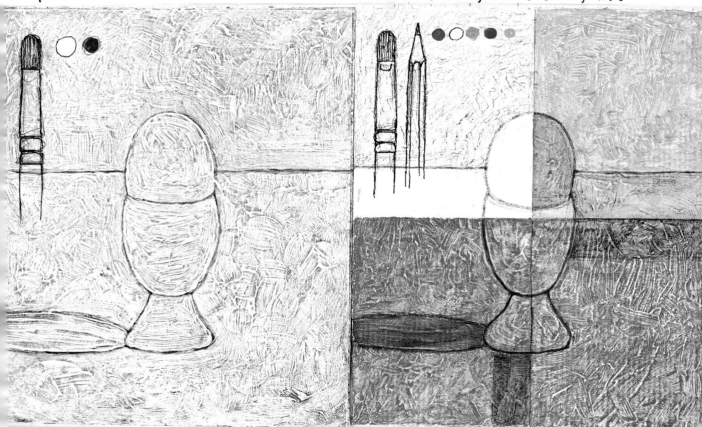

After working, clean your brushes with turpentine essence, wipe them, and rub them over with soap. Then rinse them with warm water.

Here is an example of the effect of texture that can be achieved by passing a round, hard-bristled brush (no. 10) over paint that has already been laid on, and that has itself been thickened by an impasto medium and a drop of Flemish siccative. The paint is titanium white. After it has dried, apply an oil glaze colored with burnt umber and wipe it with a cloth before massaging it with the palm of your hand,

wiping again after each massage. The color of the glaze will remain in the wiped-over crannies of the surface, while the reliefs will stand out much lighter. The same technique can be used with brighter colors, as above. In the left-hand upper square, a pencil lead has been rubbed over the surface roughnesses, which have taken on a gray tint while the hollows have remained white.

long pointed brush round pointed brush fan brush for fading off

Eyes have fingertips

The examples of materials here have been rendered with acrylic paint, which can be diluted with water and acts as an excellent fixative for fibers and powders.

By using thicker or thinner paint, the artist can transform emotion into matter and matter into emotion.

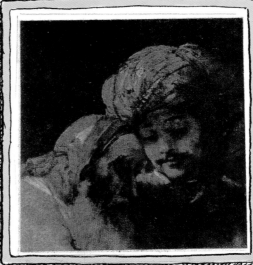

Rembrandt

The painter's brain may have invented the possibility of "feeling" images, but it was certainly not the brain that perceived the depth in perspective or the volume in skillfully executed relief. This is the effect of illusion. Roughness, streaking, thickening, grains, grooves, and other marks on the paint surface create textures that add a tactile dimension to what the eye takes in, for there are tactile values in painting. Instead of believing that the world enters our brain because of our ability to see, we might look at it this way: our minds ride out through our eye-sockets to visit things outside. The invisible fingertips of our minds have the power to touch objects, and thus the touching, feeling instrument of sight lies at the heart of our contact with paintings. When, in a museum, we stand at the right distance from paintings, our eyes caress them in a manner well known to lovers of the medium. Yet now we have ways of making perfect reproductions of paintings through photography, and this has led to a previously undreamed-of phenomenon in libraries, painters' studios, and our computers: with no difficulty we can store images of everything painted, carved, sculpted, or drawn in the world since Altamira. But the images on our shelves are just that: images, and nothing more...

Frans Hals

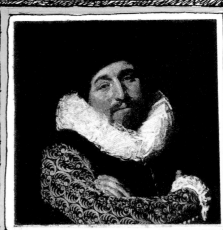

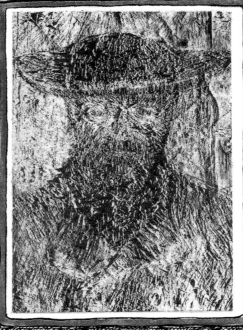

For example, the act of viewing Veronese's _Marriage at Cana_ in a reproduction measuring 8¼ x 10⅝ inches informs us of the painting's existence, gives us an idea of what it looks like, and allows us to form an opinion of its composition, colors, and style. But in a photographic reproduction the most important element of the painting is missing - the epidermis of the painting, what the French call its "_feuil_." All painted works possess a "skin", of which reproductions can offer no more than a vague inkling. Scale has nothing to do with it. A life-size reproduction of Vermeer's _The Lacemaker_ offers only a reflection of the canvas; the eye of modern man has grown accustomed to the virtual image, which makes no distinction between the smooth, enameled textures of Memling and, for instance, the thick, convulsive brushwork of van Gogh. But the painter's true physical presence resides in his textures, and this presence is cruelly absent in reproductions, for a mind without a body cannot paint. According to a number of witnesses, Leonardo da Vinci painted with his fingers, his thumbs, and the palm of his hand... his sight controlled the movements of his body. The only way we can make direct contact with works is by physically going to see the original, wherever it may be, for only then can we feel it in its palpable essence. Our eyes serve as gateways through which that essence may enter as we instinctively position ourselves in the exact spot to which the painter himself must have withdrawn when he took stock of his work in progress.

And when we approach his canvas to examine its surface more closely, we can use our sight like fingertips of the brain to probe for what is truly there.

van Gogh, Portrait of Father Tanguy, lit from the side at the Louvre laboratory

Jean Fautrier

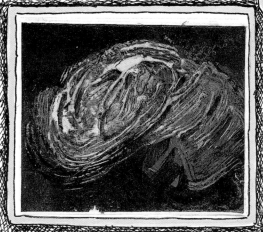

1. On a brown background (burnt umber + titanium white + ivory black + chrome green), swirls of a mixture of titanium white and yellow ochre heightened with swirls of black; then a glaze of transparent yellow oxide rubbed with fingertips. Brush, hard bristle no. 8, round-tipped.

The alphabet of the material

The feuil is the surface film created by the sum of the layers of paint laid on the support of wood, canvas, leather, etc.

Charles I, van Dyck

Feuil no. 1

Feuil no. 2

2. On a black ground (ivory black + permanent green + titanium white), swirls of a mix of titanium white with glaze applied with a soft brush (cobalt blue and chrome green), then rubbed with fingertips and palm. Brushes: no. 10 hard bristle, round-tipped, and a soft brush.

Van Dyck and Frans Hals

On his way to England, van Dyck went to Haarlem to visit Frans Hals. Hals was out at a tavern when he arrived, so the Antwerp painter sent word that someone was waiting at the studio for a portrait. Hals instantly came running; the stranger told him he wanted a likeness but could only spare a couple of hours to sit for it. Hals reached for the nearest canvas, hurriedly prepared his palette and set to work. Two hours later he showed the result to his "client," who seemed very happy and begged leave to return the compliment. Surprised, Hals fixed another canvas to his easel and took his turn to pose. It soon became clear that the stranger knew exactly what he was doing. When he was invited to look, Hals flung his arms round his visitor. "Van Dyck!," he cried, "only van Dyck can do what you've just done."

Van Dyck invited Hals to come with him to England, promising he would make his fortune. The offer was refused: Hals was quite happy where he was. So van Dyck took away his portrait by Hals, generously showering the painter's children with money, which was immediately confiscated by their father and spent on high living.

3. On a white gesso background, titanium white + impasto medium + final glaze (raw umber + yellow ochre) rubbed with fingertips and palm. After a few minutes, wipe over the reliefs with a cloth moistened with water and gum. Background: yellow ochre + impasto medium, partly covered with opaque cadmium red, final glaze of transparent brown oxide rubbed with fingertips. Hard, flat-tipped brush and brush handle.

Feuil no. 3

Feuil no. 3a

Enlarged cross-sections of feuils

4. On a white gesso background, gray glaze (cerulean blue, brown ochre), then apply titanium white + gel medium + transparent glaze of cadmium red + permanent green + cadmium yellow medium. Brushes: no. 8 round tipped + palette knife.

(center) self-portrait of Frans Hals

Feuil no. 4

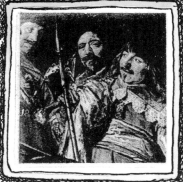

The reliefs beneath the glazes

Impasto relief is much more than an innovation in soft-paint method brought about by artists who were impatient with the constraints of dry work. Its primary attraction lies in its ability to communicate a specific vision in which the meditative reserve of the Flemish school gives way to the purely sensual exaltation of light. This light rippled the contours and blurred the shapes that the painters from the north had calculated with such precision. Titian was among those who used this technique to force his paint to express his impulses. Correggio, Veronese, Tintoretto, Rubens, and Velázquez traveled down the same road, so far indeed that Delacroix later complained that "the men of the 16th and 17th centuries have left us with very little to do." But the painter's muse continued to guide the brushes of those who labored amid the tumult of realism. From Rembrandt's <u>Slaughtered Ox</u> to Chardin's <u>The Skate</u>, from Constable's skies to Bonington's iridescence, from Courbet's virile brushwork to van Gogh's furrows and Daubigny's quivering drippings, generations of painters continued to develop their skills. With Vermeer's <u>View of Delft</u> in the 1600s and the works of Salomon van Ruysdael, Claude Lorrain, and Hubert Robert, landscape art had asserted its autonomy within the painting profession. American painters visiting Europe were injected with a passion for painting in the open air. The successors to Thomas Cole — George Inness, Albert Bierstadt, Thomas Moran, Frederic Edwin Church, and others — breathed into their landscapes the epic beauty of the New World. The Grand Canal of Venice, on which Canaletto had sailed with Guardi and Bellotto as his shipmates, led to the bridge at Narni, painted by Corot in 1826. These paintings, in turn, all proved to be a foretaste of the bright visions of the Impressionists.

A study (pencil and pen) serves as a support for a laid-on texture destined to receive various glazes that can be left for a few minutes or until the layer beneath them has been impregnated. They can then be dabbed, wiped, rubbed etc.

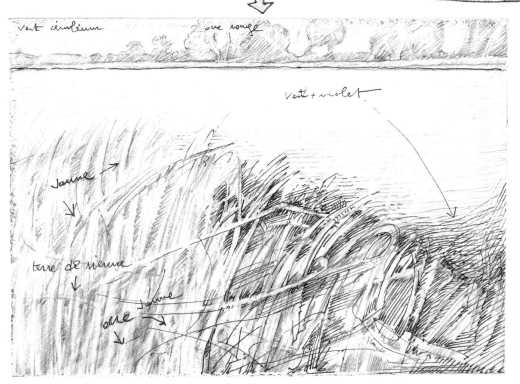

Glazes, once they have been applied, lend themselves to all manner of manipulations: scumbles, wipings, rubbings, brushings. They should never be harder than their supports. Do not forget van Eyck's technique: oily paint over thin, never the reverse.

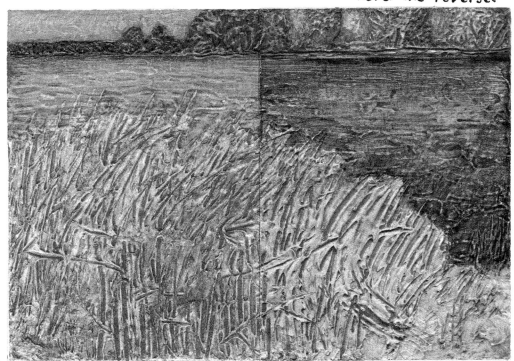

↑ The sky: a layer of cadmium yellow medium covered with emerald green. Background trees: a layer of madder lacquer, covered with ultramarine blue. On the water and the grass, a uniform layer of antique pink that is then rubbed, allowed to dry, and covered with emerald green for the water and dark permanent green for the grass.

↑ Here the entire surface is covered with raw sienna, which, when it's dry, is rubbed over with a cerulean blue glaze. The trees are covered with burnt sienna, and then the water is coated with rubbed quinacridone pink. When dry, this is greened over with a light permanent green. The grass is rubbed with a light glaze, the same as the one used for the water surface.

Sequence: on an absorbent cardboard support (about 7 x 9 inches) apply two coats of white acrylic gesso, one crossing the other. Then sketch in the main lines of the landscape without lingering over details.

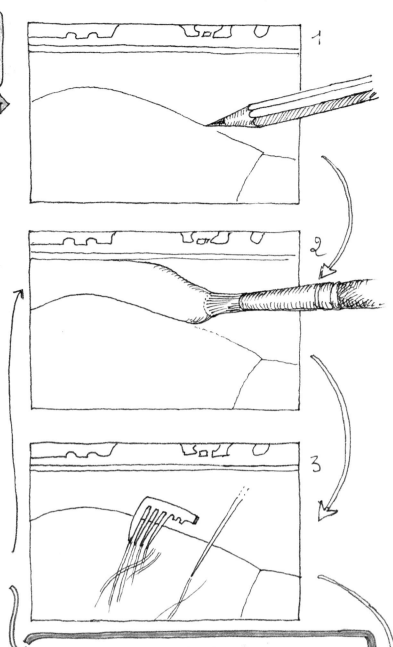

1

2

3

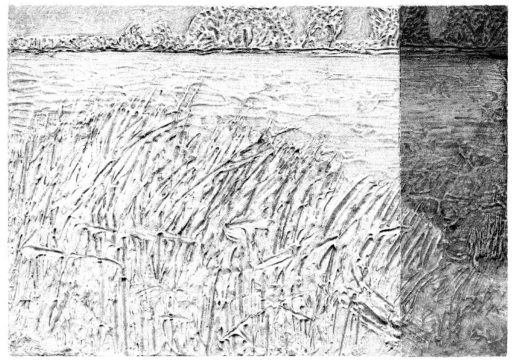

Within the contours of the drawing, spread a thick layer of the following mixture: titanium white (oil) plus an impasto medium for oil colors. You can make an identical blend with acrylic titanium white and a thickening gel, using water as a solvent, but this mix will dry more rapidly than the other.

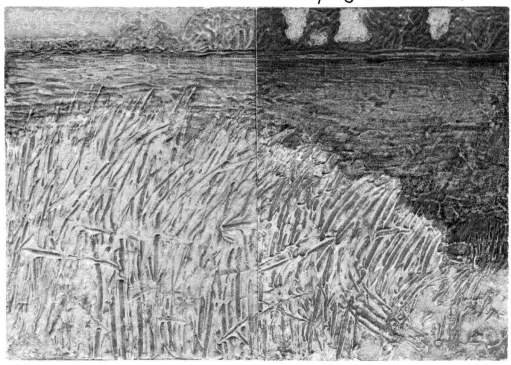

When the impasto has been spread out, score it with a comb or a pointed stick. The marks will remain in the paint. Anything that leaves prints, scratches or gouges can be put to use. The work should be done in the direction of the rhythms perceptible in the drawing. A round, hard-bristled brush will serve to dab over the trees in the background. When this minor bas-relief is finished, leave it to dry.

4 Next, lay glazes over the dried surface. This will be easy enough, provided you observe the following rules. Use only translucent tints and mix them with siccative oil, plus a little varnish. The solvent will be turpentine essence. This exercise, like all the others, does not constitute an end in itself, but deserves to be included as a tool of sensory understanding in your painting repertoire.

↑ The sky starts out with transparent permanent green and is then coated pink with a light madder lacquer, followed by an ultramarine blue made grayish with phtalo blue. The trees are begun with sienna, then covered in a blue-violet obtained by mixing manganese blue with a touch of cadmium red deep. The water begins with light ochre, which is then coated with ultramarine blue and madder lacquer. The grass is yellow ochre covered with permanent green and brown.

↑ The sky is yellow ochre covered with light permanent green. The trees are light ochre covered with cadmium red light and shaded with quinacridone red. The water begins with yellow ochre, which is shaded with a light emerald green and then covered with madder lacquer and ultramarine blue. The grass begins with yellow ochre and is then covered with burnt sienna.

Acrylics:
For the painter who can't wait

Phase 1: undercoat + drawing

Phase 2: drawing + wash + white

Phase 3: shadings + highlights under wash

Here is a vehicle perfectly adapted to artists in a hurry — it goes by the name of acrylic paint. Its properties are as follows: it dries as quickly as gouache, in a few minutes, but some mediums can prolong this. It adheres with such strength that it can double as an excellent glue. It sticks to all supports with the exception of metal. Its versatility means it can be used in liquid or paste form. Its ease of use makes it an ideal medium for beginners. It resembles no other form of paint, though it has similarities with all of them. It can lend itself to watercolor techniques, it may be used like a tempera, and it can even be worked with as if it were an oil paint. Finally, and most importantly, acrylic paint is indelible once moisture has left it. This makes its superimposition easy — you can apply another coat as soon as the preceding one is dry, without having to thin it. Acrylic surfaces can be matte like frescoes, or shiny like oils. In addition, acrylics are water soluble and have no smell whatsoever.

To paint this sequence the following tools are required: synthetic round brushes nos. 4, 6, 10 filbert brushes nos. 2, 4, 8 1 flat brush no. 14

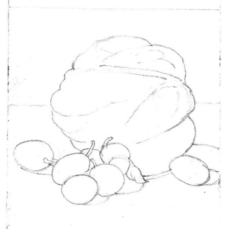

Make your preliminary sketch in pencil on a piece of cardboard about 7 x 11 inches primed with natural white gesso.

Wash your brushes with water when you're finished with them.

When you dilute acrylics with a lot of water, they can become as transparent as watercolors. Washes that are superimposed have the property of not becoming diluted due to the effect of the film that re-covers the acrylics.

Lay on a semi-opaque glaze (red ochre + yellow ochre + umber). After this has dried, go over it again with a fine no. 2 brush, tracing the line of the original sketch with red ochre. Add touches of light (titanium white) to the plums and the cabbage. Allow to dry for a minute or two.

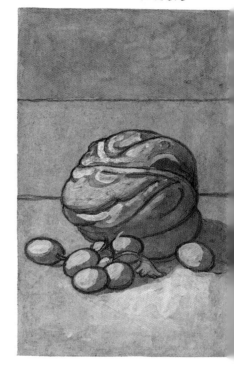

Lay on the shaded parts of the cabbage, the plums, and the base (red ochre wash and cobalt blue). Add highlights (white and yellow ochre) to the cabbage, then white and cobalt blue to the plums and base. After this has dried, apply a coat of very thin ultramarine blue.

Study of a cabbage, acrylic wash

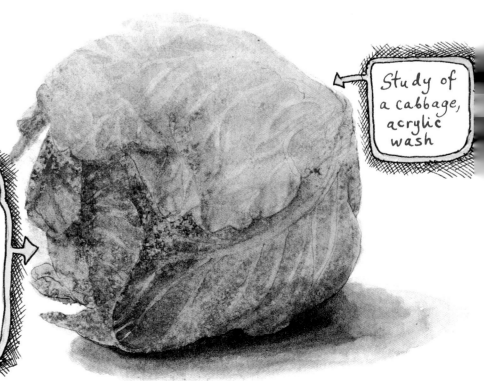

Phase 4: opacities + scumbles + glazes

Phase 5: opaque washes under glaze

Phase 6: the painting stage — impastos, reliefs, opacities, contours, saturation

Phase 7: transparent impastos gel medium, glaze, final coat of varnish

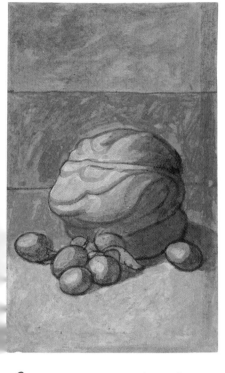

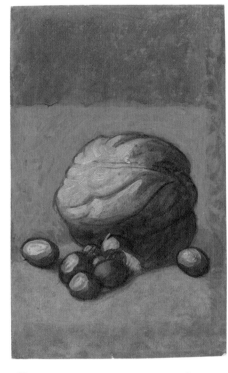

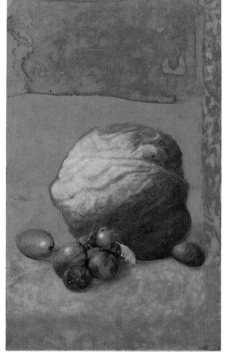

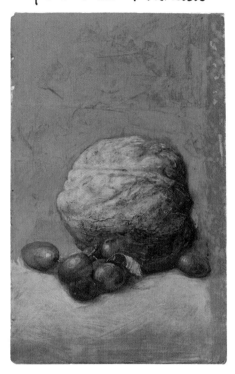

Semi-opaque watercolor-type scumble, thin ultramarine blue for the band of color at the top. Semi-opaque cobalt blue for the area behind the cabbage, then a coat of thinned titanium white and yellow ochre for the base. Allow to dry, then apply a thin coat of cadmium red and ultramarine blue (violet) over the entire surface like a wash. Before the wash has taken, lay ultramarine blue and emerald green over the shaded part of the cabbage, then apply a fairly rich ultramarine blue glaze to the plums and the shadows on the base.

Scumble on the upper band of color: violet made up of ultramarine blue and red (alizarine lacquer) and pale white.
On the rectangle that serves as a background to the cabbage, lay on an almost completely opaque glaze of cobalt blue plus madder lacquer plus thin white, and allow to take. Then apply a further permanent green glaze to the cabbage. Finally, apply a glaze of ultramarine blue and madder lacquer to the plums.

At this point you should begin the work of saturating the surfaces with thicker paint. With the addition of a medium designed to slow the process down, the paint will require a longer drying period, which will allow you to work on the reliefs with a mix of colors, using brushes that slide over, brush, and score the surface, as in oil paintings. In this way you can shape your subject matter and bring it into relief. But even this is not quite enough, for the aim is not so much to make the cabbage and plums into photographic copies of what they are, but rather to imbue them with real chromatic depth. The result may not spark a revolution in the history of art, but it will certainly free you from the toils of showy or slavish realism.
All the technical problems associated with the use of oil paint can be discounted thanks to the ability of polymeric binders to superimpose without causing harm to the other materials you have mixed together.
The work in this instance has been done with the following: titanium white, yellow ochre, red ochre, cadmium red, raw and burnt sienna, pale madder lacquer, ultramarine blue, and cobalt blue, all mixed with an acrylic drying retardant.

An acrylic thickening medium (gel) is applied to the cabbage with thick swirling brushstrokes. As it dries, the freshly painted, milky white jelly becomes transparent on the surfaces you wish to skim; the time of drying depends on the temperature of the room, but you should allow at least three hours. (A hairdryer will speed things up if need be.) Next, apply a glaze of burnt umber and madder lacquer, which will cling to the curves of the reliefs and provoke accidents of light and dark to give the cabbage leaves their curly aspect. Using a fine dry brush, highlight the reliefs by gently dabbing with a light mixture of titanium white and permanent green and yellow ochre. The base should be covered with a glaze and warmed by the presence of those lovely twin sisters of the artist's palette: raw sienna and burnt sienna.

Lastly, using a flat brush, cover the whole surface with a matte or shiny varnish; the latter will make your picture look for all the world like an oil painting.

Pencil study of plums

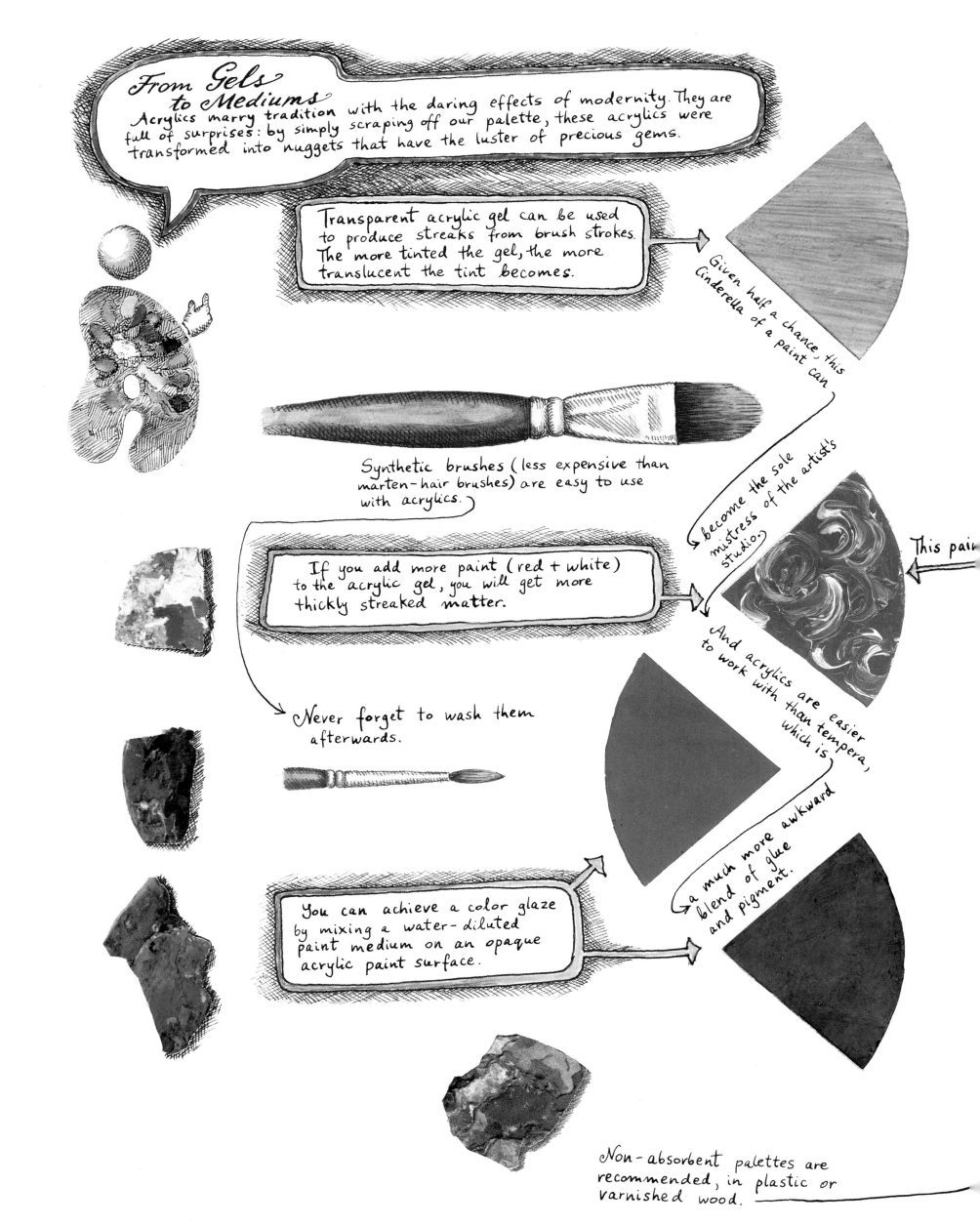

From Gels to Mediums

Acrylics marry tradition with the daring effects of modernity. They are full of surprises: by simply scraping off our palette, these acrylics were transformed into nuggets that have the luster of precious gems.

Transparent acrylic gel can be used to produce streaks from brush strokes. The more tinted the gel, the more translucent the tint becomes.

Given half a chance, this Cinderella of a paint can become the sole mistress of the artist's studio.

Synthetic brushes (less expensive than marten-hair brushes) are easy to use with acrylics.

If you add more paint (red + white) to the acrylic gel, you will get more thickly streaked matter.

This pai

And acrylics are easier to work with than tempera, which is a much more awkward blend of glue and pigment.

Never forget to wash them afterwards.

You can achieve a color glaze by mixing a water-diluted paint medium on an opaque acrylic paint surface.

Non-absorbent palettes are recommended, in plastic or varnished wood.

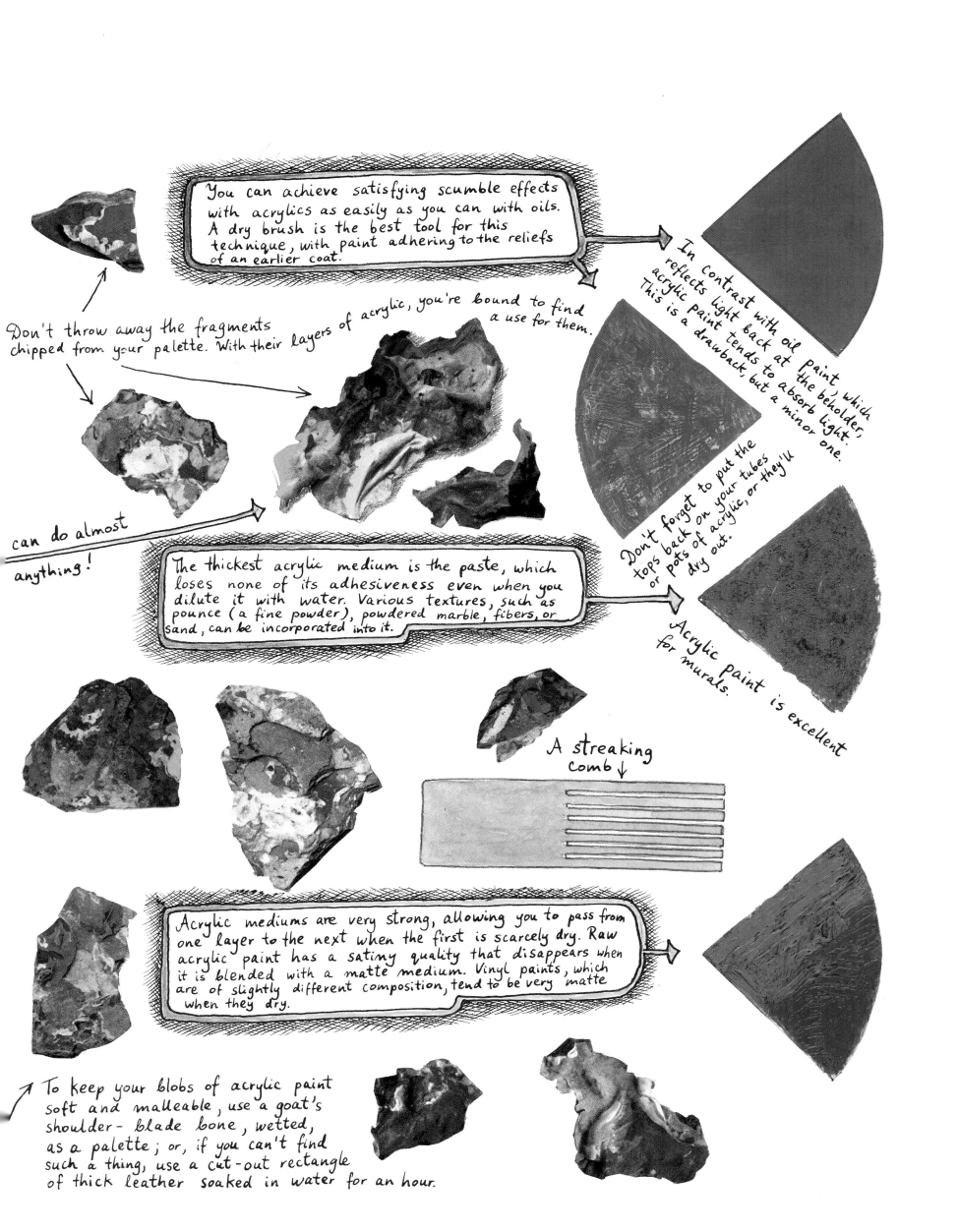

You can achieve satisfying scumble effects with acrylics as easily as you can with oils. A dry brush is the best tool for this technique, with paint adhering to the reliefs of an earlier coat.

Don't throw away the fragments chipped from your palette. With their layers of acrylic, you're bound to find a use for them.

can do almost anything!

In contrast with oil paint, which reflects light back at the beholder, acrylic paint tends to absorb light. This is a drawback, but a minor one.

Don't forget to put the tops back on your tubes or pots of acrylic, or they'll dry out.

The thickest acrylic medium is the paste, which loses none of its adhesiveness even when you dilute it with water. Various textures, such as pounce (a fine powder), powdered marble, fibers, or sand, can be incorporated into it.

Acrylic paint is excellent for murals.

A streaking comb ↓

Acrylic mediums are very strong, allowing you to pass from one layer to the next when the first is scarcely dry. Raw acrylic paint has a satiny quality that disappears when it is blended with a matte medium. Vinyl paints, which are of slightly different composition, tend to be very matte when they dry.

To keep your blobs of acrylic paint soft and malleable, use a goat's shoulder-blade bone, wetted, as a palette; or, if you can't find such a thing, use a cut-out rectangle of thick leather soaked in water for an hour.

The Revelations of Rubbing

Since the star qualities of acrylics are, among other things, solidity and quick drying, they are particularly suited to the superimposition of colored layers that can be sand-rubbed, or "pounced" afterwards. The rubbing process reveals buried colors in an uneven way, producing effects that are partly intended and partly the result of pure chance. This technique has been used in the still lifes shown here. Because acrylic medium also acts as a glue, you can incorporate whatever materials you like into it and obtain firmly affixed collages; for example, the ancient Chinese eggshell technique offers mysterious, shimmering effects.

1) Break your egg. 2) Drop the eggshell in boiling water for ten minutes. 3) Remove the caul on the inside of the shell. 4) Using an acrylic medium, glue over the drawing you plan to cover in shell fragments. The drawing should be placed on a wooden support that has received eight layers of gesso and has subsequently been rubbed (a technique best suited to flat surfaces). 5) Take your eggshell, place it round side down on your freshly glued support, and push it with your thumb. It will shatter into fragments. Then crush the whole thing with a flat piece of wood and leave to dry. 6) Cut or crush away the edges with a cutter to remove all overlapping fragments. 7) Lay on at least five coats of acrylic paint over the shell surface. 8) After it has dried take a small block of rubber or wood, wrap waterproof abrasive paper around it (number 220), and rub the surface until the eggshell fragments reappear. Each one of them will have formed a tiny trough in which the paint is lodged. You can modify the effects as you wish by further rubbing.

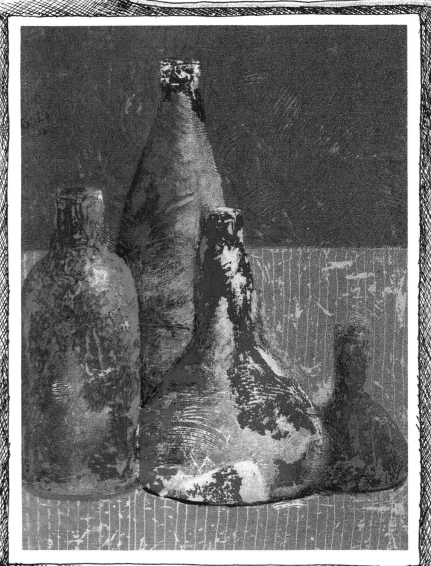

Still Life no. 1

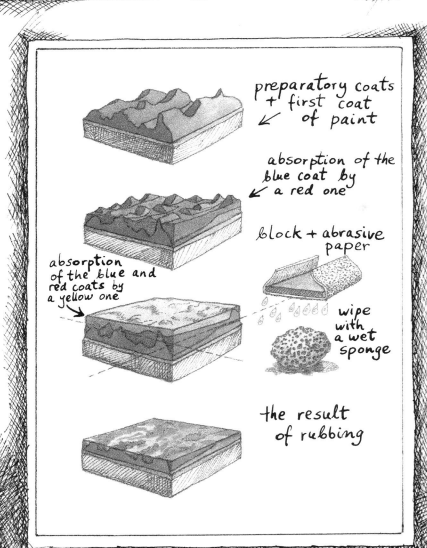

preparatory coats + first coat of paint

absorption of the blue coat by a red one

absorption of the blue and red coats by a yellow one

block + abrasive paper

wipe with a wet sponge

the result of rubbing

Rubbing technique: 1) When the coats of paint are completely dry and hard, dip a sheet of sandpaper (no. 220) in water, cut out a rectangle to fit around your block, and rub with a circular motion, wiping off the painting regularly with a sponge so you can see the effects you are creating. Rub very carefully, keeping a watchful eye on what appears. When the result is reasonably close to what you hoped for, finish off the work with a no. 400 sheet of sandpaper.

This is an introduction to the skill of laying on colored materials that remain prominent when dry, and that are then buried under paint and uncovered again by rubbing with sandpaper. This technique is similar to certain ways of handling Chinese lacquer, with the difference that acrylic paint is used instead of the resinous gums used in Asiatic painting.

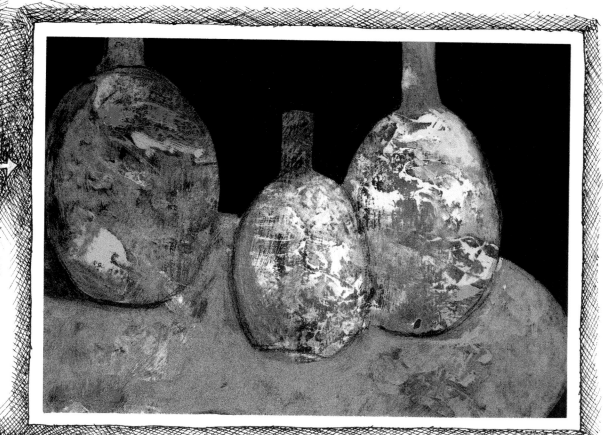

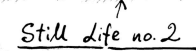

Still Life no. 2

Still Life no. 3
Marina Kamena, 1999

acrylhyper

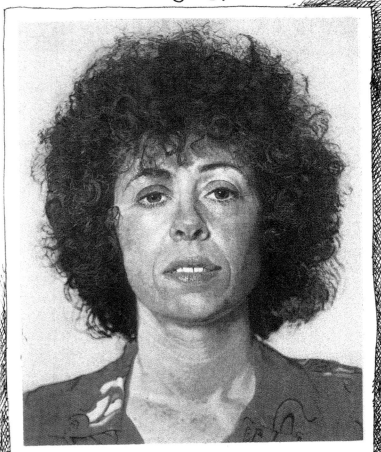

Chuck Close, <u>Linda</u>, 1975-76
acrylic on canvas
7 ft. × 9 ft.

Acrylanguage

acrylyrical
acrylinear
acrylhyper
acryabstract
acrylabyrinth
acryliberty
acrylight
acrylaquer
acrylexicon
acrideal
acrylimit
acrymania
acryllusion
acrymagine
acrymediate
acrymobile
acryrony

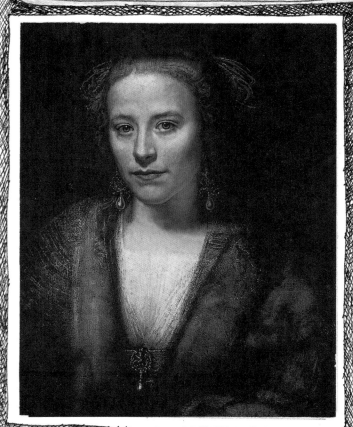

acryllusion
Rembrandt + Marina Kamena and Serge Clément
Portrait (2 ft. 6" × 3 ft.) of the actress Romaine
Bohringer as Hendrickje Stoffels, for the film
<u>Rembrandt</u>, directed by Charles Matton
acrylic paint under oily varnish

acrylabstract

Larry Poons, <u>In Here</u>, 1975
8 ft. × 6 ft. 6"

If all acrylics were to vanish tomorrow from our studios, we would be just as lost as we are when the power company cuts our electricity. We are indebted to acrylics for a large number of small, practical gestures that carry no risk of accident. They have been around for only fifty years and already their company is so familiar and automatic to us that we forget the services they have rendered. Under every possible circumstance, acrylic grounds, impastos, glazes, washes, and varnishes can be brushed, scraped, rubbed, projected, and pulverized as much as we like, and their drying time is not only unbelievably fast but also highly controllable.

In acrylics, the humblest of artists finds a vehicle of the highest quality that can spare him a long and sometimes discouraging apprenticeship. The painter's personality will do the rest—that which must be learned alone, for it cannot be taught by anyone else.

The works on this page demonstrate the wonderful adaptability of this medium, which was highly controversial when it first appeared. All objections are now forgotten. Any act of painting is always a pleasure, and painting with acrylics is no exception.

acrylabyrinth

Friedensreich Hundertwasser,
The Great Way, 1955
5 ft. ¼" × 5 ft. ¼"

acrylyrical

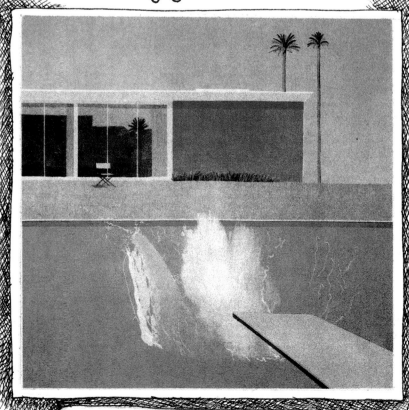

David Hockney,
A Bigger Splash, 1967

acrylinear
Richard Diebenkorn,
Untitled, 1986
Knoedler and Co, Inc., New York
paper and acrylics on paper

Organizing Space

Reality is trompe l'oeil

In his book The Lives of the Artists, Giorgio Vasari reports: "Long before the technique of cartoon composition was introduced, artists habitually set up clay models on a base, positioning small figures to observe the projections, or, more precisely, the shadows cast by them when they were lit from one side. These were the equivalent of the shadows produced by the sun on the ground, only they showed more clearly when produced by artificial light."

In this way painters would construct complete scenes with figurines, shadows and all. Clay was not the only material used: some figures were in wood (figuretti di legname) and some were articulated (manichini). These figures had been used since antiquity and were fixtures in the studios of such artists as Mantegna, Leonardo, Titian, and Veronese, to name only four examples. We learn more about them from the descriptions of Joachim von Sandrart, Giovanni Pietro Bellori, and Georges de la Tour, all of whom wrote about the studios of Nicolas Poussin. Their accounts suggest that Poussin began by installing mannequins on a plank in natural-looking poses, fixing them firmly in place with wooden dowels and dressing them in fine paper or delicate taffeta to imitate real clothing. A box fitted with windows that opened to admit the illumination of a candle and "provide all the light and half-light required for his design" was placed over the finished scene. A panel with a hole in it was placed in the front of the box so the painter could squint into his tiny theatre with one eye to study the figures that would later fill his composition.

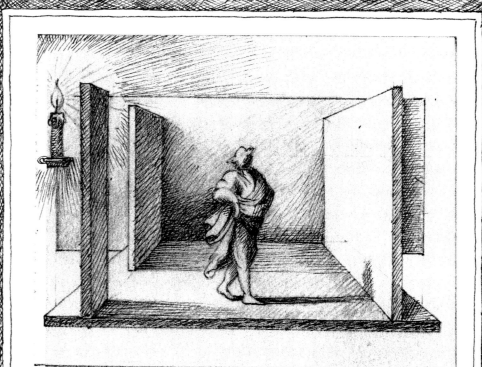

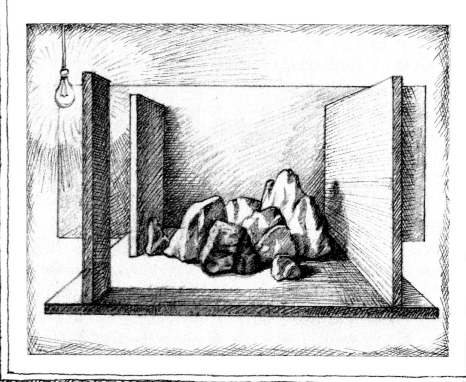

In imitation of the masters we will set up a modest installation, using not figurines but random stones, whose reliefs will catch the light. First, find a sheet of the type of pasteboard architects use for their mock-up buildings, a cutting blade, a flat metal ruler, and a tube of polystyrene glue. Cut a rectangle approximately 12 × 15 inches out of the pasteboard to use as a base. Stick on a background piece and close off the space with a single sheet on one side and two separate panels on the other, as in the pictures above, so the light can stream in from one side. Pile up your stones and pebbles inside as you would for a still life - of course, what you are constructing is exactly that - and light them with a candle from the outside. Then install yourself as comfortably as possible to draw what you see in the box. You could call it "study of stones for a landscape."

✳ "I learned from my master Giotto this method for painting landscapes. Take a stone with asperities in sufficient quantity to allow light and shadow to stand out. Then take two sheets of paper of identical dimensions and draw the stone exactly the same on both, and in the same place, with all its details and reliefs. In one of the two drawings, draw a human foot of ample size close to the stone, or on the same scale as when you found it on the road.

"Now, in the second drawing, trace curved lines from the base of the stone to evoke valleys and meadows. From the hollow of one of these, bring out a little house and tiny trees and a lake and in the distance, hills. Behold, your stone has become a mountain."

This manner of playing with the scales of elements and objects enlightens us about the landscapes in which the figures of the quattrocento moved. Just as it may be said that life imitates literature, so may nature imitate painting – for, ever since artists painted the world as they saw it, so our eyes perceive in gardens and landscapes the visions of Giotto, Gozzoli, Mantegna, Brueghel, Rousseau, and a hundred others. This marriage of eye and mind is the most salutary of illusions, and the closer this illusion is to likeness, the more it will be too beautiful to be true. Indeed, such is the role of narrative painting, which brings reality into play in order to create illusion; and it is to illusion that the art of exposing the mystery of the visible invariably returns. To look upon the apparent reality of the world is to be duped and dumbfounded. Reality is a trompe l'oeil that stems from our manner of seeing.

Painting creates illusions that don't so much deny reality as readjust it using the alchemy of the artist who is making the image. From Lascaux to Picasso, there have been as many realities as there have been painters.

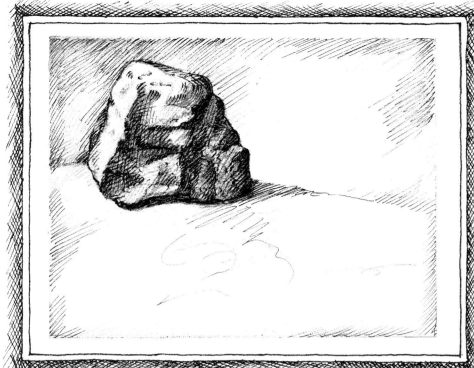

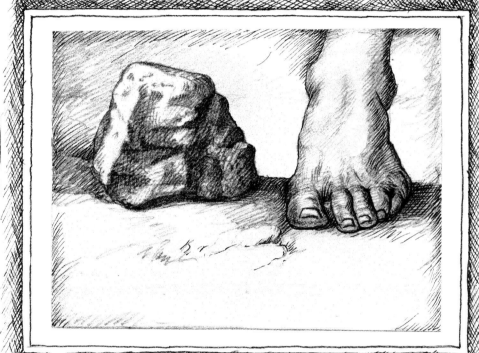

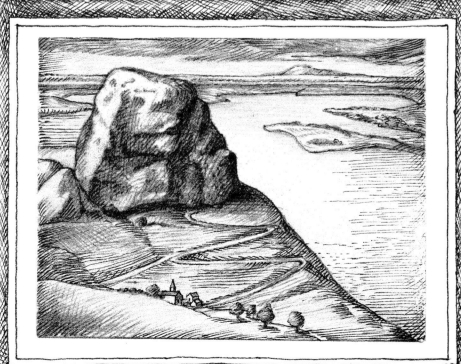

✳ This quotation, loosely rendered in its form though not in its meaning, is taken from a very old book found by a cultivated man in one of those short-lived markets of odds and ends that spring up occasionally in the old fortifications along the outlying boulevards of Paris. The book was printed in Latin and illustrated with woodcuts. Its binding was in tatters and it lay there in the pouring rain amid a grimy tangle of belt buckles and gas lamps.

We came across the cultivated man and the book he had found during the 1960s. Both have now passed out of our lives. We think the author of this precious volume might have been Oderigi d'Agobbio, who was intimately connected with Giotto, but that is only a guess. Many other artists were also associated with the great Tuscan, who in his own lifetime was recognized as the inventor of modern painting. D'Agobbio, who had worked as a manuscript illuminator, might easily have used this approach to landscape painting.

I will swap you the appearance of a stone for the illusion of a mountain

When he painted the frescoes of the Palazzo Medici in Florence, Benozzo Gozzoli fully intended that the landscape surrounding his three kings be recognizable as the Tuscan countryside. Five centuries later you still can't mistake that landscape, which is scrupulously recorded in every detail despite its overall "invented" look. In particular, what looks like a stone integrated into arrangements of villages, crops, fields, and hedges offers the illusion of a small mountain. This Gozzoli landscape is often used to represent the typical Tuscan "bel paese."

"Le Douanier" Rousseau

Henri Rousseau — nicknamed "Le Douanier" (which means "customs officer" in French) because of his job with the toll-service in Paris — often borrowed images of animals from the pages of cheap catalogues and enlarged the leaves of his irises and other plants in his vegetable garden to contrive his own exotic tropical forest. If you look very closely at your pot of geraniums, or at the small tuft of moss attached to your window box, you also may see in them a strange and wild jungle.

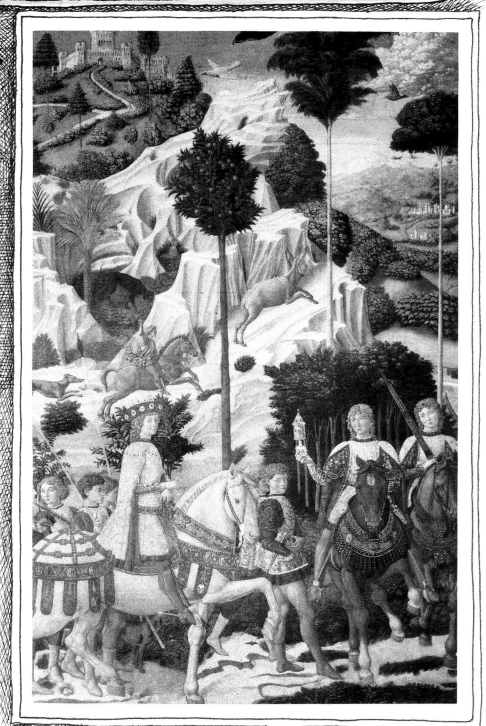

Henri Rousseau
(1844-1910)
The Snake Charmer (detail)

Benozzo Gozzoli (1420-1497)
Journey of the Magi (detail from the fresco in the Palazzo Medici, Florence), c. 1461

Andrea Mantegna had a studio in Mantua where he employed several pupils and assistants. He did designs for tapestries, theater sets, and even table settings; he executed portraits and engravings, painted pictures for several churches in the town, and argued constantly with his colleagues and his neighbors. Marchese Ludovico II Gonzaga and his sons Federico and Francesco patiently supported the authoritarian, coarse, and arrogant character of their court painter, rewarding him for his work with gifts of money and goods and with favors indicating their admiration for his talent. He died on September 13, 1506, from a fit of apoplexy.

Andrea Mantegna (1431-1506)
The Olive Garden, 1460

Pieter Breughel the elder (1525/30-1569)
The Road to Calvary, 1564

As a young painter, Pieter Breughel began by making copies of pictures by Hieronymus Bosch, earning plenty of money. He then traveled from his native Netherlands to Italy - first Florence, then Rome - where he studied the ceilings of the Sistine Chapel, painted by Michelangelo, and other works in the Vatican. Later he returned to Antwerp, where he lived from 1554 to 1556, before moving to Brussels where he completed this painting.

"Light your objects according to your own sun → — not according to the sun you see in nature. Be the rainbow's follower, not its slave." —Diderot

A few rules for painting landscapes of the imagination

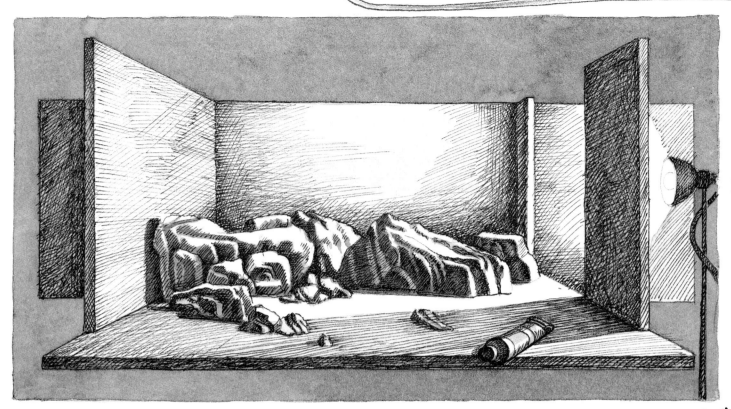

Figure 1

Painting i
that thing

with
this

direction of the light

skyline →
distance →

← background

← subject

← a bird's eye view of the foreground

As shown on the preceding page, we have cobbled together a box with stones and pebbles inside it (figure 1). We have brought home stones from the seashore and rocks from the road. By drawing them before we paint them, we intend to make a mountain out of a molehill.

We went forth with nothing and now our pockets are filled with Andean Cordilleras, the Rocky Mountains, and the Alps. Stones are not the only objects that lend themselves to this exercise. For example, the branches and pieces of bark that lie around on the ground under trees can also contribute to our growing stock of private visual material. This source will amply satisfy our need for subject matter that can be ready for any possibility.

This study begins with a summary of an arrangement, which is subsequently transposed into a topographical outline whose elements are linked to one another by the procedures of drawing, which can only be learned by the experience of looking. From 100 yards away, your aunt's bonsai plant could actually be a giant oak. Truth is in the eye of the beholder, as they say. But merely to acknowledge this fact is not enough. We need to take measures so we can truly see better — that is, paint better — for the potential in painting is so great that the span of our lifetimes can not encompass it.

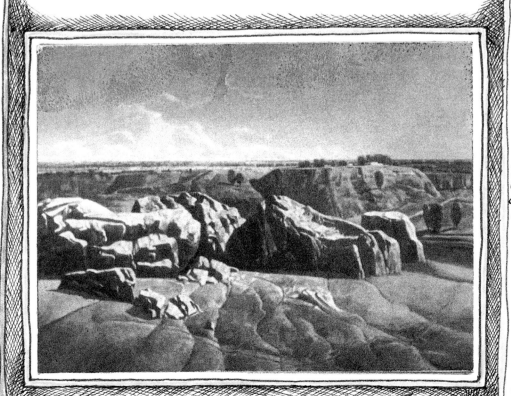

By cutting out an opening in a piece of rigid cardboard, we can place in a frame the elements of a landscape that interests us. Out of the generous chaos of nature, which, from the clouds above to the grass beneath our feet, surrounds us and delights us, we can freeze a tiny part of the giant whole by using this small window. We can see in exact detail the dizzying heights of a skyline or even the weight of the shadow of a tree— these specific features may even come to determine the composition we are planning. Ruysdael, Courbet, Cézanne, and the rest all used this technique too. The device enables you not only to be on the outside looking in, but also to center your scene. In your mind's eye try centering any scene in this primitive TV, looking through it up close enough that you don't see any borders of the image – you will be surprised by the way the various planes read.

in view of the fact that "nature is only beautiful when it imitates the effects of painting."
—Jean Starobinski

by which nature seeks itself

with that

A practical sequence of actions will help.

to begin with, paint the sky

then horizon (pale colors)

then the backgrounds (darker colors)

then the foregrounds (stronger colors)

When all these are in place, add the touches of light and the areas of shade.

In the Netherlands, Joachim Patinir (1480–1524) was the first to give major importance to landscape in Biblical paintings. He painted several pictures with Quinten Metsys (1466–1530), letting Metsys paint the figures. The mountainscapes of the Low Countries are modest, to say the least: in Dutch terms, a field of asparagus is like the Himalayas. The Ardennes were too far from the windows of his Antwerp studio to inspire him; nonetheless, with staggering mastery he managed to create an imaginary landscape illuminated by piety and harmony, where trees escort the viewer from the foreground right out to a blue horizon.

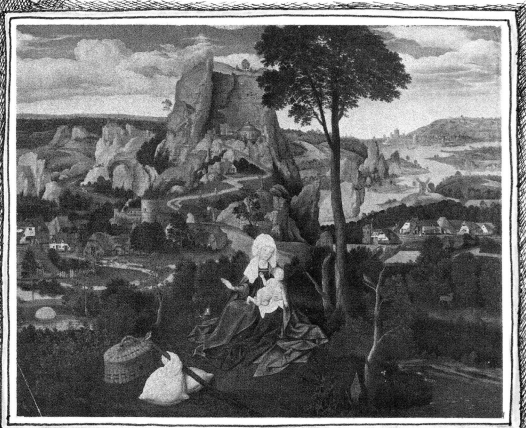

Space in motion

Francisco Goya, The Colossus, c. 1808-12 →

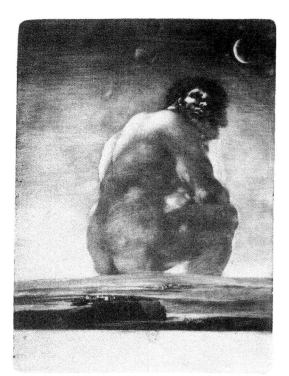

The human imagination can organize any scene exactly as it chooses, and can even contrive the toppling of one space into another. We are like Gulliver, whose travels led him through Jonathan Swift's satire on English society first as a giant, then as a midget, thus enabling the author to describe the world from two opposing points of view. In just the same way, the space with which painters have to grapple is shifting and uncertain – you can find yourself drawing a city over the original outlines of a still life of pots and jars. Moreover, the space can be changed to create dream effects (Goya), drama (King Kong), a Surrealist juggling of objects (Magritte's parody of Jacques-Louis David's famous painting of Mme. Récamier, with the subject replaced by a coffin). Tex Avery even imagined an enormous nightmarish mouse devouring New York.

Visionaries are still throwing the loaded dice of the imagination on the moving walkway of reality, but the famous expression, "no more – the game is over," has been replaced by a radically different one, "It's our turn now." We understand that any magazine illustration is something we can simply alter with a few strokes of a pencil.

René Magritte, La clé de verre, 1933 ↓

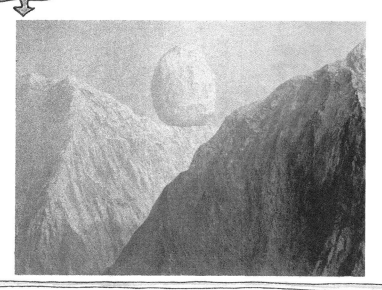

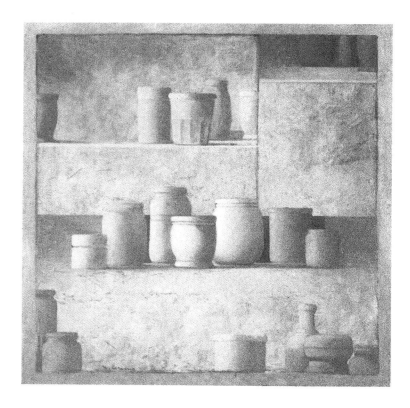

Marina Kamena, Still Life Dispersion, 1989

Serge Clément, City, 2000

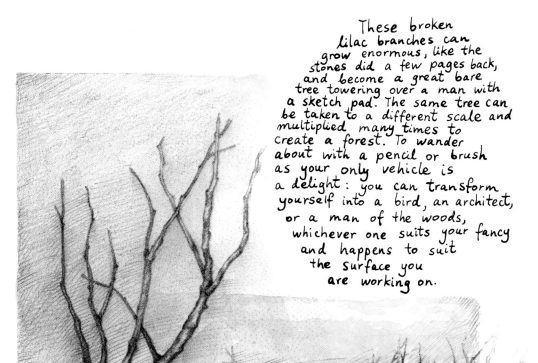

These broken lilac branches can grow enormous, like the stones did a few pages back, and become a great bare tree towering over a man with a sketch pad. The same tree can be taken to a different scale and multiplied many times to create a forest. To wander about with a pencil or brush as your only vehicle is a delight: you can transform yourself into a bird, an architect, or a man of the woods, whichever one suits your fancy and happens to suit the surface you are working on.

Experiment by making a careful study of a twig and then placing it in a virtual, but believable, setting, making its place there readable and seemingly realistic. Studies like this can be drawn, water-colored, or photographed from life.

Detail of a studio background painting by Marina Kamena and Serge Clément

Marina Kamena and Serge Clément, Head of Kong (after the book by Cooper and Schoedsack)

Tex Avery, Mouse, from the animated film The King-Sized Canary, 1947

Oh! It's going to stain...!

Leonardo da Vinci once told an apprentice painter: "Look upon walls with their different hues, and you will see many landscapes thereon, complete with mountains, rivers and hills: there may even be battles, swiftly moving figures, curious expressions upon faces, outlandish costumes and an infinity of other things, which, with your art, you can bring to their completed form.

"Take time," he added, "to observe the ashes of a fire, the clouds in the sky, or the mud beneath your feet. All these will furnish you with excellent ideas."

Pliny viewed the chance circumstances that happen occasionally and that serve to feed an artist's vision as a sign of man's good fortune. A story that comes to us from 2,300 years ago relates how the painter Protogenes, despite his best efforts, found himself unable to represent the appearance of foam dripping from a dog's jaws. In exasperation, he flung a sponge at his obstinate painting—which immediately achieved the exact effect he had been striving for, while at the same time annihilating any claim the picture might have had to genuine artistic merit.

Botticelli had strong views on the value on landscape art, believing it was not worth lingering over this part of a painting, given that if you threw a paint-soaked sponge at a wall the effect could turn out to be similar to that of a beautiful landscape. Vasari noted the eccentricity of Piero di Cosimo, who was fascinated with the curious shapes of clouds... and with the smears left on hospital walls by inmate's spittle. In such things he could see the outlines of fantastic cities, battles, and magnificent landscapes.

Initial stain: "Birds"

← Alexander Cozens (1717-1786)
↓

Thus, it would seem that from the earliest times artists have sought beauty outside conscious creation. The painter or sculptor has always known that any object produced by sheer luck can become a piece of art if he chooses to call it such. By doing this, he becomes its author and, as Roger Caillois has written, its "augmenter." This process began at the cave of Lascaux, where a bump on the cave wall was transformed into an animal flank; it continued through Leonardo da Vinci, Piero di Cosimo and Alexander Cozens, who, in 1760, launched his own method for inventing original landscapes. Cozens thought, by his procedure, to replace nature itself, trusting in his theory that the reading of ink blots on paper could result in genuine representations of things. Joseph Wright of Derby and John Constable studied and copied some of Cozens's sketches. After that, Constable's influence on Delacroix was very great, and Delacroix in turn strongly influenced the Impressionists. So, we don't have to be geniuses to

↑ Study for a landscape, 1785

From "A New Method of Assisting the Invention of Drawing Original Compositions of Landscape"*

* "Ink stains are made by putting blots of ink on paper in such a way as to produce shapes accidentally, without any lines whatsoever, but which suggest to the mind a certain number of ideas."

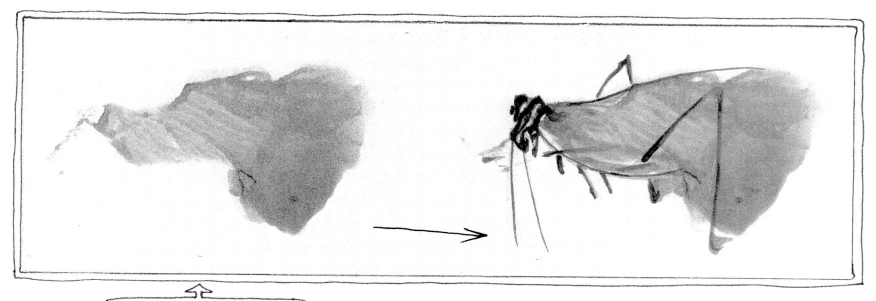

Initial stain

"Grasshopper"

Initial stain

"Putto"

understand that painters don't find their own vision in isolation. On the contrary, they must look for that vision in the tumult of shapes surrounding them, and in the forms delivered by other painters. When, by pure chance, an artist discovers in a humble blotch the basis for a full-blown painting, he will make haste to use it, as he has always used the things of the world; his eyes see what the blotch needs in order for it to become something, just as painters see what the world needs in order for it to become a painting. By the act of painting, the painter fulfils these needs. Whether he is a passive onlooker or an active participant, whether he is removing or adding to his picture, he is always an augmenter – one who defines a resemblance, but in a way that resembles him and no one else.

Initial stain ⟶ "Vincent" ⟶ "The Critic"

A stainless life is not for us

Alberto ↓

The most effective and enriching of all exercises for the painter is the exercise of interpreting blotches and stains. By its very nature, a stain of ink or paint can be compared to the appearance of the world. The fact that a stain has appeared in your field of vision doesn't mean that your eye is going to rest upon it. The same goes for the appearance of the world.

The fact that your eye is actually resting upon this stain doesn't mean, either, that it is being understood or deciphered : you can only say it has been seen. The same goes for the appearance of the world. Only a fool or a pedant will say that he has seen enough to define it in words. The idea is to make the stain itself speak, not to talk about it ourselves. There is an infallible way to learn the language of a stain, and it consists in valuing patience along with curiosity. A stain placed under too much pressure will not give up its secrets as easily as a stain that we merely caress with our eyes. The same, again, goes for the appearance of the world.

When, at last, we are ready to see, we can observe the stain at length from every side. It offers several possibilities. The first is that we read into it shapes from which appearances emerge – this is how the goal of the exercise will be achieved. In the second case, we may find the stain so beautiful, in itself, that we see nothing to add or subtract from it – we ourselves are in a state of aesthetic delight. As Barnett Newman says: "Aesthetics are to painting what ornithology is to birds." We needn't question our preference for the ornamental.

The third possibility is an awkward one, because it may be that we will see nothing on the paper except a common blot. We will be aghast at our own incuriousness, visual torpor, and indifference : we may even fall back on our TVs, whose fleeting images, on which we cannot linger, probably made us sleepy in the first place. TV runs counter to the artist's approach, which is the very opposite of the televisual ethos of : "I want it all and I want it now." The artist's approach is to discover the realities hidden behind visual enigmas, palindromes, and other such pitfalls.

To conclude with blots and stains, let us salute one of their number, which, from the beginning of time, has featured in everything that has ever been looked at – and which is always, always there for us. This blot can be pink, brown, black or amber. It is indistinct and impossible to focus on and it is always located slightly below what our eyes are clearly seeing. It is part and parcel of human vision. It is the human nose.

Once we have attained enough experience as interpreters of blots and stains to decipher their mysteries, and as soon as we know how to look beyond our noses and read the shapes of our own and other people's stains, we shall have undergone an excellent preparation for reading anatomy, landscape, and light. We shall have seen that all things are ringed with a faint but steady halo. Indeed, we will have learned to recognize the appearance of the world.

Flamenco ←

How to make good stains

Take a piece of Bristol white non-absorbent paper. Thin a small quantity of water-diluted vinyl paint, making sure it is opaque, runny, matte, and indelible. When your paint is sufficiently liquid, apply it to your support with a brush, or a dropper, or even directly. 1) Quickly lay a second sheet of paper on top of the first. Press the two sheets together on a flat table using the palm of your hand. 2) Separate the two sheets. 3) After allowing the stain to take, rub it lightly with a damp cloth or sponge. The undried parts will spread in irregular fashion, leaving transparent effects filled with surprises.

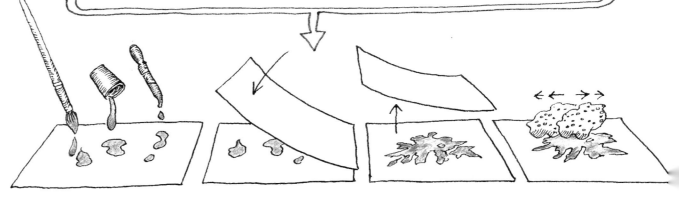

Now it's your turn. Draw over the stains you see here. You may prefer to make several photocopies so you can find several different solutions for each stain.

Perspective, the Point of Escape

Perspective, or the conquest of space

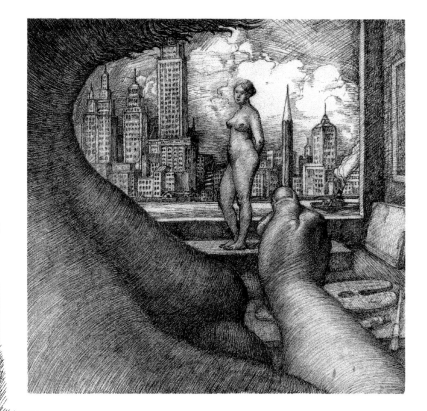

The word "perspective" has several meanings. In general, what we understand by perspective is the art of representing solid objects on a flat surface so as to give them the same appearance as they have in nature when viewed from a given point. For reasons of convenience, we shall compare the space seen by a draftsman to a visual pyramid whose end point is the place at which the draftsman's eyes are located: we shall call this point the eye. To further clarify what we mean by a visual pyramid, imagine the shape of a beam of light shining from a projector in a cinema, which begins at a given point and widens until it strikes the screen. If we were to give form to this beam of light it would resemble something akin to a glass cone or a pyramid.

Now that you have this pyramid clearly visualized, imagine it cut into slices like a cake (figure 1). These slices will have their point of departure at the eye, and from there they will widen toward the distant base of your imagined pyramid. Now, suppose we decide to position the first slice (S) at arm's length, in order to make a drawing. This slice, or panel, is the board or canvas on which we plan to draw what we see (figure 2). To begin with, we determine the center of the board by joining the angles of its quadrilateral with diagonals. The point at which they cross is the center (C) (figure 1). Now, we draw a line from the point between the observer's two eyes, bisecting points C1, C2, and C3. This line might be called the direction of the draftsman's gaze, or the axis of this range of vision.

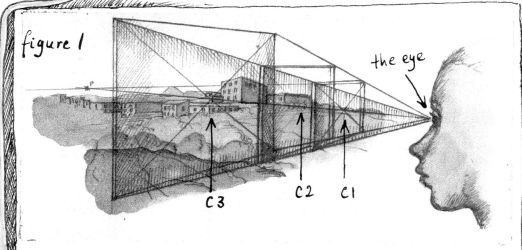

figure 1

the eye

C3 C2 C1

The axis of these panels— which are rectangular, with proportions of four long by three high - explains why it is that we can only look at one part of the space, which ordinarily we would see as a whole, at a single glance (figure 1, figure 2). If we look at an object placed close to our eyes, the base of our visual pyramid is not very broad. But if we look at the stars in the sky it can grow to a width of billions of miles.

The world begins on the surface of our retinas. When we stand on the seashore at the point where the water stops and look at the place where sea and sky meet, we see a line - the horizon, or skyline. Because of the curvature of the earth, which is round, the tangent connecting our eyes to that line is about 3.6 miles long. This is not

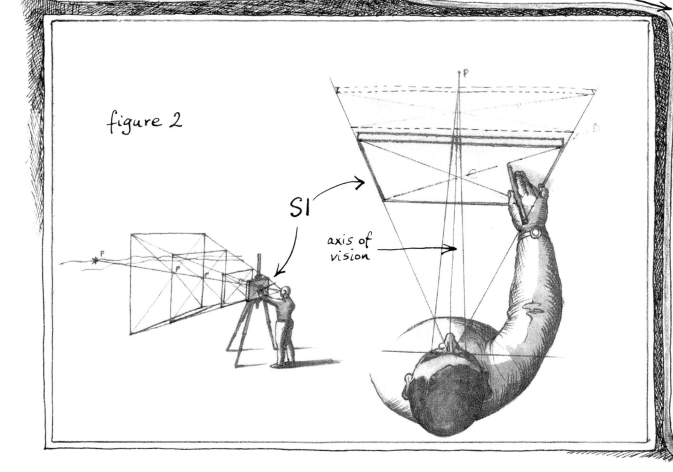

figure 2

S1

axis of vision

P

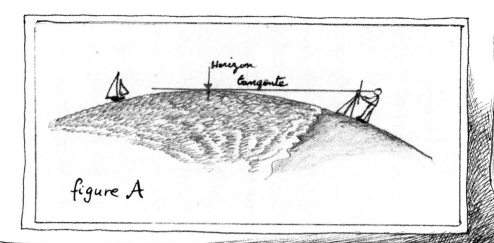

figure A

figure B

figure A

...the limit of the eye's range of perception, but the point at which the curve slopes out of sight. When, for example, a yacht has just sailed straight over this line we can see its masthead for a while longer.

Here we have chosen, as an example, a calm expanse of sea because it represents the ideal surface for demonstrating the principle outlined earlier: but if we were to find ourselves in steep, mountainous terrain, or looking out the window of a room in a city with high-rise buildings, the horizon would be physically impossible to see. There is, however, a very simple procedure for locating it. All you need is a small disc with a hole in the middle (figure B) with a plumb line threaded through. When you hold this apparatus at eye level and adjust it until all you can see of the disc is a flat horizontal, you have the line of the horizon against the image of the place or thing you are observing.

Once the horizon is established we can indicate it with a dot in the center of the canvas - the "vanishing point." This dot is crucially important because it corresponds to the intersection of your line of sight with the horizon. All straight lines parallel to your line of sight converge on it. These lines are called vanishing lines on account of the visual sensation they produce in the eye of the observer (figure C). In the example below the vanishing point is arbitrary.

Elements such as trees, houses, mountains, or clouds, which follow these vanishing lines, become progressively smaller (figure D). This information when transmitted to the brain by the eye, imparts the notion of distance—

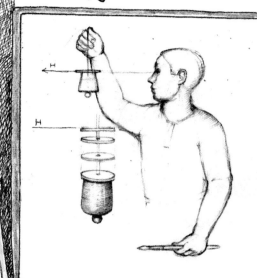

Confronted as it is by all kinds of sights, the brain must interpret what is placed before it by using exactly the same methods as people who imitate, through art, the appearance of the world. The exercise of dividing a landscape into lines or slices, as in figure D, will increase your ability to transform into art that which the methods of perspective have taught you. Remember, though, that your own personal conquest of space will never begin to encompass the inexhaustible imagination of nature.

"Above all, we must educate the eye by giving it reliable ways of correcting its mistakes in matters of distance and foreshortening...

a knowledge of nature born of long experience breeds in painters a certain familiarity with the methods they use for representing what they see." Eugène Delacroix

figure C

vanishing line

vanishing point

vanishing line

figure D

Notions of linear perspective

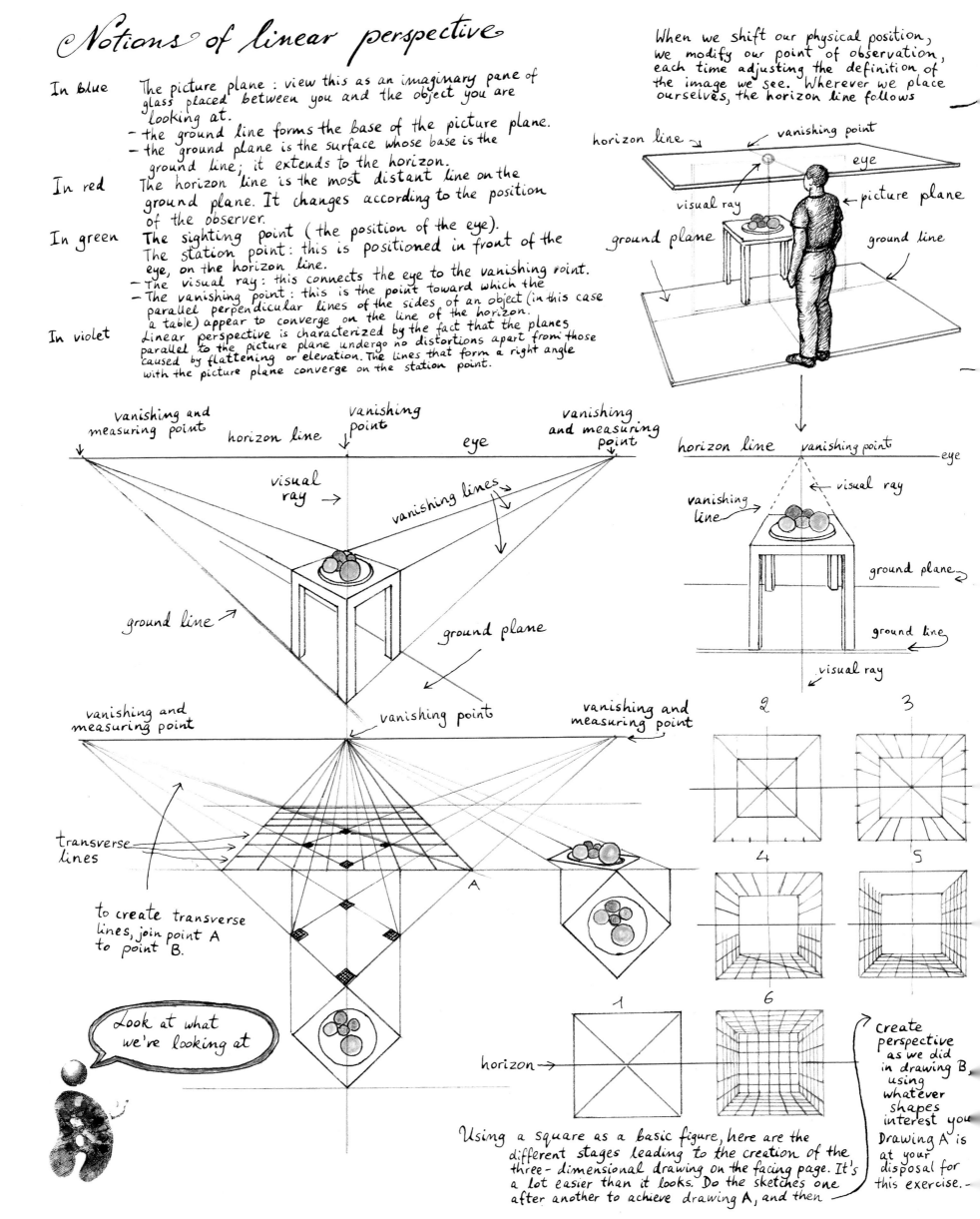

When we shift our physical position, we modify our point of observation, each time adjusting the definition of the image we see. Wherever we place ourselves, the horizon line follows

In blue The picture plane : view this as an imaginary pane of glass placed between you and the object you are looking at.
- the ground line forms the base of the picture plane.
- the ground plane is the surface whose base is the ground line; it extends to the horizon.

In red The horizon line is the most distant line on the ground plane. It changes according to the position of the observer.

In green The sighting point (the position of the eye).
The station point: this is positioned in front of the eye, on the horizon line.
- The visual ray: this connects the eye to the vanishing point.
- The vanishing point: this is the point toward which the parallel perpendicular lines of the sides of an object (in this case a table) appear to converge on the line of the horizon.

In violet Linear perspective is characterized by the fact that the planes parallel to the picture plane undergo no distortions apart from those caused by flattening or elevation. The lines that form a right angle with the picture plane converge on the station point.

horizon line — vanishing point — eye

visual ray — picture plane

ground plane — ground line

vanishing and measuring point — horizon line — Vanishing point — eye — vanishing and measuring point

visual ray → — vanishing lines →

ground line → — ground plane

vanishing and measuring point — vanishing point — vanishing and measuring point

transverse lines

to create transverse lines, join point A to point B.

A

Look at what we're looking at

horizon line — vanishing point — eye

vanishing line — visual ray

ground plane

ground line

visual ray

2 3

4 5

1 6

horizon →

Using a square as a basic figure, here are the different stages leading to the creation of the three-dimensional drawing on the facing page. It's a lot easier than it looks. Do the sketches one after another to achieve drawing A, and then

create perspective as we did in drawing B, using whatever shapes interest you. Drawing A is at your disposal for this exercise.

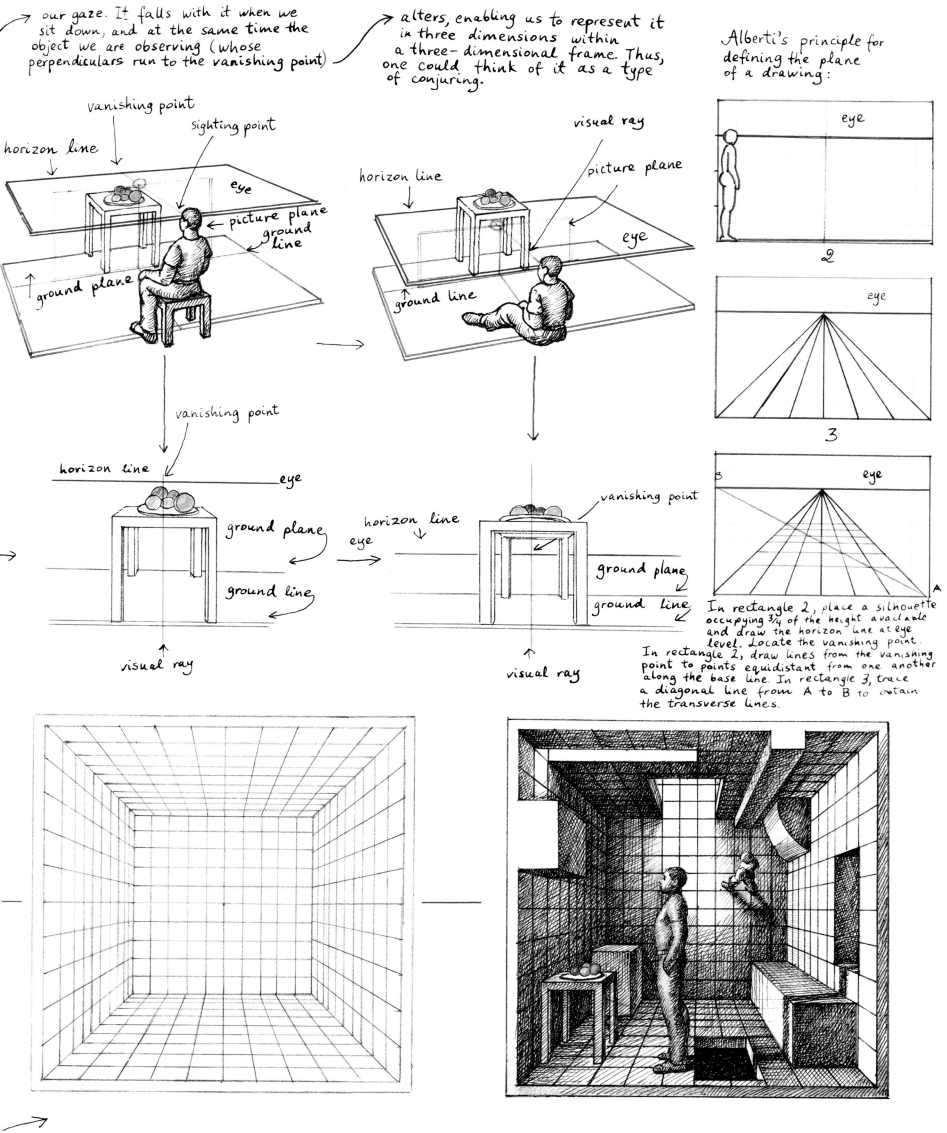

our gaze. It falls with it when we sit down, and at the same time the object we are observing (whose perpendiculars run to the vanishing point)

alters, enabling us to represent it in three dimensions within a three-dimensional frame. Thus, one could think of it as a type of conjuring.

Alberti's principle for defining the plane of a drawing:

vanishing point
sighting point
horizon line
eye
picture plane
ground line
ground plane

visual ray
horizon line
picture plane
eye
ground line

vanishing point
horizon line
eye
ground plane
ground line
visual ray

horizon line
eye
vanishing point
ground plane
ground line
visual ray

eye

2

eye

3

B
eye
A

In rectangle 2, place a silhouette occupying ¾ of the height available and draw the horizon line at eye level. Locate the vanishing point. In rectangle 2, draw lines from the vanishing point to points equidistant from one another along the base line. In rectangle 3, trace a diagonal line from A to B to obtain the transverse lines.

drawing A

drawing B

Distortion and wizardry

Distorted portrait of King Edward VI, 1546
National Portrait Gallery, London →

When you plunge a straight stick into a calm stream, the part of it that is beneath the surface is perceived by your eye as being at an oblique angle to the exact place where the surface meets the stick. The visual aberration is due to a magnifying effect that deforms the visual rays diverted by the prismatic effect of the water. One can see the same phenomenon in the beveled edges of mirrors.

You know very well that your stick is straight, but the stream tells you otherwise. Faced with this conundrum, anyone for whom the problem of appearances is at all important will look for a solution that would make his stick appear quite straight again. His conclusion will be that a correction of the shape of the stick is in order (seeing as sticks have been used for ages as instruments of correction, it is quite right and proper that they should themselves be corrected once in a while). Therefore, it must be bent before it is re-immersed, at which point it will look straight again.

Painters of domes and curved ceilings have always observed → this principle. Their work on the distortions they need to correct is done in advance so that their representations will look believable. In fact, not one but two deliberate distortions are required. The first is due to the foreshortening and flattening effects that are inherent to perspective itself. The second anticipates the aberrations in the images, given the concavity of the support, once they are placed in perspective—this second distortion will distort the first distortion in such a way as to deceive the eye. Another example: when divisions must appear to the observer as being equal, the technique of counter-perspective is brought into play. This is used in cases where the images or elements on a facade need to appear on surfaces of great height, and the observer cannot stand very far back from them. The angle of vision from the point of observation covers a zone that appears longer in proportion to the elevation of his eye.

The lover of ceiling frescoes is no fool—he knows that what he is viewing is an optical illusion. He came to see it because he is willing to be deceived; however, he derives no pleasure from that fact unless he feels he can also appreciate the manner in which the deception has been carried out and can see for himself that the deceiver's art is well done and subtly placed behind the various masks of illusion. Although he is a willing victim, the observer is aware that deceivers fall into different categories. To deceive with the object of making one's work seem spontaneous, to hoodwink in order to appear credible, is part of the game, and we delight in it. But one who tells a lie to conceal something clumsy that does him no credit is not the same as one who tells a lie to open the way to an enchantment that surpasses speech. A liar who performs the latter is, in his own way, a wizard.

A painter of vaulted ceilings anticipating (with iron determination) the projection of a distorted perspective of an image lit by a light placed at the point of his visual ray, thus enabling him to locate the visual distortions that will occur.

Though perspective is viewed as a factor of realism that reconstitutes the third dimension, it also has an aberrant, fantastical element by which its own laws are corrupted. This is called "anamorphosis," which means a distorted optical image. Instead of leading us into a progressive reduction of visible limits, anamorphosis broadens the projection of forms beyond themselves. In other words, drawings and paintings can be distorted in such a way that when they are viewed in cylindrical or even conical mirrors, they reassume their ordinary shapes. Some anamorphoses are revealed by the simple means of bringing your eye close to the surface of the motif and adjusting your position until exactly the right angle is found.

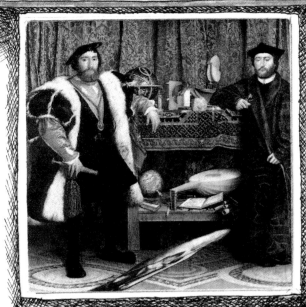

In his beautiful book Anamorphosis Jurgis Boltrusaitis claims that his subject is anything but a technical curiosity: "The very process contains its own poetry of abstraction, its own powerful mechanism for optical illusion, its own philosophy of artificiality. Anamorphosis is a puzzle, a monster, a prodigy... in which accelerated or slowed perspectives sketch the outlines of a natural order without destroying it... anamorphosis is closely linked to the occult, to theories of doubt, to the vanities..."

Hans Holbein, The Ambassadors, 1533

National Gallery, London

In this painting by Holbein anamorphosis is present in the skull that lies between the two sitters, the lute with its broken string, and the timepiece. We are looking at a representation of science, the arts, and doubt - at frequently used metaphors, which, paradoxically, the painter is using to deliver a warning against the arrogance born of possessing the advantages of science and the power of persuasion. The painter even mocks himself and his own claim to power.

I am a computerized anamorphosis of a drawing by Marina Kamena

An exaggerated example of counter-perspective.

Wan Li, 1573-1619
Couple in love →

To comprehend this anamorphosis (and others) take a piece of mirror paper, roll it into a cylinder and place it on end near the subject: at a given point it will reflect a "true" image of the distorted original.

The metaphysics of depth

Vitruvius (25 B.C.) states that in the fourth century B.C. the Greeks Anaxagoras and Democritus cited the phenomenon of rays converging toward a vanishing point to explain the illusion of an image on a wall. Three centuries later, Euclid postulated the idea of straight lines converging on the eye, and in 140 A.D. Ptolemy defined the visual ray. In the year 1000, the Arab scientist Azhalan correlated all the earlier theories and added to them the notion of light rays passing into the eye through the curved surface of the cornea.

But it wasn't until Brunelleschi's treatise on perspective in 1425, followed by the work of Alberti ten years later, that a clear system emerged allowing artists working on a two-dimensional surface to create an illusion of volume within space. Among the first to try out this new system were Paolo Uccello and Piero della Francesca, and a controversy immediately erupted over the real usefulness to artists of a knowledge of perspective.

We ourselves don't see the artist as one who goes about with a compass in his eye, a T-square in his brain, and a ruler in his hand — but, let's face it, knowledge isn't an infectious disease, and there's no shame in being methodical. In fact, there's no reason we can see why possessing information about perspective should prevent one from drawing with feeling. We can steer our own course between the rabble rousers who demand total innocence, and the nostalgists who automatically reject all novelty.

"To each collapse of certainties," says René Char, "the poet responds with a volley of hope." René will not be forgotten. Descartes did not believe in perspective, a system that allows our thoughts to perceive the true shape of things. Nor, as a method, is it vital to the artist. Perspective is no more than a seized moment in the unfolding of information about our world and in the poetic comprehension of space.

Piero della Francesca,
Virgin and Child with Saints,
1456

Piero della Francesca (c. 1416 - 1492) was the greatest Italian master of the second half of the 15th century. A mathematician, geometrician, and pioneer of perspective, he went blind in his old age and found himself unable to publish his writings. After Piero's death, one of his pupils — Fra Luca di Borgo - instead of contributing to the renown of the man who had taught him everything he knew, was mean-spirited enough to publish Piero's work under his own name. But time, as it is said, is the father of truth, and sooner or later uncovers all dishonesty.

Paolo Uccello,
Rout of San Romano, c. 1455

Paolo Uccello (1397 - 1475) was very much a man of his time, in particular because of his passion for geometry. However he was thought hopelessly eccentric by his contemporaries and received very few commissions. Today he is revered as one of the greatest men of the Renaissance. He and his great friend, the mathematician Giovanni Manetti, were fascinated by the studies of Euclid and discussed his theories at length. But Uccello's daring compositions drew more mockery than praise, and in the end he died alone and penniless in the poorhouse.

Jacopo Bellini was the pupil of Gentile da Fabriano and Uccello, working in Verona and Venice. He was one of the principal artisans of the Venetian Renaissance. His two sons, Gentile and Giovanni, with whom he created an altarpiece for the Gattamelata chapel at the Basilica del Santo in Padua, eventually surpassed him in fame and overshadowed his work.

Formerly, marquetry was known to the Italians as "Prospettiva", or "perspective." "In the 15th century, Italian marquetry developed a style of pure urban landscape, which (like that of still life) was always a step or two ahead of painting," wrote André Chastel. Craftsmen in marquetry devised their own scenes in wood, piecing together geometrical patterns with converging vanishing points according to the rules of perspective.

Descartes, Traité de l'homme, part III

"In conclusion, it must be noted that all the ways we have of gauging the distance between ourselves and the objects we observe are uncertain... because the rays coming from their different points are not so exactly assembled, one with another, at the back of the eye. The example of paintings in perspective amply demonstrates how easy it is to make errors in this. All the knowledge I have received up to the present has come to me by the evidence of my senses: and yet I have sometimes found that my senses were deceiving me."

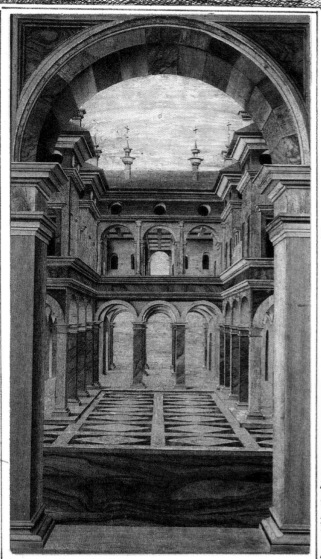

Jacopo Bellini,
c. 1400-1470,
Flagellation by Torchlight
lead pencil on parchment

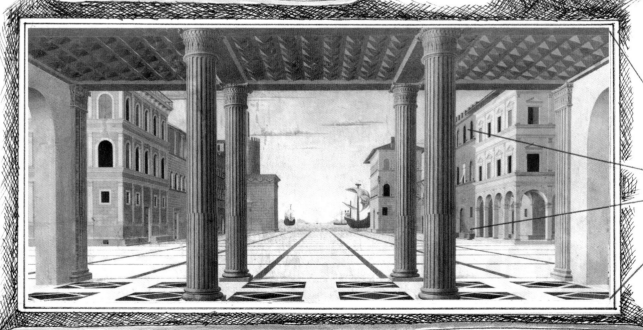

The ideal city, by an anonymous Florentine painter. The picture is at the Staatliche Museum in Berlin. Metaphors of this kind produced a completely new scenography in the genre. The ideal city extends beyond its walls in a blend of realistic and idealized construction.

Vincent Van Gogh,
The Artist's Room at Arles, 1889
↓

Thomas Eakins, Perspective drawing of
The Pair-Oared Shell, 1872

Edward Munch,
Girls on the Jetty, 1918-20
↓

All the paintings on this spread make use of perspective, even the one by Joan Mitchell, which is not constructed on the classic perspective grid. Its title, City Landscape, indicates that its planes are organized to produce a view in the usual landscape style, but the subject happens to be a city. In the examples shown here, perspective, rather than restraining pictorial expression, reinforces it with its lines. This creates

M.C. Escher, Rippled Surface, 1950

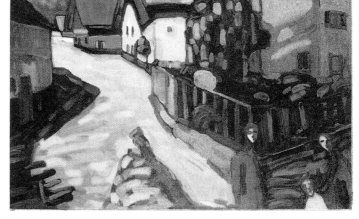

Vasily Kandinsky,
Street in Murnau, 1908

Wilhelm Morgner, Field Path, 1912

Perspectives

Thomas Eakins,
The Pair-Oared Shell, 1872

Gustave Caillebotte,
The Floor Scrapers, 1875

↗ pictorial surfaces on which the brush can break out colors that are sometimes completely pure.

The emotional sensation of perspective doesn't always penetrate the canvas. Views aren't always windows framing a section of the world that stops at the edge of the image. On the contrary, perspective brings the eye back to a place where our vision becomes a kind of gesture, and where our brains and the universe fuse together. In such a place the lines are dream-lines. Their effect is muted in the prosaic views of Hopper and Estes (which, nonetheless, have a troubling quality by virtue of their unearthly exactitude). In a way, it is still deeply satisfying that so much geometrical knowledge can result in a painting such as Girls on the Jetty by Munch or A Street in Murnau by Kandinsky.

James Ensor,
Ostend Rooftops, 1898

Joan Mitchell,
City Landscape, 1955

Edward Hopper,
The City, 1927

Richard Estes,
Café Express, 1975

↘ Probably the greatest gift God has given to man is his priceless understanding that there is no formula for the visible. Van Gogh's bedroom is not an accurate record of the place where the painter took his rest: a photograph of it might have been better for that purpose. But van Gogh himself discovered in his room a place wherein the bed spoke orange, the walls spoke blue, and floor spoke green.

As Rodin said: "The artist tells the truth: it is photographs that lie, because in reality time never stops." Four centuries after the Renaissance, van Gogh, Eakins, Victor Vasarely, and others continue to show us that the concept of depth in art is as fresh as ever. Transfigured by painting and displaying fleeting resemblances born from different artists' impulses, it still has its ability to question things perceived—but never (happily!) quite resolved.

Here is a group of pictures whose common characteristic is that they engage the eye from above - from a bird's eye view. The observer's eye does not fully enter the scene but is kept at a distance. The reason for this can easily be grasped when we realize that the ground has been tilted toward us until it is vertical; indeed, the artist carrying out this maneuver must take measures to stop it from hitting us, metaphorically, full in the face. For this he uses a technique that has the effect of pushing us well away from the surface of the picture.

In this new perception, the foreground, which normally serves as an anchor for the space, is moved farther off. This trick was present in the work of Cézanne, and it emerged fully with the Nabis, the Fauves, and then the Cubists. Its effect was to free the pictorial space in Western realist paintings from the rules established during the Renaissance. The exhibition of Japanese prints held in Paris at the close of the 19th century was largely responsible for this change, which opened up for Bonnard and Matisse (among others) a vision of a world where they were no longer restricted to a single way of seeing things.

We have all heard of the theory whereby the beating of a butterfly's wings in the Amazon jungle starts a chain of events that leads to a hurricane striking North Carolina. The arrival of the Japanese print supplied just such a beating of wings, for it ushered in a whole set of visual alternatives for 20th-century Western painters. For example, the Chinese panel by Wang Meng shown here, Caves in the Forest of Chii Chii, has a certain

Pierre Bonnard, <u>The Garden</u>, 1936
oil on canvas

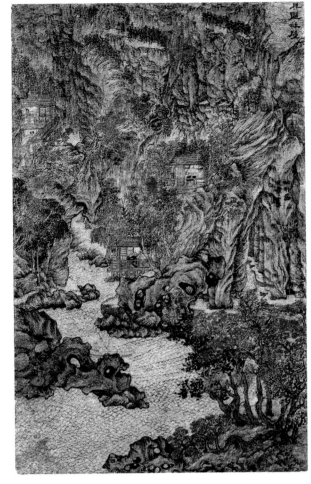

Wang Meng, <u>Caves in the Forest of Chii Chii</u>, 1369

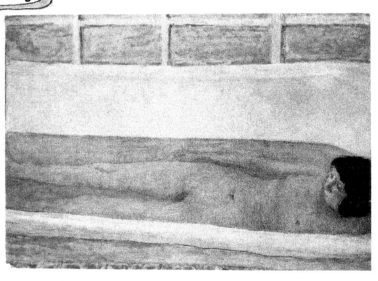

Pierre Bonnard, <u>The Bath</u>, 1925
oil on canvas

Richard Diebenkorn,
<u>Ocean Park no. 67</u>, 1973
oil on canvas

ambiguity to the Western eye because the ground is so ruthlessly tilted to the vertical. There are two ways of doing this: either you raise your panel as if it were on a hinge, or you act like a bird or an aviator and stare downward on the scene. In both cases the picture's elements will assume the aspect that cartographers use to indicate ground reliefs on maps.

Yet this is still not exactly what is happening in Wang's picture, or in Japanese prints. In effect, even though they have been made vertical, elements in them like mountains, rocks, rivers, trees, and houses keep their original profiled aspect.

This is a double reading of the world, in which the notion of depth and a description of nature each have their place. Another approach is calligraphy, which is an ensemble of the poetic, literary, and plastic arts. Japanese prints have their roots in China; we have chosen this particular example merely because we were awed by its beauty. All the same, we do not mean to fix the art of Asia within some kind of reductive codification of its many highly original approaches to relief—far from it.

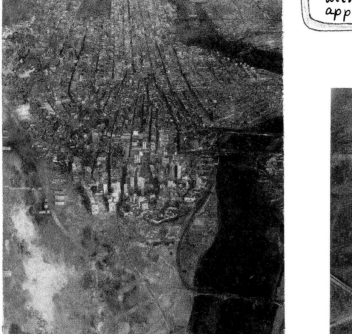

Antonio López García
New York, 1963
oil on canvas

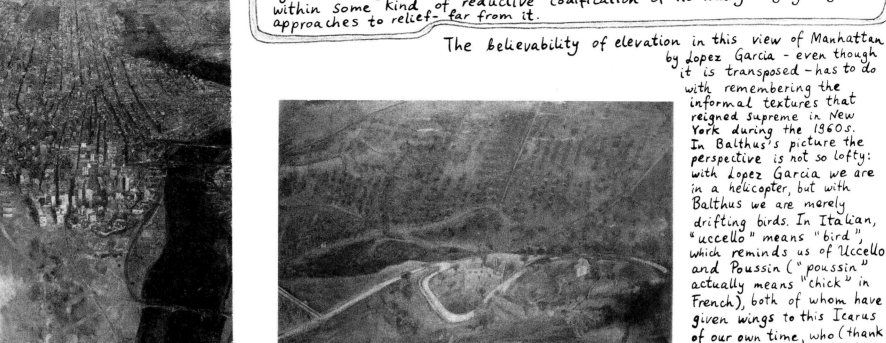

Balthus, Paysage d'Italie, 1951
oil on canvas

The believability of elevation in this view of Manhattan by López García - even though it is transposed - has to do with remembering the informal textures that reigned supreme in New York during the 1960s. In Balthus's picture the perspective is not so lofty: with López García we are in a helicopter, but with Balthus we are merely drifting birds. In Italian, "uccello" means "bird", which reminds us of Uccello and Poussin ("poussin" actually means "chick" in French), both of whom have given wings to this Icarus of our own time, who (thank God) has never allowed his wax to be melted by the hot sun of fashion.

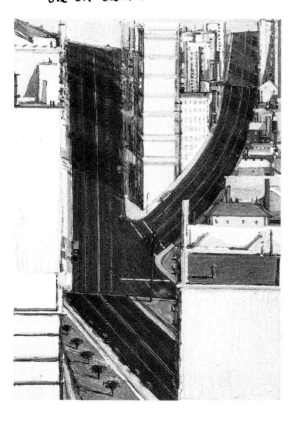

Wayne Thiebaud,
Curved Intersection, 1979
oil on canvas

Maruyama Ōkyo, 1733-1795
Cracks in the Ice, 1780
Fragments of mica sprayed on paper

As a young man, Ōkyo was employed by a toy merchant to do prints and paintings using the Western techniques of perspective and vanishing point. The idea was to combine these tricks with optical devices, such as a mirror and lens, to emphasize the three-dimensional nature of images. In these panels the composition consists of a few cracks in an expanse of ice. Ōkyo makes us understand both the flatness of the surface and its vanishing nature by making his lines fade into the distance—yet, despite his mastery of Western perspective, the work remains fundamentally Japanese in character.

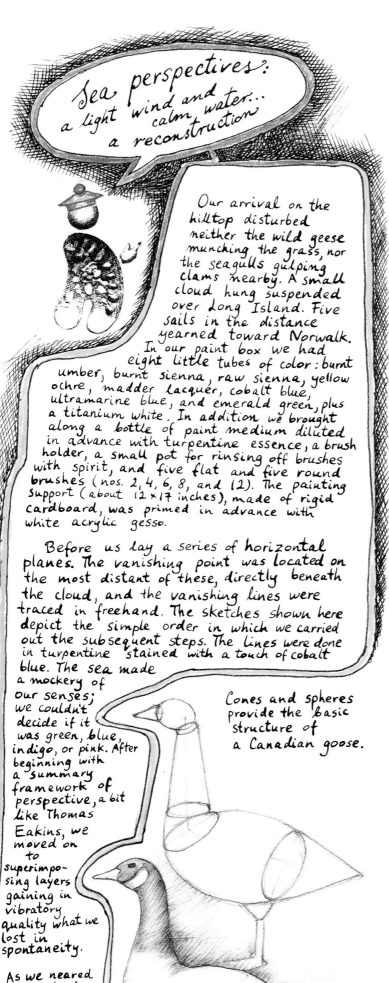

Sea perspectives: a light wind and calm water... a reconstruction

Our arrival on the hilltop disturbed neither the wild geese munching the grass, nor the seagulls gulping clams nearby. A small cloud hung suspended over Long Island. Five sails in the distance yearned toward Norwalk.

In our paint box we had eight little tubes of color: burnt umber, burnt sienna, raw sienna, yellow ochre, madder lacquer, cobalt blue, ultramarine blue, and emerald green, plus a titanium white. In addition we brought along a bottle of paint medium diluted in advance with turpentine essence, a brush holder, a small pot for rinsing off brushes with spirit, and five flat and five round brushes (nos. 2, 4, 6, 8, and 12). The painting support (about 12 × 17 inches), made of rigid cardboard, was primed in advance with white acrylic gesso.

Before us lay a series of horizontal planes. The vanishing point was located on the most distant of these, directly beneath the cloud, and the vanishing lines were traced in freehand. The sketches shown here depict the simple order in which we carried out the subsequent steps. The lines were done in turpentine stained with a touch of cobalt blue. The sea made a mockery of our senses; we couldn't decide if it was green, blue, indigo, or pink. After beginning with a summary framework of perspective, a bit like Thomas Eakins, we moved on to superimposing layers gaining in vibratory quality what we lost in spontaneity.

As we neared the end of our spell of work, a gust of wind plucked the picture away and dumped it in a mess of goose dung and pine needles. The reconstruction you see here is fairly close to what the original was like at the moment this happened – figure 6 with all its details resembles it most closely.

Cones and spheres provide the basic structure of a Canadian goose.

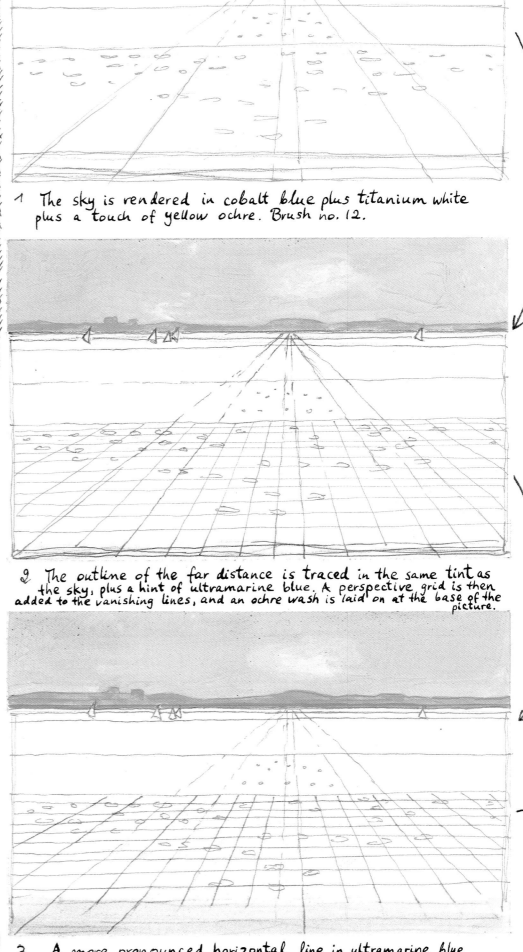

1 The sky is rendered in cobalt blue plus titanium white plus a touch of yellow ochre. Brush no. 12.

2 The outline of the far distance is traced in the same tint as the sky, plus a hint of ultramarine blue. A perspective grid is then added to the vanishing lines, and an ochre wash is laid on at the base of the picture.

3 A more pronounced horizontal line in ultramarine blue emphasizes the zones of distance on the line of the horizon. A very diluted wash of jade green turpentine (emerald green plus yellow ochre) is brushed over the ochre at the base of the landscape.

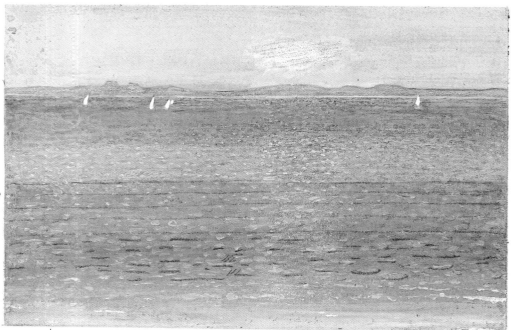

6 The blue dabs are all crowned with a light blue-gray, more tightly bunched under the cloud to depict the reflected light. On the sails: titanium white, thick and pure. Madder lacquer and ochre with medium are added for the sand.

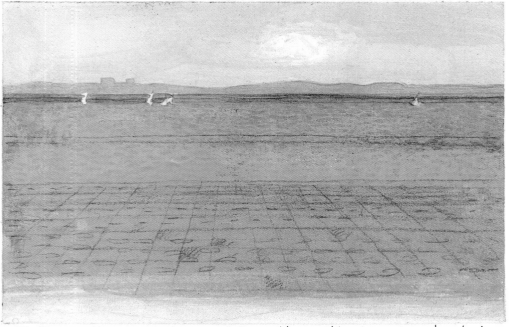

5 The gridlines, which are still partly visible, have been brushed, smoothed, and speckled over with wavy dabs. A pinkish brown now swathes the two lines on the horizon. The brushes used for this operation are much smaller.

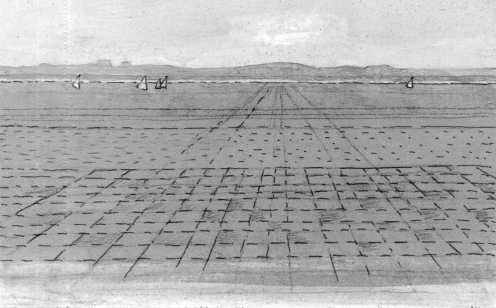

4 A cobalt blue wash diluted in the medium, plus a touch of yellow ochre and titanium white plus madder lacquer, is brushed over the gridlines. The horizontal band holding the center of the picture is cobalt blue plus ultramarine blue plus madder lacquer plus white. The checkerboard is then lightly retraced before being brushed smooth again with a no. 12 brush.

The emerald green is discreetly married to the cobalt blue, then scumbled with a dry brush, then has a yellow ochre applied over it with the same dry brush. It clings to the undercoats, which are quite sticky. (Turpentine essence evaporates rapidly in the open air). Then a light film of madder and ochre is rubbed on the cloud's surface.

By now our approach to this seascape has changed radically. The pane of glass that Dürer habitually placed between his pupil and the subject matter to make the former understand the foreshortening effect of perspective is replaced here - so to speak - by a windscreen. Imagine this: driving a racing car, our eyes apprehend planes that, as soon as they are seen, are broken up, shattered by the speed at which we are traveling. The lines along the sides of the racetrack make it seem as if we are rushing in pursuit of the point of a triangle that we can never reach. Impatient though we are to attain it, the space around us conspires to thwart us. Only a breakdown will stop the reel of film at a given frame. When this happens, our eyes readjust to the fact that the world is made up of lines crossing our path in different directions: these in turn contain singing polygons, hurtling spheres, scented ellipses, and wavelike, shimmering bands. Painters, start up your motors for the exquisite pleasure of turning them off.

This shell, an ear of the deep, whispers to us tales of distant shores, blue tideways, estuaries, river mouths, gulf streams, and Edward Hopper painting people who sit and gaze at the sea.

Within this oyster shell lies the ocean itself cradled in the hollow of mother-of-pearl—the entire ocean. We ate the oysters and they smelled of violets and hazelnuts, as well as the ocean.

By reason of its form and content, landscape painting is often viewed as a vehicle to unite the topographical features of a place with the individual style of the painter. The latter, by a few significant representations of this or that narrative element, is supposed to establish the precedence of one plane over another, so that both may be present. This is suspicious, not least in terms of sentiment. Because the composition is perceived to be made as is a photograph, from the best point of view, landscape painting has been trivialized as a genre.

In 1787 Goethe wrote to Madame de Stein: "Here in Germany we consider landscape painting to be altogether inferior. We seldom give it much thought." However, such great artists over the ages as Nicolas Poussin, John Constable, J. M. W. Turner, Jean-Honoré Fragonard, Caspar David Friedrich, Gustave Courbet, Paul Cézanne, Claude Monet, Edward Hopper, Balthus, Lucien Freud, Anselm Kiefer, Richard Diebenkorn and Wayne Thiebaud felt differently, and they were right. As yet the photographic lens still has not superseded the eye of the painter because (as its French name "l'objectif" indicates), the solitary eye of the lens simply records everything before it. No more and no less.

But the painter of the countryside, with his two thoroughly non-objective eyes, is not a hack who goes off and loses himself in a landscape and comes back with a piece of work barely suitable for the lid of a chocolate box. On the contrary, his eye gradually learns to retain a part of the whole that envelops him—of the space that gleams and vibrates above his head, at the periphery of his vision, behind his back and under his chin. He notes that the least movement of his eyeballs creates further depths in what he sees, more apparitions, more distances, more mysteries. He finds that each new view forces him to take some kind of stand and some kind of risk. Rallied by the pungent smells of moss and mushrooms, he accepts that he must select, simplify, exaggerate, and neutralize in his work; in fact he must have absolute mastery of a space that is no easier to encapsulate than is the air he breathes.

You will need a pad of drawing paper, a box of watercolors, a box of water-soluble color pencils, an eraser, a tube of Chinese white (which we actually never got around to using here), two pencils (HB and 1B), four brushes (nos. 5, 8, 12, 16), a sponge, an empty jam jar and a bottle of water for filling it, a pencil sharpener, a roll of tissue paper,

1. The first step is to choose your subject—everything around us is potentially a paintable image. In this case a hill topped with a grove of trees happened to attract my attention and I immediately roughly sketched it with a pencil, leaving out all details. Here the woods are drawn as geometrical shapes.

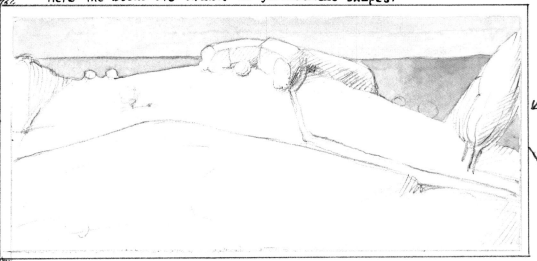

2 A watercolor wash of cerulean yellow defines the sky, while another wash, blueish with a stronger tone, defines the distance. Some hatched areas are added to the initial sketch.

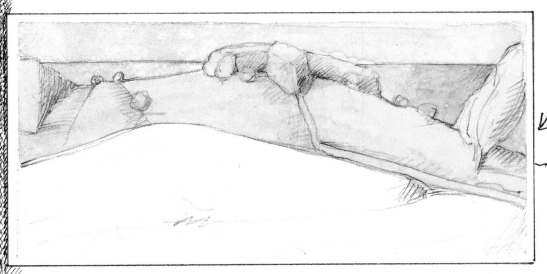

3 Here, a yellow-green wash establishes the notion that there is bright light in this zone, coloring everything that is in full sunshine. At this stage the representation has already begun to speak: three flat washes have been enough to create the stirrings of elegance. In figure 4, the laying on of a cold green in the foreground places the yellow hill in a more distant zone. We, the painters, aren't in the shade merely by chance: it's coolest in the shade, and this first zone is where we have settled to work.

The direction of the light

The hill near Pont-sur-Yonne

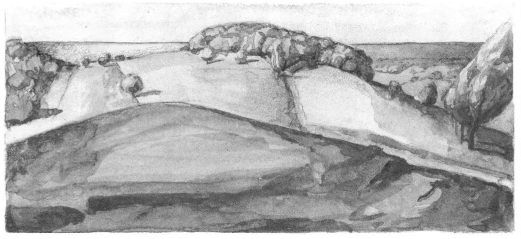

6 Resolutely painted in, the details show rough patches generated by shade, as well as the illumination of various shapes and their supports. Hopefully this page in your sketchbook will be followed by many others that will ultimately turn it into a store of images for future reference.

That day the weather was fine in northern France—so fine that one of us was moved to strip off her clothes and lie naked in the grass, reveling in la vie du champ (without Marcel).

These wildflowers—beloved by Seurat and Klimt—brought sweetness to our walk, scented the air, and dappled the green grass with millions of blue flecks.

5 The arrival of a warm brown tone with a halo of colder green further establishes the notion that we ourselves are in a shaded zone and that beyond it is a hill shimmering in the sunlight.

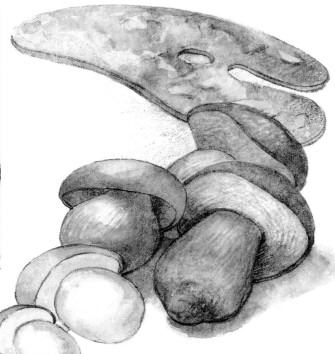

4. We also chose the shade zone because anywhere else the light beating down on our paper made drawing quite impossible—the dazzling glare of the sun is a perennial problem for landscape artists. In this figure, a color pencil supplies a summary rendering of vegetable elements and irregularities in the terrain.

These brown nuggets among fallen leaves posses exactly the kind of rich, earthy tones that attract the special attention of watercolorists, not to mention gourmet lovers of mushrooms.

Morning twilight (with a nod to Baudelaire) in dry pastels

The background of each drawing is uniformly colored gray brown — we see a glimpse of it on the bases of the first three motifs. This gray brown was rubbed on with a stick of pastel, then soaked into the paper using a damp sponge and allowed to dry before work was resumed.

The first coloring the side of the pa set to work in is to have six to color at hand, fr lightest. With pa you have with yo of options. Some many as 1,500.

Vision is more important than technical mastery. Drawing a series teaches us about the potential for change in what seems banal, but actually isn't.
This means that thousands of tiny events, perceived in and of themselves as almost nothing at all, together can become important if we approach them with a little curiosity. And once there is curiosity, technique is redefined as spontaneous skill.

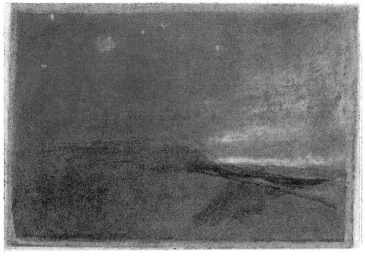

dawn, or morning twilight

dawn

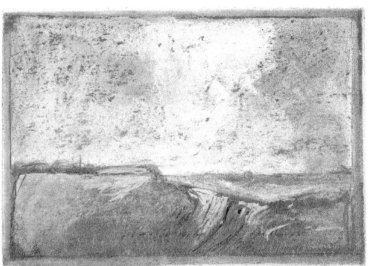

mists and brightness

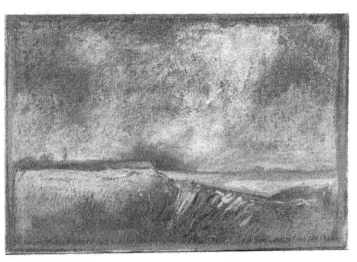

clouds in the distance

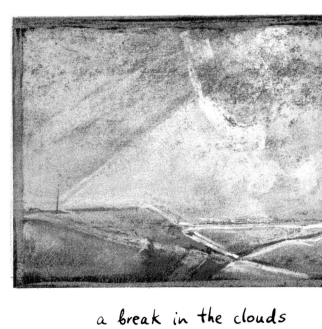

a break in the clouds

day

Each of these phases of the coming of day is drawn from memory: they were completed in the studio and are the fruit of long contemplation. Between each layer of pastel you can apply a very light fixative, which will produce a delicate grainy effect that will help the next

ere laid on with
stick. Before you
st the best policy
t sticks of each
the darkest to the
, the more colors
e greater your range
ufacturers offer as

→ You need a largish table on which
all your boxes can be opened at once
so you can pick out each stick quickly.
Pastels are marvelous for rendering the
tremulous light of early day and other
effects of weather. It is interesting that
terms such as "morning mists, clouds,
early morning," etc. all have

→ technical equivalents in pastels,
in one or several tones. Thus,
they pass from the word that
describes them to the action that
reveals them exactly as such.
Maybe it was this that prompted
Baudelaire to joke that the one
advantage painting had over photography
was that it had to be done by hand.

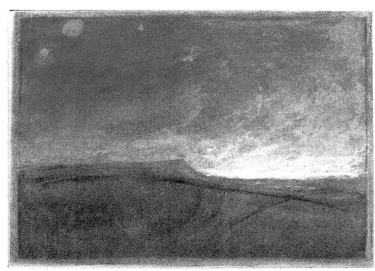

early day

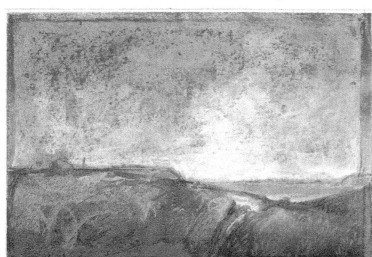

mists rising

rain

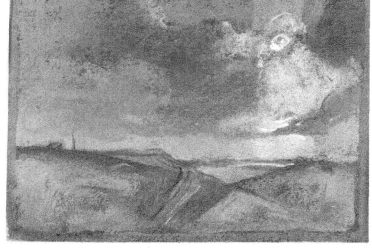

the sunrise

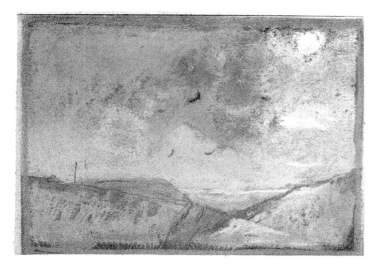

the birds

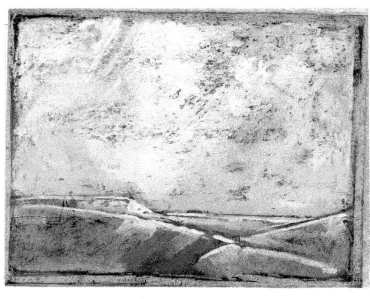

sunshine spreading

full light

pplication to adhere. But too many applications can lead to saturation, which causes
powderiness rather than an appearance of matte velvet, which is what we want from dry
astels. Each rectangle here measures about 6½ inches by 8½. The sequence is taken from
series of sixty done by Serge Clément.

When you set out to paint a subject lit by an unshaded electric light, you are confronted with a problem. The palest color at your disposal for the light source is white, which comes out of the tube looking much too drab to establish anything like the value that exists between clear light and darkness. It follows that if you paint the exact relationship between a bright light and the elements it illuminates, you're going to end up with a painting that is almost black.

This being so, you must use a more inventive strategy, making do with what you have. Starting with pure white as light, you will be surprised as you lay on the other tones when all of a sudden you need to mute the dazzling white tone that a few moments before you found so dull and dreary. This happens because the transposition imposed by the nature of the paint creates equivalents that are completely illusory.

A subtle game ensues, in which you must invent your own rules to resolve in paint this business of what looks light and what looks dark.

In many cases, the light source itself (the sun, a candle, a lamp) is going to be painted into the space along with everything else. De la Tour's work offers wonderful demonstrations of this. And when the light source is not shown, the glimmer of a neck or a breast in a painting filled with shadows poses further problems, such as how their intensity can be made confidential or dazzling, as the case may be. An interesting experiment is to take a small square of matte white paper to a museum and hold it in front of part of a painting that looks white. You will discover that what you thought was white is actually anything but. A patina of age? Not at all. What you are seeing is the effect of glazes or tinted varnishes rubbed or brushed on the surface. They quench the light and give body to the image. Artists as diverse as Titian, Rembrandt, Vermeer, Velázquez, Ribera, Chardin, Watteau, Constable, Turner, Church, and Ryder knew these secrets.

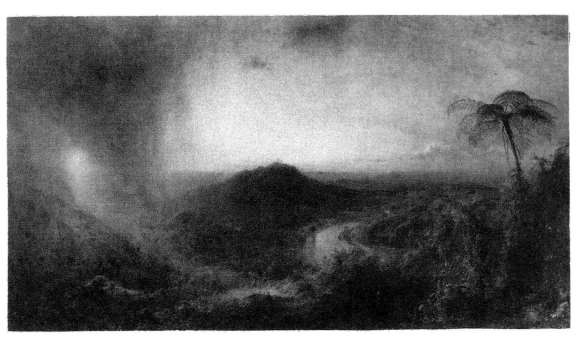

Frederic Edwin Church, Valley of St. Thomas, Jamaica, 1867
oil on canvas

Albert Pinkham Ryder, Moonlit Cove, c. mid-1800s
oil on canvas

Anthony Palliser, Primrose Hill 2, 1999
oil on canvas

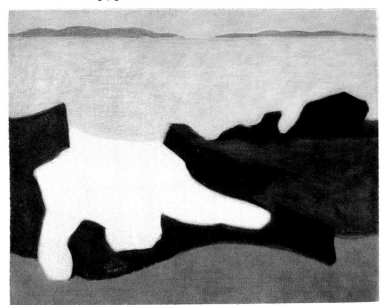

Milton Avery, Sunset, 1952
oil on canvas

Giuseppe Pellizza da Volpedo, <u>The Sun</u>, 1904
oil on canvas

Clément-Kamena, <u>Low Tide</u>, 1999
studiolo of nails and acrylic on wood

Edward Hopper, <u>Railroad Sunset</u>, 1929
oil on canvas

Making
white
off-white

On a base of
titanium
white and
acrylic gel
laid on with
a hard-bristled
brush and left
to dry, paint
a layer of
acrylic raw
umber and
yellow ochre,
both heavily diluted with water. Then rub the
surface with your fingertips.

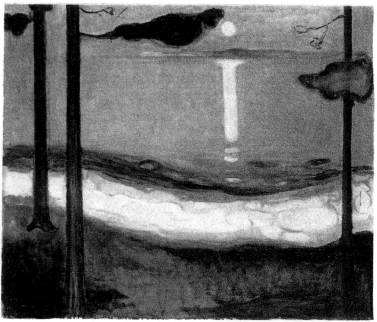

Edvard Munch, <u>Moonlight</u>, 1895
oil on canvas

Ever since Prometheus stole fire from Zeus,
light has been lurking in our paint boxes. It
goes where it can, for without darkness it has no
existence. Certain 20th-century painters went
so far as to cover their whole painting surfaces
with uniform white: no Ying or Yang, just one
or the other. It may be in consequence of this
kind of logic (and other liquidations we could
mention) that modern philosophers are
inclined to call the 20th century the "dark
century."

Anatomy: the crafting of the human body

In the preface of a book on anatomy we read the following: "The body to which we shall refer in this book is assumed to be that of a man in sound physical health." The archetype is defined below, the information we give focuses on certain arbitrary proportions - those of the artist, however, not those of the physician. This is how we propose to begin our anatomical experiment.

Before we can place a tear on a human face, we have to find a surface to put it on- a cheek, perhaps. The cheek is just part of a structure belonging to the assembly of elements called a head. Apart from the defining characteristics of eyes, nose, mouth, hair, and eyebrows, the human head is something that resembles a sphere. To understand it, we must return to the basic forms of cone, cylinder, and cube. Based on these forms, we can create a whole range of shapes that, divided up like building blocks, fit into one another and move together according to the criteria of the human body. Each of these elements is illustrated in different numbered colors to help you identify them and understand why they are placed where they are.

The visual exercise will give you a better overall idea of the effects of perspective on the various parts of the body. Transforming a body part using perspective is easier when you substitute a basic shape for the body part. A sketch of a human figure can be built with these basic shapes just as a tailor builds a man's suit (which is no more than a set of cylinders sewn together with a needle and thread). There is no substantive difference between the assembly of this pipe-body and the drawing of the apple at the beginning of this book, or the drawing of the grapes and the bottle a few pages later.

To begin with we took a thick felt pen and drew conical cylinders all over an anatomical study from the *Istesso gladiatore* - but a magazine photo would have done just as well. This approach makes it easier to understand why shapes look the way they do, and why their elements assume certain perspectives according to their position in a given space.

We should be constantly on the lookout for human shapes to draw- the street, the beach, restaurants and theaters are all wonderful sources of various spontaneous gestures and postures. It's useful later, when drawing, to have these records of the images and scenes you sketched at random. Simple human curiosity is of far more value than any number of encyclopedias and it has provided painters with more ideas for compositions than any art school ever has.

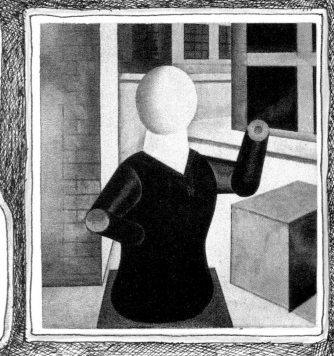

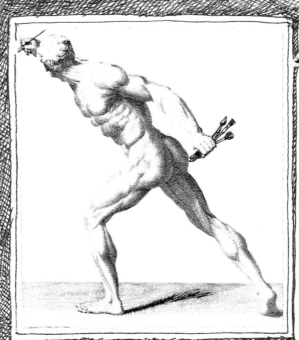

"And we shall study natural movement, and observe it in the streets and squares and in the countryside, noting down the lineaments with short descriptions, for example, for a head make an O, and for an arm a straight line or a bent one, and likewise for the legs and torso. Then when you are at home we shall bring these sketches to perfection..."

Leonardo da Vinci

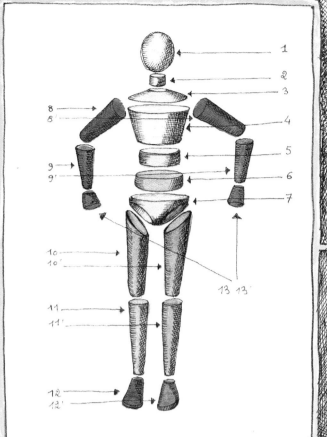

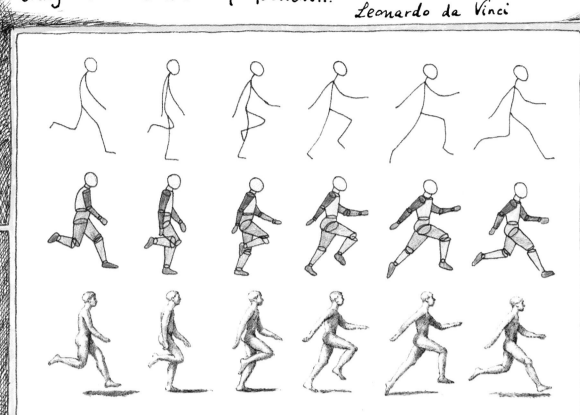

George Grosz, Untitled, 1920

The eye is part of the brain and to train it to interpret the world in this manner, even if you have no sketchbook or pencil handy, is like mental drawing. To think with the eyes is the most bracing sensation – visual curiosity is one of the best remedies for sadness and bad moods. As a novice you have as much of an instinct for this exercise as a great master does, and to bring it into play is to add a mighty arrow to your quiver. The more you play with the faculty, the more benefits and freedoms you will win for yourself and the less likely you will be to turn a living, breathing model into a still life.

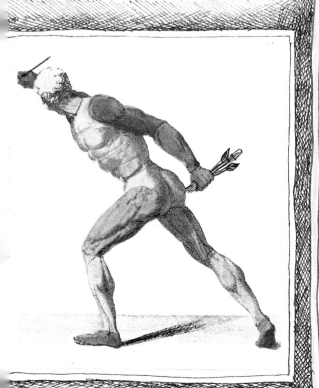

Drawing is not reproducing an object as it is, but as it appears to be. If you become a great artist, you can turn your back on questions of appearances and create a world unto yourself. But in the interval you are well advised to train your eye to observe anatomical perspective, even though you may choose to forget all about it later. It is an exercise to teach you the lesson that in art everything is deception. That which is long seems short, that which is curved seems straight, and vice versa. We are engaged in the making of poetry, and before you can make poetry in paintings you must learn to be objective. You begin with the line, clear and unadorned, and you end with the marvels of Rubens and Titian – "Those were men who hid their art with art, and such a prodigy is a fruit of illusion." This remark by Delacroix bears repeating here.

Giorgio di Chirico, Hector and Andromache 1916

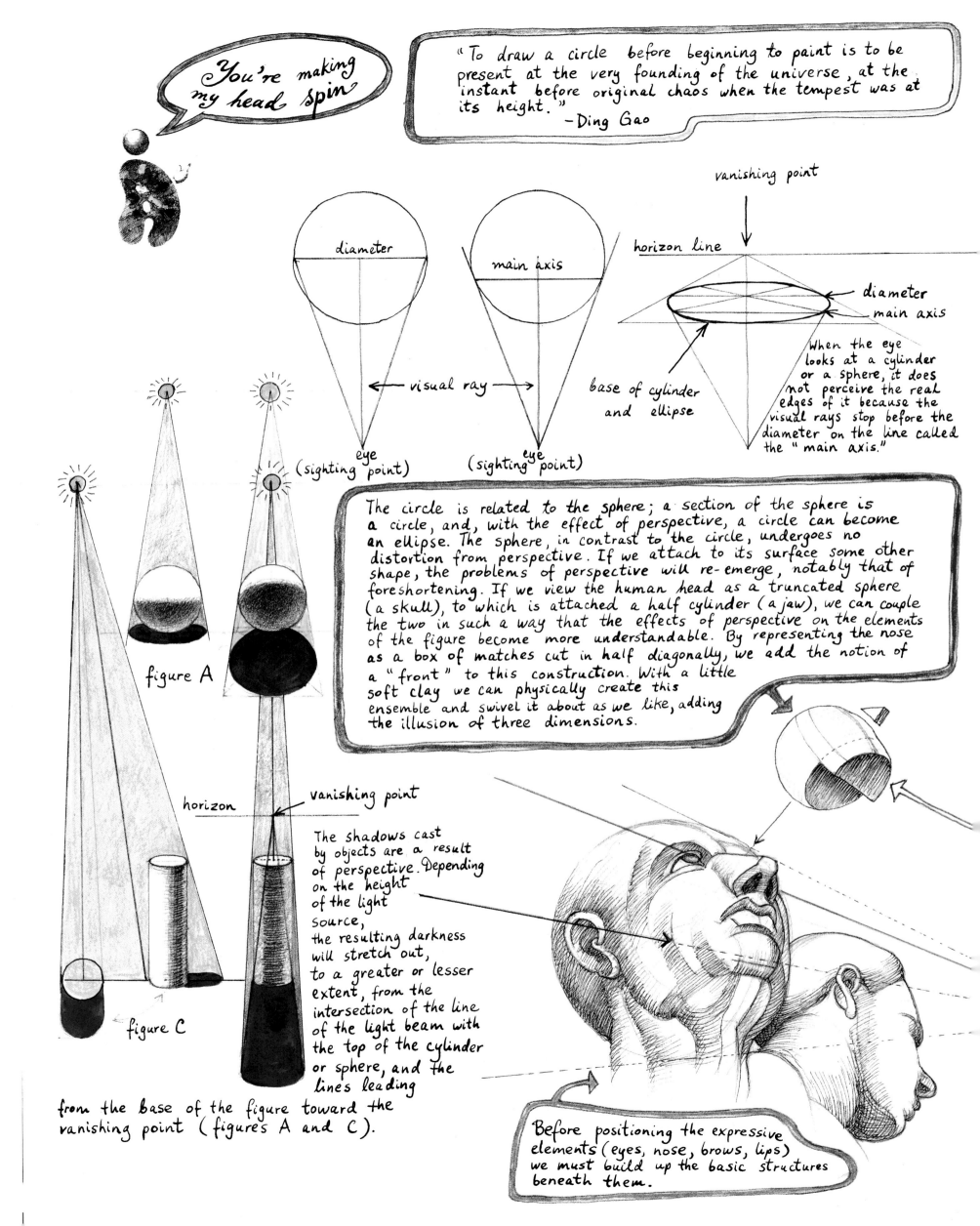

"You're making my head spin"

"To draw a circle before beginning to paint is to be present at the very founding of the universe, at the instant before original chaos when the tempest was at its height."
—Ding Gao

vanishing point

horizon line

diameter

main axis

diameter

main axis

base of cylinder and ellipse

visual ray

diameter

main axis

(sighting point) eye

(sighting point) eye

When the eye looks at a cylinder or a sphere, it does not perceive the real edges of it because the visual rays stop before the diameter on the line called the "main axis."

figure A

The circle is related to the sphere; a section of the sphere is a circle, and, with the effect of perspective, a circle can become an ellipse. The sphere, in contrast to the circle, undergoes no distortion from perspective. If we attach to its surface some other shape, the problems of perspective will re-emerge, notably that of foreshortening. If we view the human head as a truncated sphere (a skull), to which is attached a half cylinder (a jaw), we can couple the two in such a way that the effects of perspective on the elements of the figure become more understandable. By representing the nose as a box of matches cut in half diagonally, we add the notion of a "front" to this construction. With a little soft clay we can physically create this ensemble and swivel it about as we like, adding the illusion of three dimensions.

horizon

vanishing point

The shadows cast by objects are a result of perspective. Depending on the height of the light source, the resulting darkness will stretch out, to a greater or lesser extent, from the intersection of the line of the light beam with the top of the cylinder or sphere, and the lines leading from the base of the figure toward the vanishing point (figure's A and C).

figure C

Before positioning the expressive elements (eyes, nose, brows, lips) we must build up the basic structures beneath them.

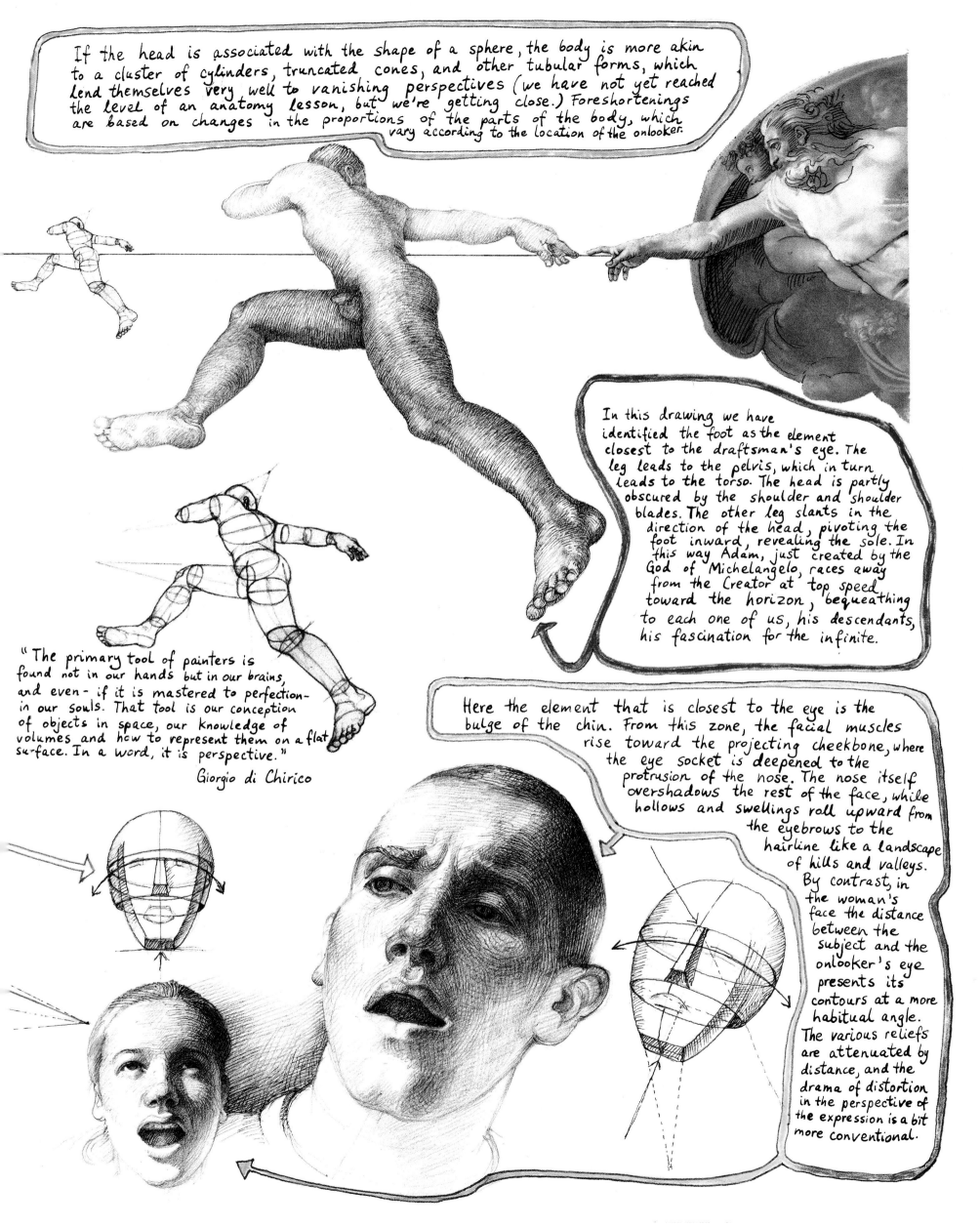

If the head is associated with the shape of a sphere, the body is more akin to a cluster of cylinders, truncated cones, and other tubular forms, which lend themselves very well to vanishing perspectives (we have not yet reached the level of an anatomy lesson, but we're getting close.) Foreshortenings are based on changes in the proportions of the parts of the body, which vary according to the location of the onlooker.

In this drawing we have identified the foot as the element closest to the draftsman's eye. The leg leads to the pelvis, which in turn leads to the torso. The head is partly obscured by the shoulder and shoulder blades. The other leg slants in the direction of the head, pivoting the foot inward, revealing the sole. In this way Adam, just created by the God of Michelangelo, races away from the Creator at top speed toward the horizon, bequeathing to each one of us, his descendants, his fascination for the infinite.

"The primary tool of painters is found not in our hands but in our brains, and even - if it is mastered to perfection - in our souls. That tool is our conception of objects in space, our knowledge of volumes and how to represent them on a flat surface. In a word, it is perspective."

Giorgio di Chirico

Here the element that is closest to the eye is the bulge of the chin. From this zone, the facial muscles rise toward the projecting cheekbone, where the eye socket is deepened to the protrusion of the nose. The nose itself overshadows the rest of the face, while hollows and swellings roll upward from the eyebrows to the hairline like a landscape of hills and valleys. By contrast, in the woman's face the distance between the subject and the onlooker's eye presents its contours at a more habitual angle. The various reliefs are attenuated by distance, and the drama of distortion in the perspective of the expression is a bit more conventional.

The head of a child viewed from the front can be fitted into a rectangle with four units of height and three units of width.

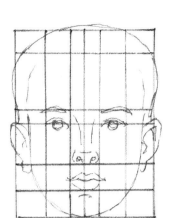

The same figure applied to the head of a teenage boy.

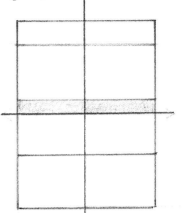

The Parramon method (inspired by Bertillon, who founded the science of anthropometry). Draw a module 3½ units high by 2½ units wide.

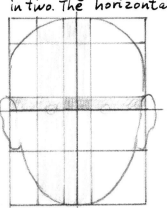

The vertical axis passing through the middle of the rectangle cuts through the nose and mouth, dividing the face symmetrically in two. The horizontal

axis passes through the center of the rectangle, and the eyes are at exactly the same level, which places them in the middle of the head.

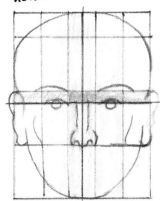

The horizontal median axis passes through the eyebrows, not the eyes.

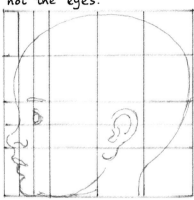

The profile fits inside a perfect square. The ear is very low and proportionately much bigger than the ear of an adult.

From Vesalus, the first to dissect a human body, who had Titian draw his human anatomies, to Dürer, who drew them himself, to Carraccio, Ribera, and many others, there is no lack of information about how to position constituent parts of the human head in drawings and how to keep them in proportion. For our description we have used two methods: one invented by M. J. Parramon, who followed the theories of Bertillon, and the other devised by Burne Hogarth, who invented the cartoon <u>Tarzan</u>. The latter actively provokes our imagination to visualize and conceive in space the volumes that make up the architecture of the human head.

Once you have grasped them firmly enough, these hints on drawing heads will serve as keys to open other doors. Your own face provides an excellent model for the studies you need to make if you are ever to draw the faces of others.

Making a face

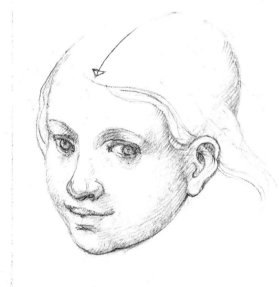

Jacob Jordaens, <u>Allegory of Fertility</u> (detail), c. 1623

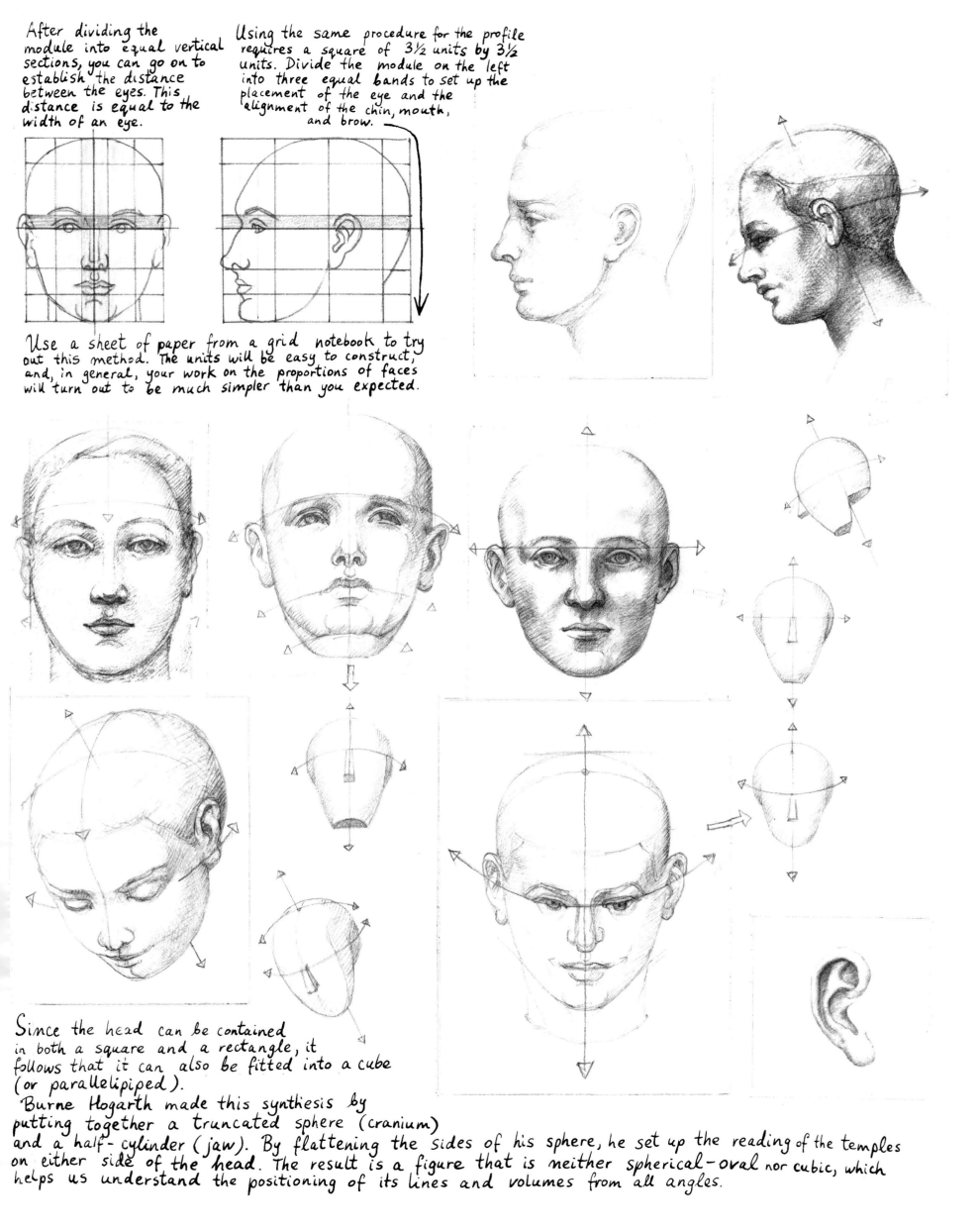

After dividing the module into equal vertical sections, you can go on to establish the distance between the eyes. This distance is equal to the width of an eye.

Using the same procedure for the profile requires a square of 3½ units by 3½ units. Divide the module on the left into three equal bands to set up the placement of the eye and the alignment of the chin, mouth, and brow.

Use a sheet of paper from a grid notebook to try out this method. The units will be easy to construct, and, in general, your work on the proportions of faces will turn out to be much simpler than you expected.

Since the head can be contained in both a square and a rectangle, it follows that it can also be fitted into a cube (or parallelepiped).
Burne Hogarth made this synthesis by putting together a truncated sphere (cranium) and a half-cylinder (jaw). By flattening the sides of his sphere, he set up the reading of the temples on either side of the head. The result is a figure that is neither spherical-oval nor cubic, which helps us understand the positioning of its lines and volumes from all angles.

 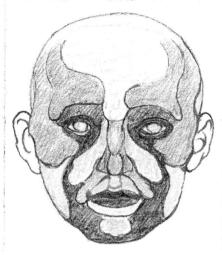 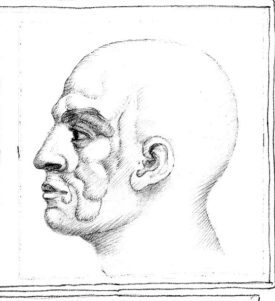

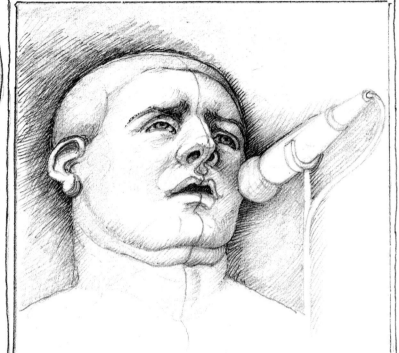

In praise of the grimace

The mobility of our human facial muscles has endowed us with a veritable encyclopedia of expressions, especially since cinema has accustomed us to view the least flutter of an actor's eyelid as being a vital ingredient in the film we are watching. Draftsmen and painters can make expressions all the more eloquent through their knowledge of the points of tension, or elasticity, in the elements of our faces.

As soon as these expressions come into play, some kind of story is told. We have not escaped this rule – we imagined that the model pictured below was being most uncomplimentary to us.

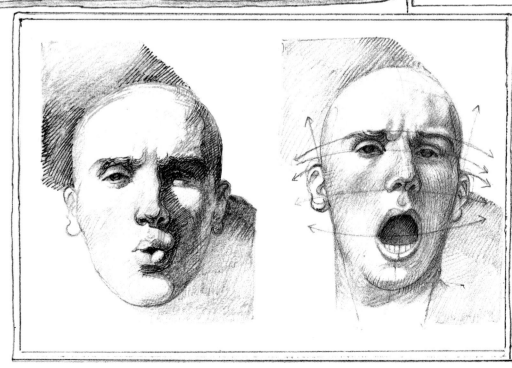 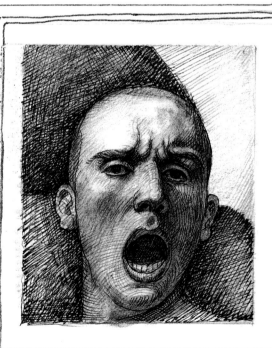

"Hey, you! Yes, you, authors. You've been running on for page after page with your advice, perspective, lines, spheres, and quotes, and I've been patient up to now.

"But it won't work. The stuff you've done looks nothing like the stuff I'm doing. I've gone through three erasers, all my pencils are broken, and my paper's ruined.

"All you do is parade your own knowledge and that's all you're good for. I didn't need lessons when I was a kid— I didn't know a thing and I was happy painting that way. Now you come along to ruin it...

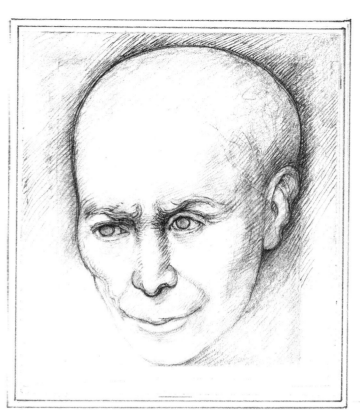

Théodore Gericault, 1791-1824,
Envy (a study from a portrait)

Alberto Giacometti, 1901-1966,
Portrait of Georges Bataille

Mystical orator

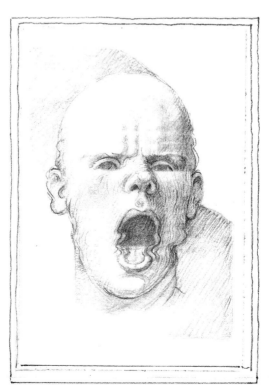

"I've had it, I'm sick of this book, I wanna smash something, I'm sick of it, sick... of... it !"

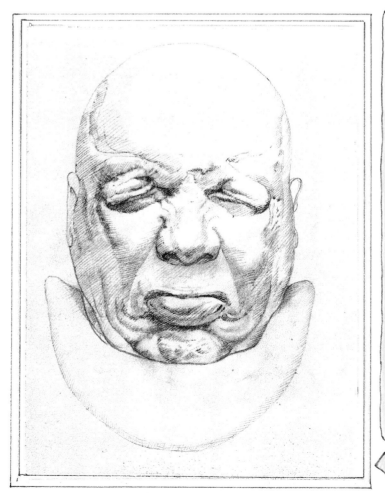

Many museums in the United States possess works by Messerschmidt, an unusually gifted artist. There are hundreds of expressions by this brilliant and unbalanced sculptor in the Österreichische Galerie in Vienna. His work is also found at the Museum of Figurative Arts in Budapest, the Germanisches Nationalmuseum in Nuremberg, the Würtemburg regional museum in Stuttgart, and the Victoria and Albert Museum in London, among others.

Franz Xaver Messerschmidt, 1736-1783,
Obstinacy (a study of a sculpture)

Figures and construction

A simpleton once asked why pure gasoline couldn't be used on its own, without the process of refinement. The same kind of ingenuousness often is found in the art world. People ask, "Do we really have to look for the principal lines around which volumes wrap themselves? Do these lines and axes, even though they supply us with information on the perspective of forms in space, really belong to the creative act? Is it really worth our while to bother with the notion of foreshortening? Isn't painting supposed to be something spontaneous? Isn't it merely the cancer of academic convention lurking behind these lessons?"

When you read cylindrical forms into a figure, you wrap them round the axial lines and define their contours.

The process is one of simple construction, and ought to be less "written" than it appears in the adjoining figure so as to preserve a platform for the paint.

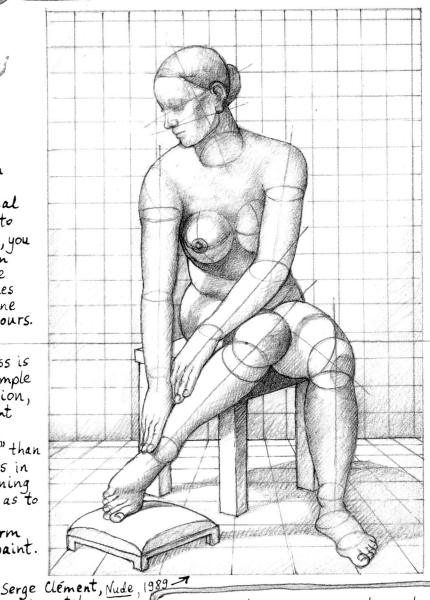

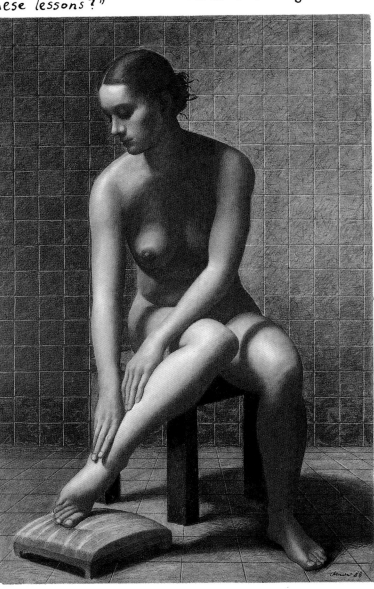

Serge Clément, Nude, 1989
soft pastel

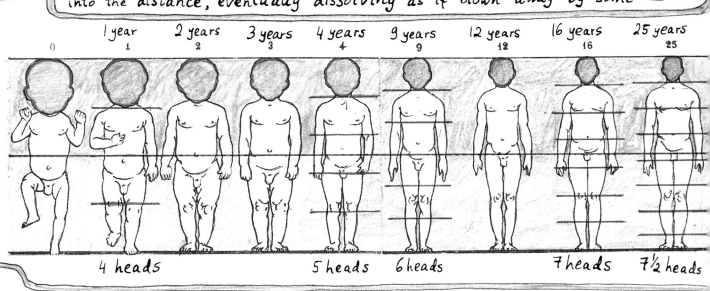

To understand space is to realize that there are several answers to each one of the riddles posed by depth. Long before the artists of the Renaissance and long after them, depth remained a preoccupation, even a passion, for painters. Francis Bacon, Alberto Giacometti, and Lucien Freud are a few modern examples.
If our brains could read images without perspective, then chins, necks, thighs, and breasts would convey nothing more to us than their own objective shapes. The fact that we perceive a forest stretching away into the distance, eventually dissolving as if blown away by some

Ages →
This table shows the different proportions of the human head and body at different ages. At four, a child's head is one-fifth the size of his body. At twenty-five, a man's head is half again as small. All the figures here are drawn to the same height, with the horizontal line dividing them exactly in two.

	1 year	2 years	3 years	4 years	9 years	12 years	16 years	25 years
0	1	2	3	4	9	12	16	25

4 heads 5 heads 6 heads 7 heads 7½ heads

To objections like these, we reply: lines or contours drawn against a well constructed background over which the only other thing needed is color, are merely clues to what may eventually be possible. A single flake of paint a fraction of an inch thick, if you analyze it in a laboratory, will give you the same results regardless of whether it has been taken from a good picture or a bad one.

Rimmer,
Muscular Outlines, No. 17

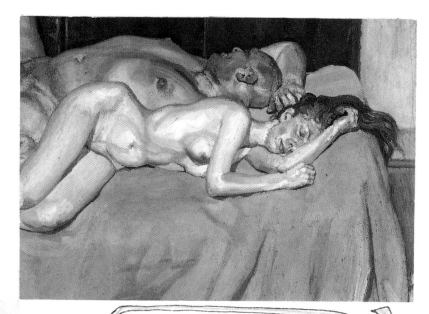

Francis Bacon,
Three Figures in a Room,
(right panel, detail), 1964

Lucien Freud,
And the Bridegroom (detail),
1993
oil on canvas

Jackson Pollock,
1931
pencil and black chalk

gigantic horizontal sigh, is no cinematic special effect: it is an event that occurs within hundreds of millions of retinas every day, in hundreds of millions of situations and ways of looking at things. Nor does the sheer abundance of these effects makes them banal. The term "shot" may belong to the language of photography, but it is exactly the way to describe what happens whenever

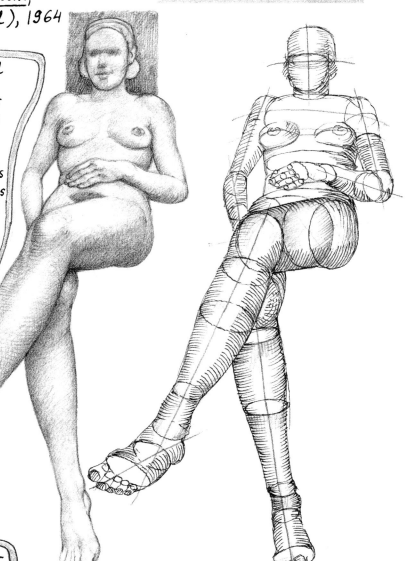

Alberto Giacometti,
Portrait of Annette,
1961
oil on canvas

any human being— let alone a painter— trains his eye on something. When we take such shots with our eyes, a different depth immediately emerges, a link between living beings and things that is just not a matter of illusion, perspective, relief, or a third dimension in such depth — it is a place where our emotions and the universe meet and mingle.

Back views

Above all, do not use painting to execute a subject, but use a subject (somebody's back, for example) to execute a painting. What does this mean? We talked about it before in the "Eyes have fingertips" section. It means that in any given place - on a canvas, a sheet of paper, a wall or a ceiling - conditions are brought together that allow for a perception of space and volume, which, by the shortcut of your vision, transmits to your brain the information you can use to apply material and physical shape to a support (provided you have coloring matter and tools for applying it). For there to be any art involved in this moment of application, it will be neither reportage, nor documentary study, nor literary narrative, nor verism (truer than truth itself), nor neutrality (which has its uses), nor even the too-easy eloquence of the artist. When the eye slides indifferently across a subject on a canvas, that is a bad sign. The eye should be arrested by the matter, or the texture, or the grain, or the canvas- it should be stopped cold in order to understand who exactly is seeing the painting and who exactly is speaking through it. Some people think you don't need to know this, but we believe it is not human to express the will to say nothing. You would need gifts beyond all human understanding to achieve true muteness, absence, neutrality, and nullity in life, and at the same time achieve eloquence in images.

Seurat painted day and night. He was handsome and discreet and he invented the technique called "simultaneous contrast," influenced by Chevreul's scientific theories about color. Prodigiously gifted though he was, poor Seurat died at the age of 32.

Georges Seurat, <u>Poser from Behind</u>, 1887

Begin by drawing the principal masses. Remember that no line can exist alone: it always drags another line along with it. Also, empty spaces are just as useful as full ones. Here a triangle is formed by the arm, the backbone, and the muscle (1) of the buttock, or the one beneath it running along the thigh (2).

Don't forget the lines of construction, the axial lines of the head, the shoulder blades, the pelvis - using hatchings lay in the notions of light and volume. Take special care with the joints, even the ones like the knee that aren't particularly elegant, because they are part of the structure that supports the body.

The placement of all these things is anything but a chore - every moment you spend drawing is interesting, and you will find special joy when your drawing is done without regard for some theory or effect planned in advance. Your model, as her name indicates, is the person whose presence will define your own singularity. That is, if you don't allow your will to dominate your instinct.

We have always maintained that these are not shoulder blades but stripes drawn out under the influence of Giacomo Balla: likewise, the pelvis and the hips shot through with blue, vibrant tones. All these things can be represented, with or without Balla, by the instinctive awareness that engenders novelty in the plastic arts. At the time when this picture was painted, this technique was called divisionism.

Here, each touch of the artist's instrument contributes to a kind of sculptured density that accentuates the way the figure of the man is gathered in on itself. The painter's bulimic vision is well served by his craftsmanship, which is almost traditional – like the version of The Turkish Bath done with a jackhammer.

Here the artist has created an osmosis between his subject and its fluid apparition in watercolor. – beneath them there is only paper. Only the greatest alchemists are capable of transforming a simple wash of madder lacquer into a miracle.

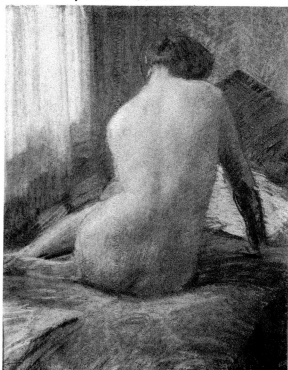

Arturo Noci, Nude, 1912

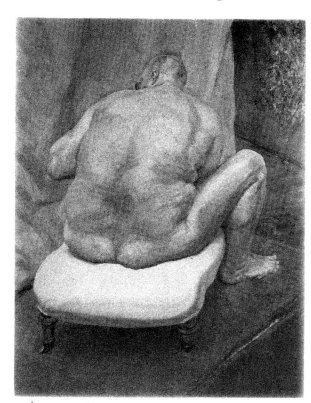

Lucien Freud, Naked Man, Back View, 1991–92

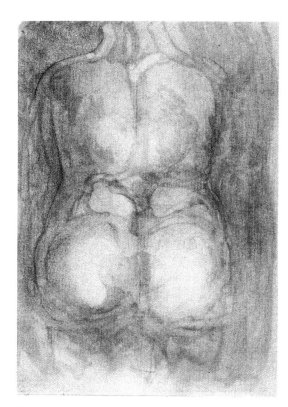

Charles Matton, Large Back, 1963–1990

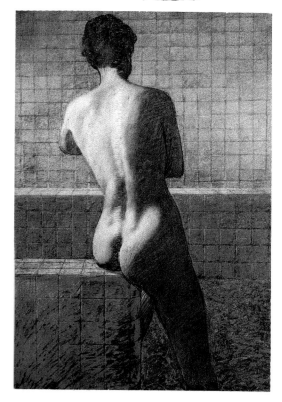

Serge Clément, The Bath no. 2, 1992

Having completed your construction, you reach for your pastels, anticipating their caresses of color, the creak of the paper as it takes and holds the powder, and the undulations of the crayons. They blend naturally, without you having to smooth together shade and light, colors and values. If the fire is what it is, it is because you lit it.

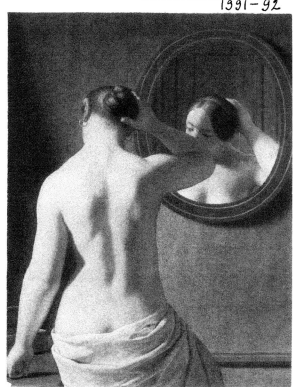

Christopher Wilhelm Eckersberg, Morning Toilet, 1837

This artist is considered "the father of Danish painting." He taught at the Copenhagen Academy and was a friend of Bertel Thorvaldsen.

"To give the various elements a fullness of shape, as in sculpture one looks for the volume and plenitude that human contours must express."
— Matisse

Nobody could put it better.

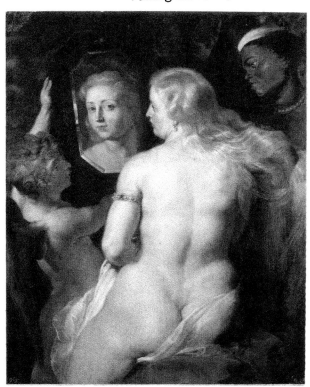

Peter Paul Rubens, Venus at her Looking Glass,

Like Anthony van Dyck, Rubens is out of fashion. Is this because of his spectacular life, because he was so prodigal in his works, or because of his brilliant diplomatic career? Rubens negotiated the peace between Phillip IV and Charles I in London, and 2,235 of his paintings are attributed to him. But, above all, he painted Hélène Fourment's beautiful back, along with some other portraits of her that don't deserve to be out of favor at all.

Black is a color

"Because I admired Renoir very much, I went to see him at his house at Cagnes-les-Collettes. He received me very kindly. I showed him some of my pictures and asked him what he thought. He looked at them reprovingly and said: "To tell you the truth, I hate what you do. I would like to tell you that you aren't a good painter or even that you're a bad painter. But something prevents me from doing so. I see that when you put black on your canvas, it stays in its allotted plane. All my life I've thought one could —

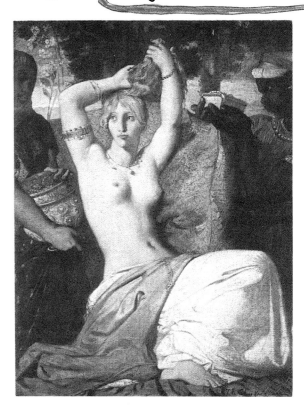

Théodore Chassériau,
Toilette of Esther, 1841

Chassériau said: "We must observe the antique and render it through nature." He was known as an Orientalist and deserved the title because in his work the mighty orchestra of blue-blacks (on the left) and warm browns (on the right) are fully present, just as they would be later in the work of the Nabis and the Fauves. Their function here is to answer the acid green of the cushion and the carmine-tinted siennas of the drapery. The grace of the bust is accentuated by a paint mix that is rich in greens, reds, blues, ochres, and whites, adding up to a luminous grey-pink.

Henri Matisse,
Nude with a Tambourine, 1926

The colors that are most expressive are not necessarily the descriptive ones: in this case a too great descriptiveness would spoil the effect of the arabesque. Yellow expresses sheen and luminosity, but Matisse's yellow patch on the floor teaches us that yellow is also sunshine. Black (hatched all over the sketch) runs firmly round the edges of the red floor. The black rectangle also lights up the blue-red-violet-gray of the sky.

Matthew Smith,
Fitzroy Street Nude no. 2, 1916

In figurative painting, as well as in other types, colors used in their pure, or almost pure, state can be eloquent, provided they are juxtaposed. A mix of them always turns out to be less rich. For example, yellow and red put side by side will yield a more vibrant effect then they would if they were first blended on the palette. All the colors Smith used here are enriched by the light from the black (candle black?) of the hair, the thigh, the roof outside the windows, and the parallel lines on the carpet.

Today's eye has grown lazy, lacking the insight to recognize the difference between drawing and the line of the body. At one time, these differences were hotly debated in Venice, Florence, and Bologna. At the beginning of the 20th century, painters who looked more closely than their contemporaries did not invent: they revealed. And when they sought to free themselves from the prevailing canons of harmony, it was the end of all certainty in painting.

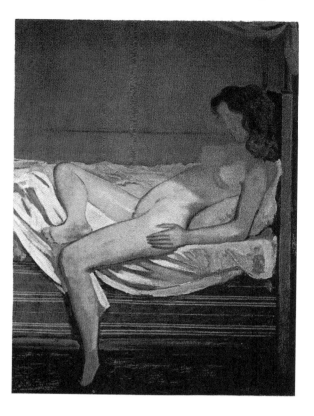

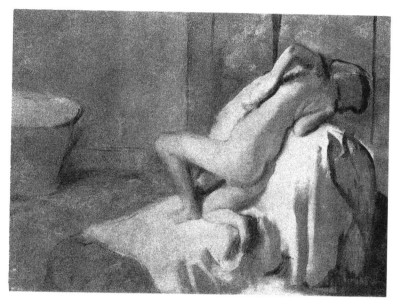

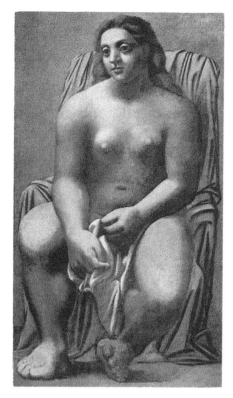

Edgar Degas, <u>After Bath</u>, 1896

When a painter says he wants to free himself of his emotion, he means he wants to pour it out on the canvas; for without emotion a painting is nothing more than a few streaks of coloring matter on a flat surface. Technically, we can state that the black-browns running beneath the arms, the thigh, and the sheet make the rest of the picture sing, almost literally (but you will have already noticed that). Likewise we would point out that the weight of the body, saturated as it is silvery white, pink ochre, and cobalt blue, solid as a rock on the bedsheet and displaced toward the right, creates a composition that is both ornamental and stable. This is because Degas was fully aware of what is called "the science of intervals" and knew that including the end of the bathtub, with its blackish-violet shadow, would re-launch the horizontal lines and, indeed, the whole weight of his composition, in a leftward direction. Did you spot that as well? If you did, we'll overlook what's happening in the area between the knee of the girl and the tub, because based on the evidence above, you're ready to do a little painting yourself. Quite a lot, in fact.

Balthus, <u>Nu</u>, 1939

According to Matisse there can be no rules and even fewer practical recipes in painting, for otherwise art would be an industry. In this picture Balthus has deemed the presence of primary colors unnecessary. The black and ochre stripes on the mattress and the heaviness of the floor serve as a support for the broad, simple rhythms of the sheet. This, in turn, leads to the creamy blandness of the girl's body, whose pelvis is only illuminated by clear ochre, the upper parts being relegated to shadow. The curves of the figure are solidly outlined; they create an image within which sentiment is overpowered by the painter's art. "I am a painter of angels," said Balthus.

Pablo Picasso, Grande Baigneuse, 1921

"I do not seek, I find." Here, Picasso has (as usual) found an antique ochre made monumental in the figure of a woman that is precisely contained in a rectangle. Precise is the word for this: the masterly volumes, the grays and blacks of the fabric, the relief, the volumes are all correct and precise to a fault. Most precise of all is the exaggeration, which announces that life is strong and powerful like this painting. It would be deeply pessimistic of us to believe that Picasso left nothing more for future painters to do. We must continue to dream...

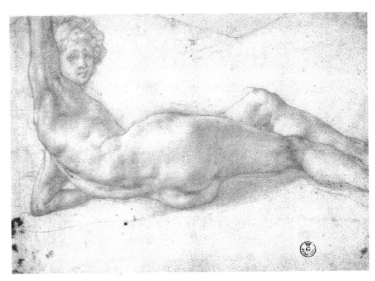

Pontormo, Figure Study for the Loggia Frescoes
for Careggi Castello, 1535-43

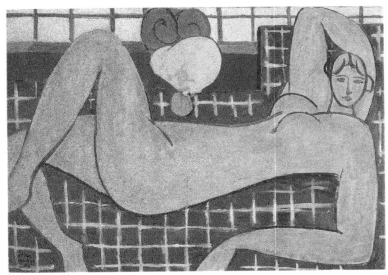

Henri Matisse, Pink Nude,
1935

Milton Avery, Lanky Nude, c. 1950

Nicholas de Staël,
Nude Standing, 1953

Figures

Over time, the problem of representing the human figure has boiled down to appearances. The vocabulary of each painter in each epoch defines the possibilities at his or her disposal. To understand this, note how Pontormo, remembering Michelangelo, defines the contour of his figure by using firm, sensitive lines, beginning and ending with exactly the ones the shape requires. Working with the side of a stick of ochre chalk, he reveals a bodily geography across which the eye can rove at will. There is elegance here, and latent strength.

In the Matisse picture, a broad pink, ochre, and blue zone stands against a background of blue criss-crossed with gray. When the line has reached its climax a figure appears that, in Matisse's day, could claim to be the ultimate in simplification. The layer of paint covering the surface is a very thin one since Matisse worked with turpentine containing a minimum of oil. This raises concerns that Matisse's paintings will one day deteriorate.

Milton Avery cuts to a minimum the decorative elements that formerly gave the painted figure its ornamental character. His restraint is not so much a canceling out as an ascetic revelation of the presence of his model within a space delimited by blue-gray zones, painted very thinly in blues and ochres and rhythmically applied in squares and rectangles.

De Staël favors an approach whereby the refusal to describe appearances does not lead to a complete break with reality. In this standing nude, his palette knife and brush seem to have penetrated the very flesh of the paint.

Marina Kamena, Homage to Ingres no. 2, 2000
conté chalk and charcoal

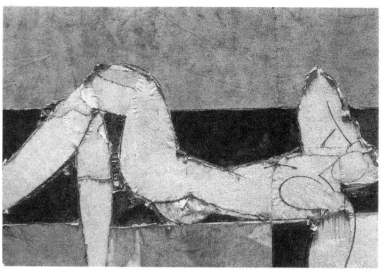

Manolo Valdés, Matisse comme prétexte, 1987

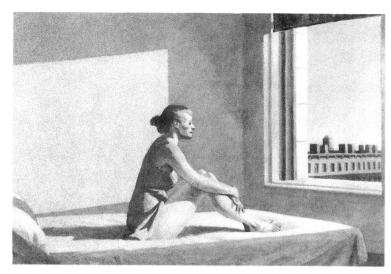

Edward Hopper, Morning Sun, 1952

Manolo Valdés's Matisse-inspired figure is sophisticated and celebratory. The shapes are cut from unbleached fabric and sewn against the sheen of black that Velázquez, Goya, and Picasso would use to remind the light that its reign was entirely reliant on the whim of darkness.

Edward Hopper has painted his figure with laconic care, surrounding this person whom the morning light has illuminated but not warmed with expansively painted zones. There is no anecdote attached to this work, the means used by the painter to express what he has seen are pictorial and innocent of narrative complacency. Neither nostalgic, nor futuristic - merely contemporary.

Francis Bacon, Triptych
(left panel, detail), 1983

The shadow that Francis Bacon places beneath his figure is a completely natural one, and the figure itself is revealed by a few elliptical flashes of fluid paint. A scintillating background of powdered pastel irradiates the carmine violets hurrying across the body as it writhes in stylized torment.

Then there is Monsieur Ingres, who recalls us to the pure strength of drawing. His paper support makes for an image that cannot last as long as those that continue to gallop across the limestone walls of Lascaux: nevertheless, what he has begun will be continued in our own vinyl-walled modern caves.

In these pages our aim has been to offer you apparel for a journey, not through the continent of art, but through the land of painting with its great metropolitan centers (pictures), its streets (drawings), alleys (sketches), and structures (perspective, anatomy, and the rest). We have visited only a very few places, and from them you may have garnered nothing more than vague possibilities. Nevertheless, even if you yourself don't settle down to paint, we hope you will have seen enough to spread the news that the whole world is still out there, waiting to be painted.

Jean-Dominique Ingres,
Study for The Turkish Bath,
1852-1853

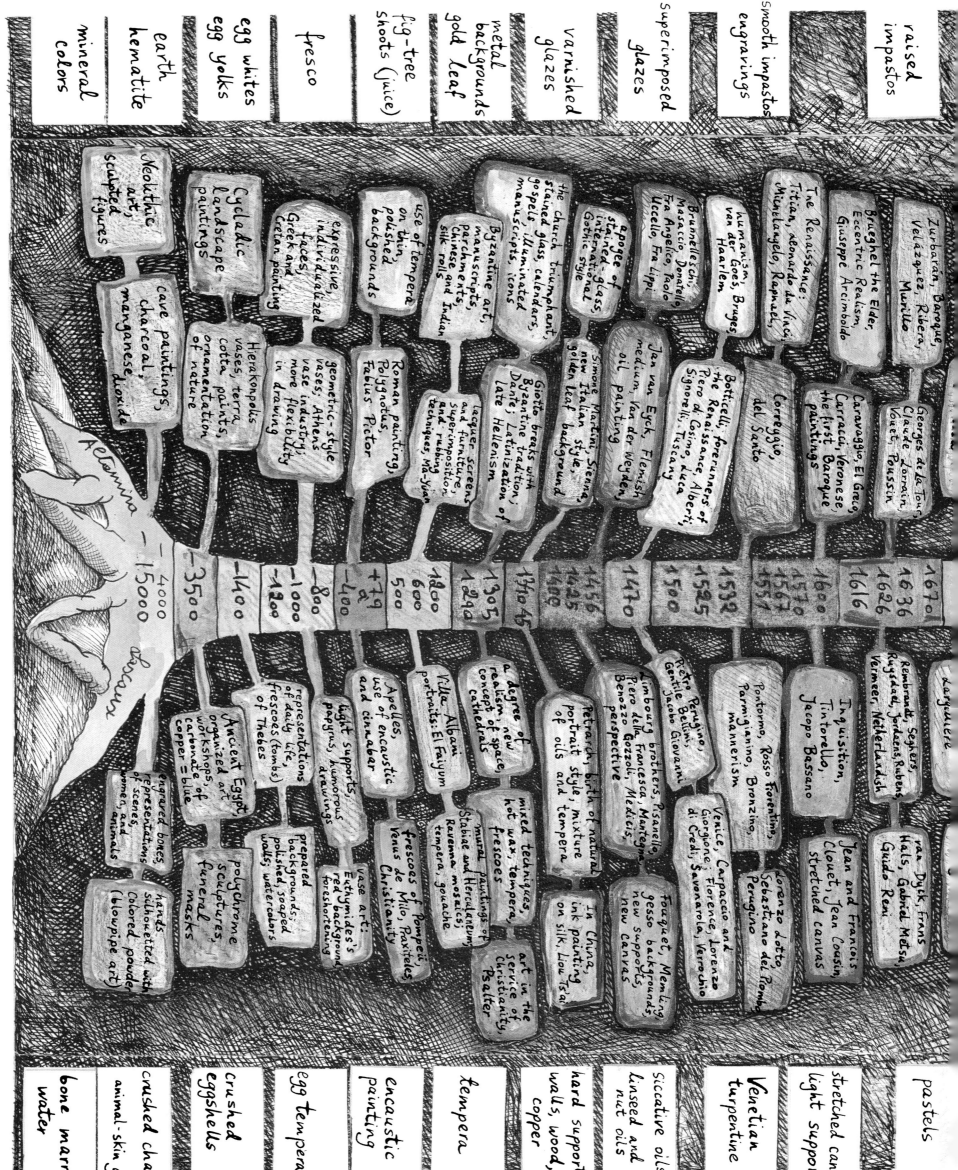

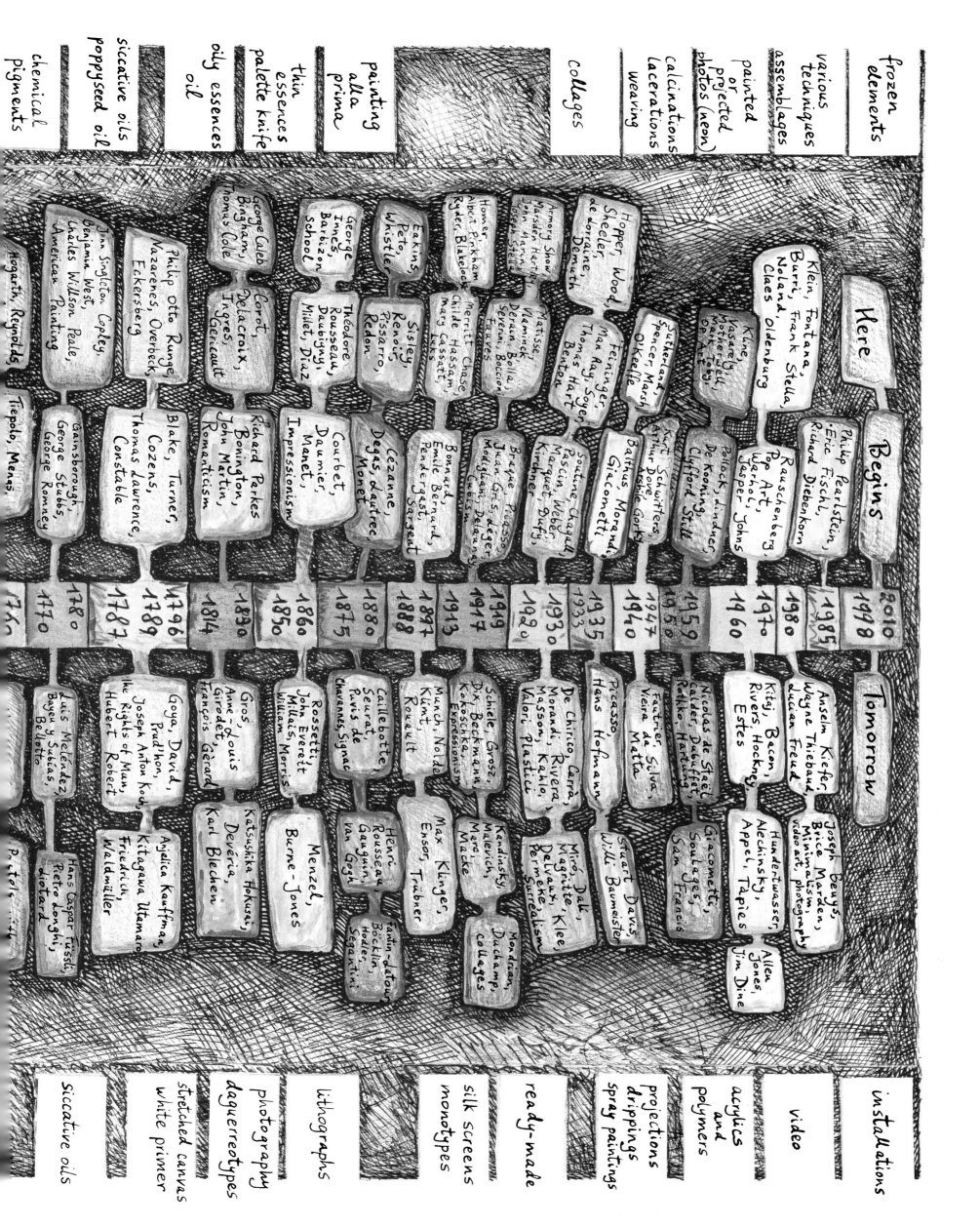

Credits

The majority of reproductions come from the personal collection of the authors with the exception of the following: Page 40: *After the Bath, Woman Drying Her Left Foot,* Edgar Degas; Musée d'Orsay, Paris. © Lauros-Giraudon; Page 42: *Self-Portrait with Spectacles,* Jean Siméon Chardin: Musée des Beaux-Arts, Orléans. © Giraudon; Page 106: *The Ideal City,* anonymous; Bildarchiv Preussischer Kulturbesitz; Page 106: *Flagellation by Torchlight,* Jacopo Bellini; Louvre, D.A.G., Paris. © Photo RMN, Gérard Blot; *Rout of San Romano,* Paolo Uccello; Gal. Degli Uffizi, Florence. © Alinari-Giraudon; *Virgin and Child with Saints,* Piero della Francesca; Pinacoteca di Brera, Milan. © Alinari-Giraudon; Page 108: *Café Express,* Richard Estes; The Art Institute of Chicago; *The Pair-Oared Shell,* Thomas Eakins; Philadelphia Museum of Art; *Girls on the Jetty,* Edvard Munch; Nasjonalgalleriet, Oslo; *Street in Murnau,* Vasily Kandinsky; private collection; *Field Path,* Wilhelm Morgner; Bochum, Kunstsammlung. © Giraudon; *The Artist's Room at Arles,* Vincent van Gogh; Musée d'Orsay, Paris. © Giraudon; *The Floor Scrapers,* Gustave Caillebotte; Musée d'Orsay, Paris. © Lauros-Giraudon.

The historical anecdotes from the lives of painters were taken from *La Vie des grands peintres racontés par eux-même et leurs témoins* [The Lives of Great Painters as Told by Themselves and Their Witnesses] by Michel Ragon in collaboration with Jean-Jacques Levêque. Éditions du Sud.